372.5 WEN

This book is due for return on or before the last date shown below.

2 8 SEP 2007

5

For Freddy
with love, as always

Martin Wenham is a practising artist who until 1998 was a Lecturer in
Primary Education at the University of Leicester, specializing in science
and art. Much of his work is centred on lettering and language, using shape, space
and colour to express and communicate meaning. He works in a variety of
media and exhibits widely, most recently in a solo exhibition, *Language
Visible*, at the Goldmark Gallery, Uppingham, Rutland.

Understanding Art

A Guide for Teachers

Martin Wenham

University of Leicester

P·C·P

Paul Chapman

First published 2003

Paul Chapman Publishing
A SAGE Publications Company
6 Bonhill Street
London EC2A 4PU

SAGE Publications Inc
2455 Teller Road
Thousand Oaks, California 91320

SAGE Publications India Pvt Ltd
B – 42 Panchsheel Enclave
Post Box 4109
New Delhi – 100 017

Library of Congress Control Number: 2002106580

A catalogue record for this book is available from the British Library

ISBN 0 7619 7477 6
ISBN 0 7619 7478 4 (pbk)

Designed and typeset by DP Press Ltd, Sevenoaks
Printed in Great Britain by Cromwell Press Ltd, Trowbridge, Wiltshire

Contents

List of figures

List of colour figures

Between pp.00 and 00.

Preface

The aim of this book is to help teachers to start developing effective teaching and learning in art through first-hand exploration of visual elements such as line, colour and shape. In the practice of art, which includes teaching and learning, the visual elements are combined and used to create a visual language, which we 'read' when we look at artwork such as paintings, drawings and sculpture. An understanding of these visual elements can be gained only through first-hand experience and is part of the knowledge-base which underpins all effective art. This book has been written to help teachers and students, especially those with no background knowledge or specialist training in art and design, to learn about the visual elements, and to help children learn about them, through investigation, experiment and observation.

Apart from Chapter 1, most of the chapters have the same basic layout, though this varies in detail. The first section develops the idea of the visual element, or the aspect of it under discussion, and shows how it is related to others. The middle part, which in some chapters is in more than one section, discusses the properties and potential of the visual element, and practical activities through which these can be investigated. The final section shows, by reference to particular works of art and craft, how the visual element has been used in a range of contexts, periods and cultures.

 Although written in the form of observations and discussions, much of the text can be used in a very direct way as the basis for children's investigations, experiments and creative work. Paragraphs which can be used in this way are marked with a symbol in the margin and printed with a grey background.

In works of art and in the wider environment, the visual elements are hardly ever seen in isolation from one another, so discussing them separately, though necessary, is also artificial. At every stage there is a need to link up the focus of a particular investigation with what is known of the other visual elements, with the aim of seeing art as an organic whole, rather than a series of unconnected parts. To help achieve this there is extensive cross-referencing throughout the book, showing how the visual elements, and what can be done with them, are connected and related.

The selection of artworks for discussion in the final section of each chapter is listed in Appendix 5 and is based on my own work in schools and with teachers, but has been subject to other constraints which have resulted in its range being both restricted and distorted. The first constraint has been one of relevance. Examples which illustrate clearly the properties and potential of visual elements in a creative and interesting way are not, in all cases, easy to come by. In addition, much of our present understanding of the visual elements was developed by twentieth-century artists in Europe and America, most of whom were men. The second constraint has been one of availability. As far as possible I have chosen as examples works which are either available as images on the Internet (Appendix 4), or which have been reproduced in low-cost books or other resources which may be available in schools. The need to do this has, regrettably, reinforced the gender and cultural bias evident in the contents of major art galleries and art books for the mass market. There is in particular far too great an emphasis on European and American male artists, which has resulted in both women artists and other contemporary cultures being badly under-represented. The most effective way of correcting this is for teachers to research and exploit the resources available in their own areas and communities, which may also make it possible for children to meet artists and experience more works of art at first hand.

Acknowledgements

Although one person's name appears on the titlepage this book, like most others, could not have been written without the help and cooperation of a large number of dedicated colleagues. It is based on my own teaching in primary and special schools in Leicestershire as well as in-service and ITT courses at the University of Leicester. To all my pupils, students and teaching colleagues, who have enabled me to learn far more than I can ever have taught them, I extend my warmest thanks.

During the planning and writing of this book I have received constant help and advice from Sally Pudney and Peter Halliday, who have not only read and commented on the text in draft form but have also given me the benefit of their extensive classroom experience in a wide range of teaching situations. Their advice and support have been invaluable.

I am grateful to the children and parents who have kindly allowed their artwork to be reproduced, and to Morag Hunter-Carsch, who has given permission for reproduction of two photographs by her husband, the late Henry Carsch. Thanks are also due to the children, teachers and head teacher of Hamilton Primary School, Colchester, for trialling some of the ideas in this book and sharing the results with me.

Marianne Lagrange of Paul Chapman Publishing, Susie Home and the production team at Sage Publications have been an unfailing source of help, advice and encouragement. I would also like to express my thanks to Penny Butler, whose skill and insight as copy-editor have greatly improved the book, both overall and in many details. Numerous individuals have also been generous in their help for the project, including Peter Jackman of Calder Colours (Ashby) Ltd, who kindly supplied the paints used in my experiments and for Colour figures 1–8; Jon Palmer who produced Figure 4.5b on his computer; Jonathan Westgate and Paula Buck of the School of Education at Leicester University who continue to help me keep my computer functioning; and Matt Wenham and Kate Grice, who finally got me linked up to the Internet.

Lastly, my greatest thanks must again be given to my wife Christine, who has lived with this project every day for nearly a year. Without her love and support this and every other endeavour would be impossible.

Martin Wenham
Bangor, Gwynedd
March 2002

1 Art as Exploration

1.1 Investigating, making and responding to art

Any attempt to understand art, and to help children learn through doing artwork for themselves, is greatly helped by realizing at the outset that there are no neat and tidy definitions to tell us exactly what art is. Even within our own society, the word 'art' means too many different things to too many different people to be summed up adequately in a few words, and people of other times and cultures thought, and still do think, of art in ways quite different from our own.

Three aspects of art

Many people, perhaps most, in Europe and America today think of art mainly or wholly in terms of product. To them, art means the contents of art galleries or museums; the things which artists make, such as paintings, drawings, sculpture and prints, including perhaps artefacts from other civilizations. To most artists this view is too narrow. Although the works they see in galleries and which they themselves produce are very important, an artist's view of art is likely to centre more on what artists do; on art as an activity or process.

For us as teachers, the artist's view is still too narrow. We have to add a third aspect to our idea of art to make it workable and effective in the classroom. As well as what artists make (product) and what they do (process) we have to consider the response of ourselves and our pupils, not only to our own and other people's artwork, but also to the experience of designing and making it. What do we feel about these things and experiences, what can we learn from them, and what do we do as a result? This view of art is summed up in Figure 1.1, as a set of feedback loops, with the artist, learner or teacher in the middle. Each double arrow represents an interaction; a two-way flow of ideas, questions, feelings, knowledge and, for some of the links, activity.

Figure 1.1 A teacher's idea of art

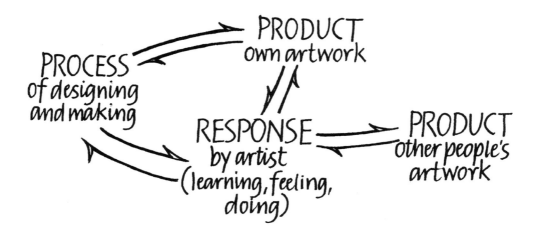

Art and intention

Although art on a world scale is enormously diverse, all of it is related because all art is an intentional human activity. Claims that some animals behave as artists are unconvincing: only humans engage in the designing and making of art, and no one does so by accident. The means and materials artists use and have used worldwide may seem diverse, but apart from some modern media such as video they are rather limited. Nearly all artwork, whether historical or contemporary, is made out of mark-making substances and materials, surfaces to make marks on and materials to model, carve into or build with. For example, we know quite well what prehistoric artists were doing when they drew and painted on cave walls, and can deduce something of how they went about it. What we do not know at all, and can only guess at, is why they were doing it. It is intention, not materials and methods, which gives art its great diversity.

Materials and methods do not change fundamentally from age to age and civilization to civilization. What do change are artists' intentions, their own view of their role and their ideas on what it is they are setting out to do. The more clearly artists understand their own intentions, the more likely they are to succeed, and this is no less true for us as teachers. If we are to succeed in helping children to learn in and through art, we need to be quite clear about our own intentions, and also be ready to help children clarify theirs.

Art as discovery

At different times and in different cultures, the activities we loosely group together as art have been used for a very wide variety of purposes: to record and commemorate, to tell stories, to teach or indoctrinate in moral, religious or political dogmas, to entertain, to decorate, to bind societies together or split them apart. Most of these uses (or abuses) of art are still with us, in one form or another, but during the past 150 years, art in Europe and America has developed in a way which seems quite new in world history: it has become a major means of enquiry, investigation and experimentation. This approach was well summed up by the English painter Frank Auerbach, who in a television interview in 2001 remarked: 'To do a painting that one knows how to do is not art ... Art is discovery'.

What is it that teaching and learning art can enable us to discover? We can learn about materials and develop the skills needed to use them effectively. We can learn about how we perceive the world, learn to question what we see and what we feel about it, and develop the ability to observe critically. We can find out how we respond to other people's artwork and begin learning how to express and communicate our own ideas and feelings. Most importantly of all, like all great human endeavours such as literature, science and drama, art can help us learn about ourselves and how we relate to other people and the world around us. But to do any of this, intention is not enough. We need a foothold: things to do, ways to investigate and a place from which to start. The purpose of this book is, quite simply, to offer such a starting-place.

1.2 Visual language and the visual elements

It has long been realized that art is based on a visual language, in which people express themselves and communicate with others through designing and making images and objects, rather than by speaking or writing. The main building-blocks of this visual language, such as line, shape and colour, are usually known as the visual elements.

Between the sixteenth and nineteenth centuries in Europe, some aspects of the visual elements and visual language, such as perspective (a kind of illusory space, see pp. 98–100) and some interactions of colour (Chapters 6 and 7) were very thoroughly investigated. In the twentieth century, artists and teachers began to experiment with other aspects such as line, shape and space, which appear very simple but which are in reality a rich and varied source of ideas.

What they found was that each of the visual elements has its own properties and potential even before it is combined with others in images such as paintings or drawings, and objects such as sculpture. As a leading contemporary painter, Bridget Riley (2002: 16), puts it, 'the elements of painting are not just a means to an end, but have distinct characteristics of their own'. By investigating these properties, applying what they discovered to their own work and learning from each other, artists in the twentieth century greatly extended and deepened our knowledge of the visual elements and our understanding of visual language. The most visible results of this research can be seen in art galleries all over the world: they are the works which collectively are known as modern art (see also pp. 128–9).

Although modern art is not one art-form but many, what all its varied forms have in common is that they are based on experiments in different ways of perceiving, making and responding to images and objects: investigations into different forms of visual language. For children of today, no less than for artists of the twentieth century, a very effective way to begin learning about visual language and art, and become artists in their own right, is to learn about the visual elements through experimenting with them, to find out what their properties are and how they can be used effectively.

Relating the visual elements to each other

There are nine visual elements, each of which is the subject of one or more chapters in this book: point, line, tone, colour, shape, space, form, texture and pattern. Their relationship may seem complex, but in fact is fairly simple, based on the way in which some elements can contribute to others (Figure 1.2).

Figure 1.2 Relating the visual elements

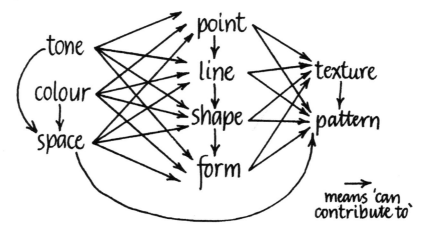

The three elements at the left of Figure 1.2 represent different qualities or kinds of surface or space: colour, tone (how light or dark a surface appears) and the space around marks or objects. This space itself has tone, and can have colour, for example the background to a picture or pattern which can be any colour, or the sky which can be pale blue, deep blue, grey or the black of midnight.

The four elements in the middle represent different but related kinds of mark or object which occupy space, either the two-dimensional space of surfaces if they are marks or flat objects, or three-dimensional space if they are forms in the round. Colour, tone and space contribute to all of the elements, because marks and objects can be seen only if there are contrasts of colour or tone between them and the space around them, or each other. In addition, all four are related because points (dots) can be placed so that they make lines, lines can join up to make shapes and flat shapes can be bent, folded or assembled to make forms.

The remaining two elements, texture and pattern, are more complex, because they are made up of combinations of the simpler ones. This is particularly true of pattern, and some patterns involve all of the other eight visual elements.

1.3 Learning through investigation of the visual elements

Getting started

For most children, an effective way to begin learning about a visual element and how it might be used in designing and making is to experiment with it, find out what its properties are and what can be done with it using different materials. In working with some elements, for example with point or line, this process of experimentation can at least begin with some kind of unstructured, exploratory play, trying a range of materials with the aim of generating visual ideas which can be developed further (Figures 2.2, 3.1). In other areas, for example when working with tone or mixing colour, it can be useful to structure the introductory play more, so that some simple techniques are learned early on, which can be used later in more free and creative ways (Figure 4.1; Colour figures 1–4, 9). These differences are reflected in the approaches adopted to the various visual elements in this book.

Developing knowledge and understanding

Exploratory play can be and usually is a good way of starting to develop children's knowledge of the visual elements and visual language. To be effective, such knowledge has to be developed from hands-on activity and lead back to it, though other resources may be useful along the way. There is little point, for example, in knowing what complementary colours are, and that orange and green-blue are complementary, if we have no practical experience to tell us how they might be used or what effect they are likely to have in a picture or pattern (pp. 53–4, 65–6; Colour figure 8). It may, however, be useful to look upon knowledge and understanding of each visual element as being in two parts. The first part is our idea of the visual element, what it is and how it relates to the other elements; the second part is our knowledge and experience of how it can be used, and has been used, by other artists. This distinction can be useful because across the range of visual elements the balance between the two kinds of knowledge is very different.

On one hand, there are the apparently simple elements such as point and line. It is very easy to develop a clear idea of what a line is, but this tells us very little about how line can and has been used in art, because its potential seems endlessly varied and cannot be explained in words. What this means in practice is that almost all our knowledge and understanding of line has to be grounded in first-hand investigation and experiment. Even looking at the way artists of genius such as Vincent van Gogh and Paul Klee used line in their work is unlikely to tell us much until we have found out

something about what we can do with line for ourselves. This in turn explains, in part at least, why line is such a powerful and expressive medium, since individuals, unless slavishly copying someone else's work, are almost certain to develop their own personal styles as they learn how line can be used.

Learning about pattern, on the other hand, is quite different. The basic idea of pattern and the methods used to make different kinds of pattern are quite difficult to grasp, but they can be explained effectively in words and pictures (pp. 131–4). This means that although children may enjoy and learn a lot from inventing patterns for themselves, adapting and reusing the patterns of other artists and civilizations can also be worthwhile creative activities. Once we know how a kind of pattern is developed and can make it for ourselves, this tells us a great deal about how it can (and cannot) be used effectively. However, this in turn means that pattern is rarely as personal, recognizable and expressive a way of making images as line can be.

Between point and line on the one hand and pattern on the other are the remaining six visual elements. All of them have basic properties which are more complex than those of point and line, but it is easier to explain and demonstrate at least some of the ways in which they can be used. For example, it is more difficult to develop clear concepts of shape and colour than it is of line. However, once these ideas have been established through personal investigation, perhaps with help from other resources, it is easier to learn how we can use colours and shapes for ourselves, and how they contribute to works by other artists, than it is to understand the subtle and expressive qualities of line. In comparison with pattern, colour and shape can usually be used in a more personal way, to express and communicate ideas more effectively.

Learning strategies

As children investigate and begin to learn about the properties and potential of each visual element, they can begin to use it and combine it with other visual elements in a more purposeful way. All through the investigating and learning process, however, it is helpful to remember that in art, as in science and other areas of the curriculum, different children are likely to use a range of different learning strategies.

Most children show a preference either for a knowledge-first or an experience-first approach to learning. Knowledge-first learners are often reluctant to explore and experiment until they have at least begun to develop a conceptual framework to which they can relate their activity as it develops. They may do this by looking at books or other resources, or watching a demonstration by their teacher and asking questions. Experience-first learners may find it very hard to begin developing any kind of knowledge or understanding, for example about the properties and potential of colour, until they have some first-hand experience of it through exploratory play. Colour mixing is an example of an activity which is likely to develop in a number of stages, at each of which individuals in a class may need to adopt rather different strategies and patterns of working if they are to learn effectively.

Different learning strategies also seem to be linked to different ways of responding to the artwork of others, though these are usually much more difficult to observe. Experience-first learners seem more likely to have a holistic, intuitive and even emotional response to a work of art, only later being able to begin thinking about it more analytically to find out how it was arrived at and why it works and affects them in the way it does. In contrast, knowledge-first learners appear to analyse first and respond in a deeper and more intuitive way later, and perhaps more gradually. What is

important for us as teachers is to recognize that the intuitive and the analytical are both part of a complete response to a work of art. Observing how van Gogh used texture and colour combinations, for example, need not lessen or blunt anyone's sensitivity to the emotions he was attempting to express and communicate, and an immediate, intuitive response should not make us blind to the value of recognizing and understanding the technical mastery which enabled him to succeed.

1.4 Building on the foundations

Moving on

In the context of art education as a whole, the ideas and investigations discussed and suggested here can never be more than starting-places. One useful way of considering teaching and learning in art is to see it as developing through two (or more) levels of activity. This book is about the first and simplest of these, sometimes called art basics. At the second level, the knowledge and skill learned through investigating the visual is expressed in more complex activities such as drawing, painting, collage and sculpture, which involves working with many or all of the visual elements.

How successful children are at any of these activities will depend at least in part on how effective their learning at the more basic level has been. A well-established strategy for moving into more complex activities in art is to begin a new theme or programme by revisiting one or more of the visual elements, reinvestigating relevant aspects of them and developing activities from what is discovered. If, for example, a class needs experience in selecting and recording from first-hand observation by drawing, this could be achieved by investigating some aspects of line, tone and shape through working on still-life. Examples of this approach are given in SCAA, 1997: 10, 11, 14, 20, 23, 30, 31, 32–3, 34, 38.

Developing visual literacy

Another major outcome of investigating the visual elements is that children and their teachers will begin developing the wider visual awareness which is sometimes referred to as visual literacy. It is not only work in art, craft and design which can be understood in terms of the visual elements, but also the whole of our visual environment, from the inner city to the mountain wilderness. Developing a visual understanding of the environment is as important in art education as looking at works of art in galleries, books or other resources. Both are complementary aspects of the same activity, which is looking critically at and questioning what is seen, rather than simply accepting it.

All seeing is a process of active enquiry. In order to perceive anything we have to 'read' and interpret what we are looking at. The ability to do this is developed so early in life and becomes so habitual that for much of the time we never think about it. For most of our waking lives we look and see uncritically, with other purposes in mind which mask our ability to question our senses and prevent us from fully experiencing the visual properties of our environment such as forms, colours and textures.

One way to overcome this limitation is to start looking at our wider environment with the same attention that we give to exhibits in an art gallery. When looking at paintings or sculptures, critical seeing is our purpose. We set aside other needs and goals, even if only for a short time, and concentrate on trying to understand as much as possible of what it is we have come to see. Learning to do this when surrounded by everyday objects and images is likely to help children look more critically at artwork,

both their own and other people's, to enjoy it more and learn more from it, but it may also have a wider significance.

Developing the habit of looking and seeing critically is the basis of visual literacy, the ability to interpret and understand what is going on, in visual terms, in the world around us. This in turn may result in a greater regard for the quality of the visual environment in school, at home and in the environment as a whole. None of this is possible without understanding based on personal experience. Working with the visual elements to discover their properties and ways in which they can be used in art, craft and design is perhaps the most effective way, for us as teachers, to develop visual literacy.

2 Point

2.1 The concept of point

In art, a point is a dot or mark, so small that although it can be seen, its shape cannot be distinguished clearly. Points of light, shade and colour make up much of our visual environment, sometimes singly, but more often in groups making textures and patterns. Familiar examples include grains of sand looked at closely, pebbles on a beach or leaves on a tree seen from further away, houses on a distant hillside and stars which are very great distances from us. Comparing these examples is worthwhile because it shows the importance of scale and distance in what we see. Whether a particular object is seen as a point or as a shape or form depends both on its size measured in units such as metres or millimetres, and on the way we look at it. Sand grains, though small, can look like huge rocks when viewed through a microscope, whereas stars, which are immense, appear as no more than tiny points of light because they are so far away.

Figure 2.1 Point and shape

Observing points and shapes

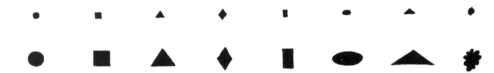

To see the difference between point and shape, look at Figure 2.1 from different distances. From about 2m, the upper row of small shapes appears as a row of point marks, whereas the similar but larger shapes in the lower row are distinct. Bringing the page nearer will allow the shapes in the upper row to be seen, and moving it further away will make even the lower row appear simply as points. You can get the same effect by looking at Figures 2.2, 2.3 and 11.5 from different distances in a similar way.

Figure 2.2 Point with printing-sticks and pens

Figure 2.2 cont

g h i j

k l m

Figure 2.3 Point with sprayed paint

a b c

d e

These observations, though very simple, are significant because they are examples of a principle which runs through the whole of art: everything we see depends to some degree on what is around it and how we look at it. To put it more formally, there are no absolutes or fixed measurements in art to compare with scientific units such as metres or seconds: everything we perceive is relative. Shades of grey, colours, shape, space, texture and pattern all change their appearance and affect us in different ways when viewed at varying distances, in differing lights and in changing combinations.

Relating point to the other visual elements

A single point, whether black, white, grey or coloured, is unlikely to be interesting. It simply marks a place and does not appear to move or do anything. But points can be developed into other visual elements which are much more visually active and exciting. There are two main ways of doing this. The first way is to make a point move and leave a trace, as the point of a pencil or pen does. Moving in this way the point makes a line

and so can trace the outlines of shapes (e.g. Figures 3.1, 3.2, 8.3–8.5). Developing points into lines and lines into other visual elements is discussed in Chapter 3.

The second way of developing points is to group and combine many of them together. A group of points will make an area of tone (Figures 2.2, 2.3, 4.1c, 4.2k), or colour, which is distinct from the space around it and so may define a shape (Figures 2.2m, 8.3m, 8.5a, 8.5b). If a group of points is large enough, it is likely to have a visual texture (p. 125; Figure 11.5a, 11.5c) and points may also be grouped into patterns (Figure 12.2b–d).

2.2 Investigating points and their potential

There are many ways of producing lines, shapes, textures and patterns using point in art and design, but children are likely to find three of them most productive. These are: first, printing or drawing with sticks or pens; secondly, spraying paint or ink; and thirdly, mosaic.

Making points with sticks and pens

Printing points with sticks

You can make points of differing size and shape by printing them with sticks or dotting and drawing with pens. In either case this is likely to be a slow process, but because it is possible to place each point precisely and vary their sizes easily, textures and patterns can be built up in an endless variety. Printing-sticks with ink or paint are longer-lasting and more economical than felt- or fibre-tipped pens, and have the added advantage that any colour can be used with them. A good material is a stick of balsa or other soft, porous wood. Sharpen it like a pencil, then cut its tip off with a very sharp craft knife to give a flat surface for printing. Different effects can be obtained with a stick of high-density closed-cell plastic foam, which can be cut to shape with scissors.

Some simple effects are shown in Figure 2.2. Try printing points in varying densities with a small stick (a–c) or a larger one (d–f) using dilute paint or ink, in any colour and with any colour of background. If thicker paint is used (g–j), the points become circles as paint is squeezed out to the edge of the printing face, giving an attractive variation in tone or colour. Points of different sizes can be combined, as in example (k) which used a stick and plastic foam, and in example (l) which was made by combining stick printing and drawing with a fibre-tipped pen.

Compositions in point

Quite complex compositions can be built up from points, as in Figure 2.2m, for which a stick, plastic foam and a pen were all used. The example also shows how points can be combined into line, shape and a variety of textures. Using point in this way is likely to be time-consuming, but with a range of paints, inks, or both it can be an effective way of exploring optical colour mixing and colour interactions (pp. 47–9, 52–6). It can also be very helpful as a way to encourage less confident children to experiment, as they can control the process and build up their work gradually.

Using sprayed paint

Point, shape and texture

A more rapid way of building up shapes and textures with points is to spray paint or ink on to paper. The easiest way to do this is to flick liquid from a brush with stiff, springy bristles using a finger. A stencil brush is ideal, but an old toothbrush makes a good substitute. The process is quite rapid and with a little practice children can achieve quite a lot of control over it. In general, the thinner and more runny the paint, the larger the droplets will be, but any one batch of paint gives quite a wide range of droplet sizes. Children should try to obtain a range of effects such as those shown in Figure 2.3. Sprayed paint can give very soft gradations of tone (a), but sharper boundaries can be obtained by spraying over shapes cut or torn from thin card and placed on paper (b). The two effects can be combined, and shapes repeated, both in dark-on-light and light-on-dark (c and d). The range of effects can be extended by cutting and assembling sprayed papers, as in example (e), which also gives a strong illusion of depth (p. 97), and by using colour.

Mosaic

Mosaics in Roman colours

True mosaic work uses small pieces of hard material (tesserae) glued or cemented on to a surface as points of tone or colour, arranged to make a pattern or other design. Children can investigate the visual properties of point and the generation of pattern by making mosaics of small paper squares glued on to a sheet of thick paper or thin card.

Although children can use any designs and a wide range of vivid colours, some of the most rewarding mosaic designs for them to work with are patterns from Roman floors, which are remarkable in that most of them use only two or three fairly subdued colours, yet are full of interest. Field (1988b) illustrates numerous examples and gives instructions for drawing the patterns. The most common three materials in Roman Britain were a dark blue-grey limestone, a very pale brown, almost white limestone and red-brown fired clay (terracotta), usually in tesserae about 1 cm square. The colours can be imitated with poster-paint on paper strips, from which squares can be cut as needed. The mosaic will look better if brown or grey card rather than white paper is used for the background, and it is helpful to draw the design in outline before starting to glue the tesserae down.

2.3 Point in context

When points are combined into shapes, textures and patterns, they interact visually with one another to give a great variety of appearances (Figures 2.2, 2.3, 11.5), but the contribution which they make to art, craft, design and our wider visual environment is often overlooked. Points, together with the textures and patterns made up from them, tend to stay in the background and do not seize our attention in the way that a vivid patch of colour or the image of a face are likely to do. Good artists, however, like good scientists, pay attention to things which other people fail to notice, and it is always worthwhile looking carefully at drawings, paintings and other artefacts from different distances to observe how dots of tone and colour are contributing to what we see of them.

Examples of point in the wider environment with which children are likely to be familiar include stars and distant lights, pebbles on beaches and gravel on paths and roads, all of which can be used to help show the importance of scale and distance in what we perceive. Looking at trees in leaf from different distances is particularly helpful to develop an understanding of the relationships between point, tone and shape. Bird feathers, butterfly wings and flower petals are natural examples which could be brought into the classroom to look at their markings. You could look also at cereals and other small seeds in jars or spread on paper. These will help children understand the concepts of point and texture (p. 121). Many animals' skins and wings have points of colour on them, either as camouflage or as a warning to predators, and pictures of these are good sources of ideas for developing textures, patterns and colour combinations based on groups of points.

Point in textiles

Many kinds of textile incorporate textures and patterns composed of points, which result from the ways they are made. The four main processes are weaving, knotting, knitting and stitching. If in weaving a fabric the fixed-warp threads contrast strongly in tone or colour with the woven-in weft threads, a pattern of points is produced, which varies according to the order in which the warp threads are raised and lowered in the weaving process. In knotted textiles, such as oriental carpets, each tuft of the pile is anchored by a knot and forms a point of tone or colour. These are grouped to make shapes and patterns, and can be seen more clearly by looking at the knots on the underside of the carpet rather than the pile. Rag rugs traditionally made in many parts of the United Kingdom have similar but coarser patterns. In knitted textiles, stitches of contrasting yarns form points from which patterns are built up, as in traditional Fair Isle designs. True tapestry is woven, but needlepoint, sometimes called tapestry, uses stitches set in special open-weave canvas. These appear as points of colour from which complex designs are built up.

Point in modern printing

If points grouped together are small enough, or looked at from a great enough distance, they appear to merge into areas of tone or colour. This effect can be seen by looking at Figure 11.5 from 2–4m away, and has been extensively used in modern printing. A method of picture reproduction with which children are likely to be familiar is the printing of black-and-white photographs in newspapers, properly known as half-tones. Half-tone pictures are made up of dots of varying sizes, which can easily be seen by looking at them through a magnifying glass: black dots on white in the lighter grey areas, and white dots on black in the darker ones.

In the commonest kind of colour reproduction, for example in newspapers, four patterns of points like those in half-tone are printed over each other: one in each of three primary colours in transparent inks, plus black. When looked at with a good hand-lens the various colour-points can be seen, but when the image is viewed normally the points appear to merge into areas of colour. Inkjet printers for computers employ a rather similar system, but the points of colour and black are random rather than in patterns. This merging effect is known as optical colour mixing (pp. 47–8) and has been much exploited by modern artists.

Two examples of point in modern art

From the last quarter of the nineteenth century onwards, many painters experimented with the use of points of colour. Some of the earliest were the Post-Impressionists, who tried to increase the brilliance of their colour mixtures by placing points of vivid colours next to each other and relying on optical colour mixing to blend them (pp. 47–9). The most well-known of these painters was Georges Seurat (1859–91), whose work is discussed on pp. 50–1, 37–8, 128; see also Appendix 5. Many other painters after Seurat experimented with this technique, which became known as pointillism or divisionism, but some of the most interesting results came about when artists also exploited the ways in which colour points interact with their backgrounds.

Robert Delaunay (1885–1941) was an experimental artist who with his wife Sonia (1885–1979) did much to develop the use of colour in abstract painting in early twentieth-century art (see also p. 50 and Appendix 5). Around 1910, Delaunay was experimenting with abstraction, exploring shape and form by transforming what he could see of Paris from the window of his studio into complex compositions of interacting shapes. In some of his experiments he made layers of shapes by painting a chequer-pattern of opaque colour points over the larger shapes behind them. A beautiful example is *Window on the city no. 4* (see Appendix 5). In some of the shapes the colour of the overpainted points is changed at the edge of a background shape, which makes a very emphatic boundary. In others, the areas of overpainted colour points run across from one background shape into another. This not only produces a wide variety of interesting colour interactions (p. 52), but also makes the angular geometric shapes softer, rather like looking through glass with a pattern moulded into it, and gives a mysterious sense of depth.

Experiments which are technically rather similar but quite different in intention were carried out by the Swiss-German artist Paul Klee (1879–1940) during the early 1930s. Klee was an accomplished violinist as well as a supremely inventive artist, who investigated the visual elements very thoroughly and was also fascinated by the parallels between the harmonies we can see in painting and those we can hear in music. In his *Polyphony* (see Appendix 5), the background dominates. As in Delaunay's paintings the colour points, each painted twice with great precision, sometimes reinforce the boundaries of the rectangles behind them, and sometime run over from one to another. The overall effect is that they soften, modify and interact with the shapes and colours of the background like a melody over a ground-bass. *Ad Parnassum* (see Appendix 5) is a freer, more complex and more subtle composition. The colour-points are small rectangles and there is an almost perfect balance between them and the background shapes, so neither is dominant and attention shifts from one to the other, in a beautiful example of alternation between figure and ground (p. 92). The texture of points seems to hover in front of the coloured shapes behind them, the two combining and separating like an endless, subtly changing musical chord, played very softly by a huge orchestra.

Point in modern Australian aboriginal art

Patterns and shapes built up from points of tone and colour form a major element in aboriginal art, the art of the native peoples of Australia. They have developed painting based mostly or entirely on colour points, partly in response to the availability of modern canvases, boards and acrylic paints, which also help to make the artwork much more permanent than the traditional paintings on tree-bark were. Numerous examples

are illustrated by Caruana (1993). To the artists and their communities the paintings are symbolic and deeply significant, but people of other cultures can enjoy and learn from them purely as abstract compositions of point, tone and colour. Aspects to notice particularly are the ways in which points are combined to produce both sharp contrasts and subtle gradations of shape and texture, often with a restricted range of colours which reflect the earth colours of the artists' homeland, but which are also very similar to the tetrachrome palette of the ancient Greeks (p. 50).

3 Line

3.1 The concept of line

Marks, objects, lines and shapes

Lines make up an important part of our visual environment, and though there are many different kinds of line, only two are likely to be of major importance to children in their artwork: linear marks and linear objects. If a point moves and leaves a trace of some kind, this trace is a line. This idea of a line as the mark made by a moving object is very useful when thinking about lines in art and the ways in which they can be made and used, but we need also to remember that many objects in our environment, both natural and man-made, are perceived as lines.

Marks or objects are most likely to be perceived as lines if they are narrow, long in relation to their width and more or less parallel-sided, but as with points, distance and scale also play a critical role in determining what we perceive as lines (p. 8). If lines are very short they may be perceived as points unless they are seen from very close up (e.g. Figure 11.5c), and if they are broad enough they are likely to be interpreted as shapes. In Figure 3.1 the narrow, parallel-sided marks in example (c) appear as lines at a normal reading distance, whereas the viewer is likely to be more aware of shape when looking at (d) and (f). Variation in width is also likely to make us more aware of shape, but the boundary between shape and line in our perceptions is always very vague, as a study of Figures 3.4c and 9.3 will show: both have transitions between line and shape, but in neither is there any obvious point at which line ends and shape begins.

| Figure 3.1 | Comparing mark-making materials |

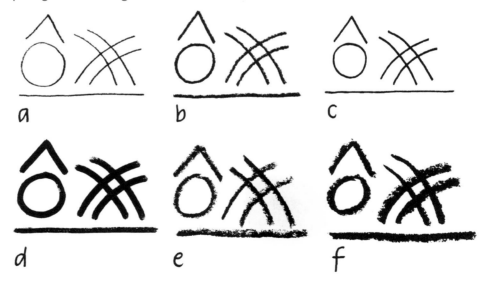

A very narrow, parallel-sided line has effectively only two visual properties: length and direction. Even rather featureless lines like this may gain a great deal of visual interest by means of grouping, differences in length and changes of direction, as shown in Figures 3.6–3.8. Once additional properties such as visual texture, variations in

breadth or weight and differences of tone or darkness are added, the variety of line which can be generated is almost endless. These properties are discussed on pp. 18–19 in the context of children's investigations.

Relating line to the other visual elements

Line is related to point in three ways: first, the path of a moving point is a line; second, a short, narrow line may be perceived as a point (Figure 11.5c); and third, points can be placed and combined to make a long, narrow area of tone which is perceived as a line (Figure 2.2m). Lines, like points and shapes, can be seen only if they contrast with their background, either in tonal value or in hue, or both. Of the two, tone is usually the more important in determining how much lines influence us visually, and the greater the contrast in tonal value between line and background, the more emphatic the line is likely to be (Figure 3.1). Lines grouped by being placed alongside each other or superimposed combine visually to make areas of tone or colour (e.g. Figures 4.1d, 4.3l, 8.3i–l). If outline shapes are filled with colour, the line may make the colours on either side of it appear more vivid (pp. 59–60; Colour figure 9b).

If a mark-making point is moved so that it returns to its starting-point or crosses its own track, the line will trace the outline of one or more shapes (Figures 3.2h, k–n; 3.7f–h; 8.3c–h; 8.8a–c), but lines can also be drawn so that they build up shapes, which may be hard-edged (Figures 8.3i–l) or soft-edged (Figure 8.5c, 8.5d). These figures also show that lines can be used to create visual textures, and there are other examples of these in Figures 11.2f, 11.5b and 11.5f. Line is an essential element in the making of many patterns, both directly (Figures 12.2e–i, 12.3–12.6, 12.9) and in the form of grids upon which space-dividing patterns are based (Figures 12.11–12.14).

3.2 Investigating line: some starting-points

Children are likely to encounter an abundance of lines and linear objects in their daily lives and there are many more ways in which they can make lines for themselves. Rather than attempting a survey of these, attention is focused here on a few examples of making and using lines which have proved particularly successful as starting-points for children's investigations and creative learning.

Lines and mark-making

Most of the lines children make are likely to be marks drawn or written on paper by points such as pencils, pens and brushes, which leave traces as they move. Even if they experiment only with commonly available materials and equipment, the variety of line which children can draw is likely to be very great (compare, for example, Colour figures 9a, 12a, 12b). It is often worthwhile carrying out some simple tests to compare mark-making materials, because although the differences between them are wide, they may be fully apparent only when the results of using them are seen side by side (Figure 3.1).

Comparing line-making materials

Children should draw and compare simple sets of lines in different directions, as in Figure 3.1. This will not only show contrasts in width and tone (blackness or greyness), but will also indicate something of the visual texture likely to be produced by each material and the degree of control which can be achieved. In Figure 3.1, example (a) was drawn with a medium (HB) pencil; (b) with a thick, soft graphite pencil; (c) with a microliner fibre-tipped pen; (d) with a 'bullet-point' felt-tipped pen; (e) with a wax crayon and (f) with a pastel. It may also be helpful to compare the

results of using different materials on a range of papers before deciding which combination to use. Soft materials such as graphite pencils, wax crayons, pastels and charcoal, in particular, may give very different qualities or textures of line on smooth photocopier paper, cartridge paper and the rougher surface of sugar paper. Coloured materials such as crayons, pencil crayons, pastels and inks can of course be used for making line-marks, but will have their greatest impact when the lines are grouped to make shapes, textures or patterns.

Line as a record of movement

A drawn line is a trace left by a moving point, so it is a record of the movements of whatever was impelling and controlling the mark-making tool. The moving point can be controlled by devices such as rulers, templates and compasses, and lines can be drawn by computer, but such lines tend to have a uniform, mechanical quality. Although lines of this kind have been used in modern art (p. 28), lines drawn by hand have an elusive but definite quality which makes them more visually interesting and effective as a means of communication, just as good handwriting gives a feeling of contact with a person and communicates in ways which type and printing cannot achieve.

| **Figure 3.2** | Line as a record of movement |

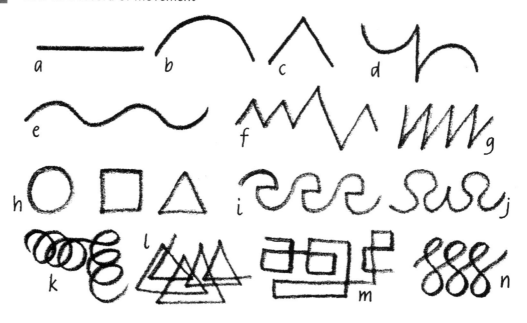

Experimenting with length and direction

Very narrow lines have only two basic properties: length and orientation (p. 16). Together these are an exact record of the way in which the mark-making point was moved and, in particular, of the ways in which its movement was changed and controlled by the person drawing with it. Children should experiment with this idea in mind to see how many different kinds of line they can draw. Figure 3.2, drawn with a soft graphite pencil, shows some simple examples. If the direction of movement does not change, the line is straight, as in example (a). If there is a gradual, continuous change of direction the line is curved, as in example (b), whereas a sudden change causes a corner to be drawn (c). These changes can be combined in a sequence, as in (d). If change of direction is reversed in a rhythmical way, the line

undulates if the changes are gradual (e) and becomes a zig-zag if they are sudden (f, g). If the point is moved so that it returns to its starting-point, outline shapes are drawn (h), the exact outline depending on how the direction of movement was changed (see also pp. 73–4 and Figure 8.3c–h). In Figure 3.2e and 3.2g the path of the point is predictable, so a pattern can be perceived (pp. 135–6). This kind of rhythmical pattern can be made more complex by changing direction in more than one way (Figures 3.2i, 3.2j; 12.4 e–j; 12.6a, 12.6b). If the moving point repeatedly crosses over its own path, a series of loops or other shapes is drawn (Figure 3.2k–n; see also Figure 3.7f–h).

Line as a record of gesture

Line and gesture

All the lines in Figures 3.1 and 3.2 were drawn deliberately and slowly using a fairly constant downwards force, exercising quite a lot of control. If the mark-making point is moved in rapid gestures of the whole arm and hand, the results are more difficult to control and predict but are more spontaneous and exciting. Lines drawn rapidly with changing force not only record the movements which made them but suggest the mental and physical energy involved. Soft materials such as graphite pencil (Figure 3.3a) make more expressive marks than hard ones, but perhaps the most characteristic gestural lines are drawn with brushes and paint or ink (Figure 3.3b). Controlling this very difficult medium in much more complex sequences of strokes with pointed brushes is the technical basis of Chinese and Japanese calligraphy.

Figure 3.3 Line as a record of gesture

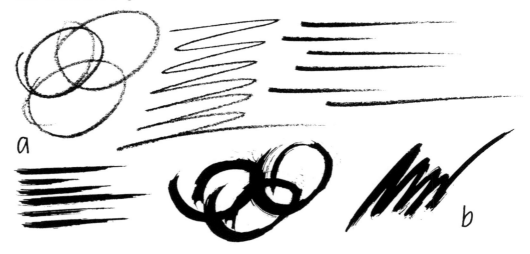

Lines which are not drawn

Although most of the lines which children make in their artwork are likely to be drawn in some way, there are many other kinds of line which they can usefully investigate. Two that are very useful, either in solving problems or stimulating creativity, are lines made by cutting and tearing, and linear objects which may be found and used in a variety of ways.

Lines made by cutting and tearing

When paper or thin card is cut or torn, the cut or tear is a line and the knife, scissors or fingers which make it are the moving point whose movement the line records. A good way to start is to cut a simple shape of paper or card into pieces with a sharp knife or scissors, reassemble the pieces on a contrasting background and then move them apart. When this is done the cuts appear as lines, and simple cuts can be made more interesting visually by moving the pieces round a little in different ways, to give

Cut lines

variations in the width of lines (Figure 3.4a, 3.4b). However, the gaps between the pieces must remain narrow if the line effect is to be maintained. In Figure 3.4c, the gaps at the left-hand end are perceived as lines, whereas those at the right-hand end are too wide to be seen as lines at this scale, and appear as shapes which seem to shift between white-on-black and black-on-white – an example of alternation between figure and ground (pp. 91–3; Figure 9.3).

Figure 3.4 Cuts and tears as lines

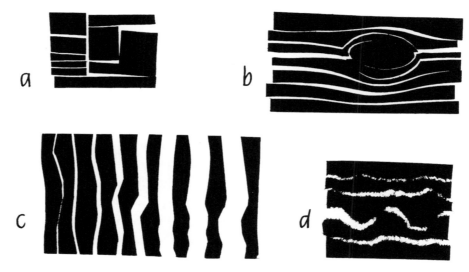

You can also make lines by tearing the paper instead of cutting it. With most papers and with thin card the tearing can be controlled quite closely if it is done little by little, between forefingers and thumbs kept very close together. The torn edges are usually much more ragged than cleanly cut ones, with the result that when the pieces are moved apart the lines produced can be very exciting visually (Figure 3.4d). Notice also that as in examples (a) and (b), the pieces have been moved

Torn lines

sideways and tilted a little to give a greater variation in line width. Both cutting and tearing can be developed in complex ways, but great care is needed to keep all the pieces in order (see also Figure 8.9).

Linear objects At any one moment our visual environment usually includes a wide variety of lines (pp. 24–5). Some of these are likely to be linear objects which may be used in artwork. They have the advantage that they can be handled and manipulated in exploratory play, so that their visual properties can be assessed before they are used. As a result, younger and less confident children especially may find working with them more stimulating and less threatening than drawing as a way of investigating lines. At the same time, the visual effects produced by linear objects tend to be somewhat unpredictable and so they offer opportunities for experiment.

Using flexible materials as lines

Among the most versatile and useful linear objects are flexible materials such as string and thread. These can be woven, stitched, glued on to a base, coated with paint and printed (Figure 12.9), or dipped in paint and pulled across a surface, with very interesting results when the direction is changed. Build stiffer materials such as wire, sticks and straws into constructions and alter them by bending or twisting if they are flexible enough (p. 111; Figure 10.5b). The edges of objects such as rulers, cut card or wheels are often overlooked as linear objects, but they can work when coated with paint and printed, or impressed into clay and other soft materials.

3.3 Developing line

In this section attention is given to ways in which any kind of line can be made more complex and visually interesting. Lines are and can be seen as tracks, traces and the record of movement in space. The actual process of making lines is one of growth, and because children can see this happening as they draw, they can work with and elaborate lines much more easily than shapes. The development of line is an endless source of ideas and a good approach in the classroom is to introduce it through open-ended investigations which can lead to further creative experiments such as in Figure 3.9. One is in effect devising a visual game, which is played by drawing, by arranging linear objects such as string or sticks, or both. Unless the results are to be as chaotic as a tangled ball of string, however, the game has to have rules, which we devise and change as we progress. Being clear about what the rules of their particular games are has two great advantages for children. On the one hand, they are more likely to work consistently and so fulfil their intentions, and on the other they are also in a better position to modify their game-plan, should they wish to go in a different direction.

In Figures 3.5–3.8, the lines have been developed only in the most basic way, by changes in direction, and all have been drawn with the same pen. They are no more than ideas in graphic form to use as starting-points. Some suggestions are made for developing each kind of variation further, but it should be borne in mind that all of them can be made much more visually exciting by introducing elements such as different line widths, contrast, colour and variations in scale.

Simple branching

Symmetrical branching

Branching means making a line divide. Lines can of course divide into many pathways at once, but branching into two at each junction is the simplest option and provides plenty of opportunities for interesting outcomes. Simple branching into two equal lines (Figure 3.5a, 3.5b) can be repeated indefinitely and if the branches at each stage are drawn at about the same angle and length (3.5c), the whole system will remain fairly symmetrical, making an attractive pattern with beautifully-shaped spaces between the lines (see also Figure 12.2i).

Figure 3.5 Branching

Figure 3.5 Branching

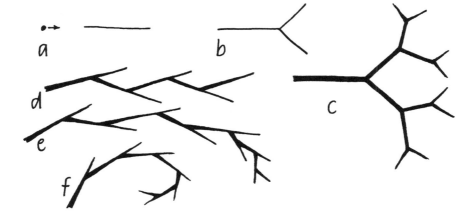

**More kinds of
branching lines**

In Figure 3.5c every line is developed by branching into two, but if only one of each pair goes on to branch in its turn, another kind of branching is formed, which is symmetrical if the branching is left and right alternately and equally (Figure 3.5d), or curved if a slight inequality is introduced (Figure 3.5e). If the branching is all on one side an inward spiral will start to form (3.5f). As children may observe for themselves, all these kinds of branching line are found in plants. All of them can be drawn quite quickly, and can be enhanced with colour or textured materials, or used as the basis of more complex patterns, as shown for example by comparing Figure 3.5d with Figure 12.6c.

Developing single lines: folds, waves, spirals and loops

The simplest kind of line is single and unbranched, but even this can be developed in a large number of ways. Though some of these are very complex, children are likely to find some of the simpler methods very interesting, in a wide range of media.

**Folds and
waves**

A single line can be folded repeatedly without crossing its own path, so that it creates shapes or areas of tone (Figure 8.3k, 8.3l). Examples like these one can be drawn directly, or made by glueing string on to card, which can be used as a printing block. In folding, the line is made to move back and forth, and this kind of movement can progress by changing the size of the movement in systematic ways, a few of which are shown in Figure 3.6. Example (a) shows a simple wave increasing in size. This process can be carried much further, by elaborating the shape of each successive wave to a greater and greater degree as well as making it bigger, as shown in example (b), which was drawn from the tip of a fern leaf. Other patterns of development, illustrated by examples (c–f), include changing the pattern of growth in size and direction, and using zig-zags and 'square waves'.

Figure 3.6 Waves

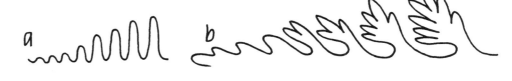

Figure 3.6
cont

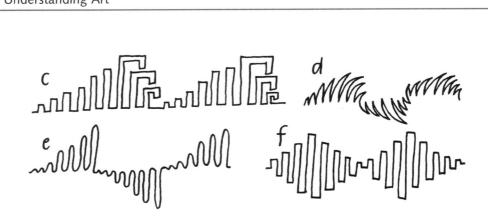

Spirals

If a single line changes direction so that it always moves away from its starting-point, it will trace a spiral. Single simple spirals can be of various shapes (e.g. Figure 8.3i, 8.3j) and can be extended indefinitely. If two simple spirals are linked, as in Figure 3.7a, 3.7b, their development is limited but they are more decorative and visually interesting. Notice that in example (a) the spirals show rotational symmetry, both being clockwise, whereas in example (b) they show line symmetry. In order to link a longer series of spirals they have to be double, with a change of direction in the centre of each, as in Figure 12.6a, 12.6b.

Figure 3.7 Spirals and loops

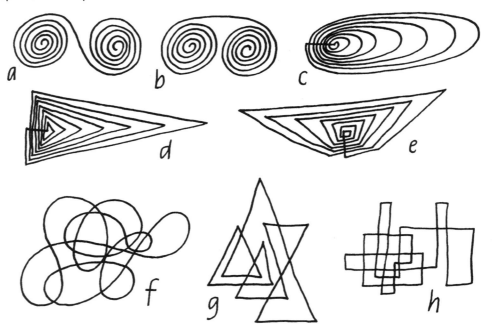

Eccentric spirals

In Figure 3.7a and 3.7b the line follows an approximately parallel path within each spiral, but if this is altered in an organized way the spiral will be distorted, which can be visually interesting and offer many possibilities. Figure 3.7c–e shows three such eccentric spirals, each based on a different kind of movement, in which the line also returns to its starting-point. These offer excellent opportunities for experimenting with sets and sequences of colours, such as tints and shades (pp. 46–7; Colour figure 4) and different colour groupings (pp. 64–6; Colour figure 8).

**Loops and
other shapes**

Loops are drawn when a line crosses over its own pathway (Figure 3.2k–n) and provide the greatest freedom in line development: literally anything is possible. But this has to be tempered with restraint if the results are not to be entirely chaotic. A good way to begin investigating looping lines is to base each experiment on one kind of simple shape, as in Figure 3.7f–h, in which circular, triangular and rectangular movements were used. In all three there are also changes from clockwise to anticlockwise movement, which may be needed for variety.

**Developing
looped lines**

Filling the outline shapes of looped lines with colour will help children study both the interactions of shapes (pp. 77–80; Figure 8.7g–i) and the balance and placement of colours. However, because great freedom can be enjoyed while drawing the lines, a corresponding degree of discipline needs to be exercised when choosing and using colours. If any area is coloured, attention is immediately drawn to its shape, so questions which children could ask themselves include: which shapes are the most interesting? What kind of colour group do I wish to use, and how should the colours be placed? (pp. 64–6; Colour figure 8). Do all the shapes need to be coloured in, or should some be left as spaces bounded by the lines? In compositions of this kind, it is necessary to look at one's work critically as it progresses, and judge when it is time to stop.

Developing groups of lines: contrast and progression

**Interaction
of lines**

Two or more lines near or overlapping each other will interact visually and be much more interesting than either would be on its own. They may do this by making each other look more or less energetic, or by suggesting and producing outline shapes which would not appear if they were further apart (see also p. 80; Figure 8.8). Children should experiment with pairs or groups of lines to exploit this interaction and produce interesting designs and ideas. A good way to investigate the interaction of lines is to draw two strongly contrasting lines close to or overlapping each other, as in Figure 3.8a–c. In all three examples, a meandering line is contrasted with another drawn over it. In each case the lines interact differently, and these interactions could be emphasized by making some parts of the lines thicker, by using colour in the outlined shapes, or both.

Figure 3.8 Developing groups of lines: contrast and progression

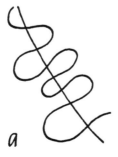
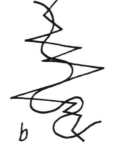
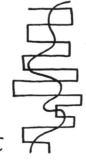

a b c

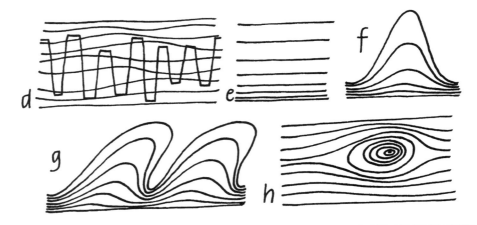

Figure 3.8
cont

In Figure 3.8a–c all the lines appear quite energetic, but if a line which suggests strong movement is contrasted with others which are gentler, more of these may be needed to interact effectively. This is shown in Figure 3.8d, where the gently undulating lines emphasize the strong vertical movement of the 'square-wave' line.

Progressive development of lines

Lines which do not overlap can interact very effectively if they show progression of movement. Straight lines drawn parallel have little visual interest (Figure 3.8e), but introducing a simple wave movement (f) produces a pattern of elegant shapes, and the wave effect can be made to appear more energetic by making it asymmetric (g). A similar kind of progression can be used in reverse, where energy and disturbance seem to centre on a point, becoming less and less as the lines are drawn further away, as in (h), which shows a pattern often seen in sawn wood with knots in it.

3.4 Line in context

Line in the visual environment

The visual environment of most children includes a huge variety of lines. In their own artwork most of the lines children use are likely to be marks which they make themselves, whereas in the world around them most of the lines they see are likely to be linear objects. Learning to observe these is an important part of developing visual literacy (Section 1.4), because many of them make up forms, textures and patterns which not only are good as the source of ideas for artwork, but also contribute significantly, for good or ill, to the quality of our visual environment.

Natural lines in the environment tend to be more numerous but less varied than man-made ones. Plants such as grasses, reeds and bamboos have unbranched stems and narrow, tapering leaves whose straight and curved lines often interact strongly and, from further away, combine to make textures. Trees have three-dimensional branching which links line to form (p. 104) and which in deciduous species can be seen very clearly in winter as a complex pattern of lines. This kind of large-scale branching structure is not much used in sculpture and modern architecture, though it is seen in the fan-vaulting of Gothic churches, but at a smaller scale the branched lines of twigs are very beautiful and a useful source of visual ideas. Cracks in dried mud and in the bark of trees make networks of lines, and at a smaller scale still, the veins of leaves and insect wings show branching in many different patterns. A magnifying-glass may be good for looking at these, and though they may appear very complex when viewed as

a whole, most are built up from very simple kinds of branching, repeated many times.

Natural examples of spiral lines are rather uncommon (as opposed to spiral forms such as shells), but the stems and tendrils of climbing plants such as peas, beans, bindweed and vines are worth looking out for. Strongly interacting natural lines may be easier to find, and examples which may be useful in design include spiders' webs, cracks and lines of intrusive rock in hard beach-pebbles and the pattern of annual rings in sawn softwood timber (Figure 3.8h).

In most built environments man-made lines are very numerous and almost infinite in their variety, though by no means all of them are attractive or interesting. Modern building techniques, for example, create rectangular patterns of lines between bricks and tiles or slates and in window-frames, but the more varied patterns of joints in old brickwork, old stone walls and paving may be more productive of visual ideas. Fences and gates, especially of wrought iron, often show more patterns of lines than the buildings they enclose. Structures of girders, for example in geodesic play-frames, pylons, cranes and industrial installations, are usually visually exciting even though they may seem very harsh and intrusive in the landscape.

Cables in tension which hold up suspension bridges, roofs and even whole buildings make patterns of straight and curved lines. In a similar way, the curves of overhead cables and telephone wires contrast strongly with the poles or pylons carrying them, particularly if they can be viewed obliquely along their length rather than from the side. Coils of rope, wire, string, flexible pipe and cables make loops which can, either by chance or by arrangement, contrast strongly with straight lines nearby. One of the best and most easily available sources of contrasting lines is a bicycle. Rims, spokes, frame, forks, cables and chain are all linear structures which contrast and interact strongly with one another.

Finally, Figure 3.9 (see Appendix 3) shows a variety of lines deployed creatively in one complicated drawing.

Figure 3.9 Tŷ Coeden (Tree-House) by Hefin, age 8

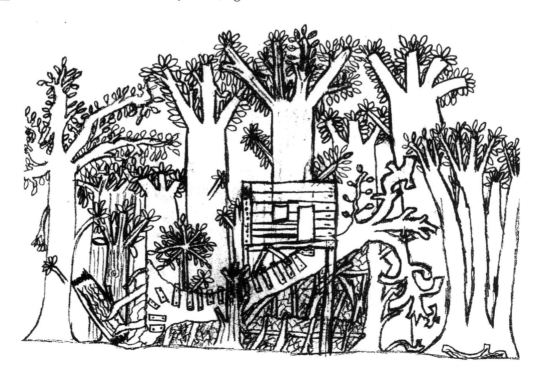

Line in art and craft

Line has been used in art and craft by most cultures in all parts of the world and at all historical periods. Rather than attempting a survey of these, attention is placed here on some cultures and some modern artists, whose work has developed line in distinctive and interesting ways.

Both the ancient Greeks and ancient Egyptians had a mastery of line drawing which was the foundation of much of their art. Examples of both are to be found not only in the British Museum in London but also in many provincial museums, and it is well worth finding out what material is available locally for children to see at first hand.

Ancient Egypt Egyptian painting, both on wall plaster and on sheets of papyrus, was dominated by drawn outlines in black which were then filled with areas of paint in a restricted range of colours, which were enhanced by the line-boundaries around them, as well as by the way the colours were placed next to each other (pp. 49, 59). Careful outline drawings of figures and hieroglyphs were also made on stone to show masons the designs they were to cut. Egyptian drawing appears less naturalistic and more stylized to us than that of the ancient Greeks, but this is because the Greeks are our artistic and intellectual ancestors. Both the art and the thought of Western Europe and North America are much more closely related to ancient Greek civilization than to ancient Egyptian. We know that styles, conventions and rules about the use of line in drawing were highly developed in ancient Egypt, because unfinished wall-paintings exist in which the apprentice's drawing in red has been corrected by the master drawing over it in black. Archaeologists excavating ancient rubbish heaps have also found books of patterns and pupils' sketch-books.

Ancient Greece The ancient Greek line drawing we know most about was on their ceramics, because more of these have been preserved, but similar kinds of drawing were also engraved on metal and used as the basis of wall-paintings. They show, over a long period of time and in various city-states, the evolution of extraordinarily vigorous line drawing in both figures and patterns. At different periods lines were drawn both as dark-on-light, probably with brushes, and as light-on-dark, incised with a point through a silhouette (often in black) into the pale clay beneath. If suitable clays and slips are available, children can practise both techniques for themselves on partly dried leather-hard clay, which can then be dried and fired.

Celtic and Anglo-Saxon art Between the seventh and eleventh centuries AD, decorative art based on complex patterns of lines was developed in Britain and Ireland in a wide variety of media, including illuminated manuscripts, metal and stonework. The best known of these are the interlaced knot and braid patterns which, though they are often referred to as Celtic, were used both by Celtic and Anglo-Saxon artists and craftspeople. Art historians often prefer to call this art insular, i.e. belonging to the British Isles, but even this term is misleading because it was in fact cosmopolitan. Many of the line motifs of this period were derived from late Roman art, and others can be traced to different parts of Europe and the eastern Mediterranean. Numerous examples are illustrated by Laing and Laing (1992), and Bain (1994) gives instructions for drawing many Celtic patterns.

In the tenth and eleventh centuries, Anglo-Saxon monks also used line drawing in

quite a different way, to draw figures of humans and animals. Often these, like the patterned decoration, were illuminated with gold and colour (p. 50), but sometimes they were left in outline. The lines were drawn with pen and ink, the best of them in a very distinctive, lively and beautifully flowing style, which may be contrasted with the pen drawing of van Gogh (see below and Backhouse et al., 1984: 55–8).

Japanese art Brush-drawn line is the basis of much Japanese art. This includes calligraphy, the art of fine writing, which the Japanese regard as a mirror of the mind and esteem, together with ceramics, as the highest and most expressive of all the arts. The brushes are pointed, held vertically and used with black ink, though colour may be added later. The brush-strokes of a master artist are extraordinarily swift and gestural (p. 18; Figure 3.3), but executed with great control and skill.

In Japan brush-painting developed in many ways, notably the art of multi-colour wood-block printing, which keeps much of the liveliness of the brush line but allows the artist and block-cutter to add distinctive line-based textures to the image. Two of the greatest masters of this complex medium were Katsushika Hokusai (1760–1849) and Utagawa Hiroshige (1797–1858), almost any of whose prints will show children a wide range of line used with great inventiveness.

The Japanese print perhaps best known in the West is Hokusai's *Great wave of Kanagawa* (see Appendix 5), in which the wave-crests are shown stylistically as a complex set of lines developed into claws, which interact strongly with the curved face of the wave, the lines of the boats helpless beneath it and the static, symmetrical shape of Fujiyama in the background. The contrasts between wave and mountain in terms of size, scale, symmetry and asymmetry help to make this image a masterly piece of communication through the use of shape and space as well as line, giving an impression of movement and irresistible force. Figures 3.8g, 8.8b and 8.8c show very simple examples of a similar use of line and shape.

This print is also unusual in that it is almost entirely in shades and tints of blue, and was produced in 1831 partly in response to the import into Japan of the synthetic pigment Prussian blue from Europe. When Hokusai's powerful, dynamic image was exported to Europe later in the century as part of a fashion for all things Japanese, it influenced many artists including the Impressionists (see pp. 128–9 and van Gogh, see below). It is also said to have inspired the French composer Claude Debussy (1862–1918) to write his orchestral masterpiece *La Mer* (The Sea) in 1905.

The drawings of van Gogh One European painter who bought, studied and was much influenced by Japanese wood-block prints was Vincent van Gogh (1853–1890). Although he is best known as a painter, van Gogh's drawings are also very varied in style, and children can learn a great deal from studying them. Many of these drawings, used as the basis of paintings, were executed in various media, but van Gogh's most characteristic lines were drawn with a reed pen and ink. Good examples to study (see Appendix 5) are *Wheat fields with cypresses* and *The postman Joseph Roulin*. In both he used a wide range of weight (width) and tone (blackness or greyness) in the lines to build up tone, shape and texture, which were translated into brush texture and colour in the paintings.

Van Gogh's lines are short and abrupt, a very direct record of repeated rapid gestures, utterly unlike the carefully thought out, flowing lines of the best Anglo-Saxon drawing (see, for example, Backhouse et al., 1984: 53–8). In his landscape drawings

especially, van Gogh uses the directional properties of line distinctively, to give an extraordinarily vivid impression of movement in plants and clouds blown by the wind.

Twentieth-century art In the early twentieth century line was used by many artists not so much to draw pictures and depict objects as to express and communicate ideas. In particular, the idea of modernity and of living in what was thought of as a machine age was expressed by ruler-straight lines and geometric shapes which till then had been more characteristic of engineers' drawing than artists'. The Suprematist paintings of Kasimir Malevich (1878–1935) are particularly good examples of this (see p. 101). Some artists, however, used line in much more complex and varied explorations. Two of these, Klee and Ben Nicholson (1894–1982), used line as a prominent element in their work throughout their careers, but in different ways.

Paul Klee Although some of Klee's paintings are based entirely on tone, colour, shape and texture, most of his work is based on line, used very prominently in an extraordinary variety of ways (Hall, 1992). In the 1920s and early 1930s these are usually delicate and range from the geometrically perfect to the obviously organic. Compare, for example, *Fruits on red* with *Conqueror* and *Three subjects, polyphony* (see Appendix 5). Klee uses the mathematically near-perfect straight line and circle as symbols of the machine age and modernity, but unlike Malevich he uses them satirically: his 'conqueror', as Hall points out, is an image of 'fatuous bravado'. In contrast, the organic, growing lines in the other two examples reflect his lifelong fascination with growth, and the connection which he was often seeking to make between the interweaving lines we see and the strands of music we can hear (see also p. 13).

Klee also used to draw freely with a single wandering line and then make images from whatever resulted: 'taking a line for a walk', as he put it. This process sometimes gave him lines which loop and interact in the most extraordinary way. A good example is *Little jester in a trance* (see Appendix 5), a painting in which the figure is formed almost entirely from a single line which crosses and recrosses its own track rhythmically.

Ben Nicholson Like Klee, for Nicholson also line was a very clear and visible part of his mature work, but in a more abstract and less pictorial way. Although he did use straight lines and, occasionally, perfect circles, the overwhelming majority of his lines are obviously drawn by the human hand, and the shapes are derived from objects in his studio or in the landscape around him. It is its character which makes Nicholson's line so distinctive. Unlike Klee's organic, growing line, or van Gogh's expressive, gestural pen-strokes, Nicholson's line is static, very fine, hard and often unvarying in width, with an extraordinary tension and no hesitation or ambiguity. These qualities are well shown by his *1945 (still-life)* and *1953, February 28 (vertical seconds)* (see Appendix 5). Here again children can learn a lot by observing how the lines interact, as well as the interplay of shapes and the placement of colours (see p. 71).

4 Tone

4.1: The concept of tone

Some things, such as the sun, flames, electric lamps and computer monitors, give out light: they are light sources. Everything else we see is visible only because light is reflected from it into our eyes, and this includes not only mirrors and other shiny surfaces, but also the dull, matt surfaces of most artwork.

The concept of tone is, in essence, very simple: it is the property of surfaces which determines how light or dark they appear. This in turn is a measure of how much of the light falling on a matt surface is reflected by it. Of all the materials with which children are likely to work, matt black poster-paint reflects the least light and so has the darkest tone, whereas smooth white photocopier paper reflects the most light and so has the lightest tone. In between these two extremes are materials which reflect intermediate amounts of light. These include not only all the shades of grey, but all colours as well.

Tonal value

A grey surface such as Figure 4.1a, which appears flat, with no variation, can be assessed by comparing it against a standard scale to find what is known as its tonal value. On the grey scale, black has value 0, white has value 10, and there are nine progressively lighter greys making up the values in between, with what appear to be equal differences between them (p. 33). Assessed in this way the grey square in Figure 4.1a has a value of about 6. A grey scale forms part of Colour figure 4, showing how tonal values can be used not only to compare greys, but also as a means of relating greys to colours and colours to each other.

Relating tone to the other visual elements

Tone is related to all the other visual elements. Perhaps the closest relationship is that between tone and colour, since value is one of the three fundamental properties of all colours (p. 41; Colour figure 4). The different values of colours have fundamental effects on the way they interact when they are placed together (see pp. 55–6; Colour figure 7; p. 67; Colour figure 8).

When colour is absent, points, lines and shapes are visible only if there is a contrast of value between them and the space around them (Figures 2.2, 3.1). Points and lines can be grouped together to create areas of contrasting tone (Figures 2.2, 2.3, 3.7a–e, 4.1c, 4.1d, 4.3k, 4.3l). Varying the grouping and sizes of points or lines creates subtle gradations of tone when viewed from a distance, an effect which has long been used in different forms of printing, for example in line-engraving (Figure 9.7a) and half-tone reproduction of photographs (p. 12). Boundaries between areas of differing value, whether sharp or gradual, are one way in which shapes are defined (Figure 4.6; pp. 72–3, 75–6; Figures 8.2c–n, 8.3i–m, 8.5).

Tonal contrast also has a significant influence on the way shapes interact with the spaces around them (pp. 91–3; Figures 9.2–9.4) and these figure and ground effects are much weaker if contrast is reduced (Figure 4.2). A combination of tonal values, contrasts and boundaries, particularly in landscapes and artwork based on them, provide one kind of visual information (depth-cue) which helps us to perceive how objects and images are related in space, whether real or illusory (pp. 97–8; Figure 9.5). Tonal variations, in particular shadows, also help us to perceive form and to interpret how forms interact with each other and the space around them (pp. 104–5; Figure 10.1).

An area of tone which is not completely flat and featureless is likely to have texture (Figures 4.1b–e, 4.3c–l, 11.1–11.5), and contrasts of tone play an important role in almost all patterns (Figures 4.1e, 4.2, 11.5e, 11.5f, 12.7b–d, 12.12d–f), even highly coloured ones.

4.2 Investigating tone

Some surfaces children use in artwork appear flat and textureless, such as well-mixed poster-paint on paper. Controlled mixing of paints to give flat greys is a useful skill which is discussed below (p. 33), but as a starting-point for learning about tone it is not very interesting. Tonal surfaces may have variations in value in the form of points, lines and shapes making textures and patterns, and though they have no colour and may appear simply grey to a casual glance, they can be full of visual interest. Carrying out simple experiments in making and matching a variety of surfaces such as those in Figures 4.1 and 4.3 will not only enable children to develop their knowledge and understanding of tone, but also give them opportunities to compare the properties of commonly-used materials such as paint, pencils, pens, pastels and different papers.

Making tones to match a sample

Figure 4.1 is the result of a simple exercise in making and matching tone, which shows some examples of methods for children to use as a starting-point for their own experiments. Starting with a flat grey painted square for reference (Figure 4.1a), different materials are used to make textures and patterns which appear to have about the same value when viewed from a distance. Example (b) is made by rubbing a graphite pencil on cartridge paper, making the texture of the paper visible (pp. 122–3; Figure 11.1). Examples (c) and (d) are drawn with a pen in point and line respectively, and in (e) small squares of a darker grey are glued in a pattern on a larger, lighter grey square. Other examples of visual texture, with which children could experiment to learn about tone, are discussed on pp. 123–6 and illustrated in Figures 11.2–11.5.

Figure 4.1 Making and matching tone

a b c d e

Contrast and boundaries

Points, lines and shapes without colour are visible only if there is a difference in value between them and the space around them. This is a property exploited by many polar mammals and birds, whose white fur or plumage acts as camouflage. Difference in value gives rise to contrast of tone, but perceiving contrast is not as simple as it may seem (pp. 33–4; Figures 4.4, 4.5). Children should have opportunities to observe that the greater the difference in value between marks or objects and their background, the higher the contrast and the more conspicuous they are likely to be. This is clearly shown by the lines in Figure 3.1 and the shapes in Figure 4.2. The high-contrast shapes in Figure 4.2b would, for example, be much more useful as a road-sign than the low-contrast ones (Figure 4.2a) because they stand out much more when viewed from a distance. Our perception is also affected by boundaries between areas of different value, which can be sharp and hard or blurred and soft. The photograph in Figure 4.6 shows a wide range of both tonal contrasts and boundaries. Different combinations of contrast and boundary can have significant effects on how we interpret shape and space (pp. 93, 97–8). The effect of contrast on our perception of tone is investigated further on p. 34.

| Figure 4.2 | Contrast and visibility |

a *b*

Tonal gradation

Gradual, even changes from dark to light cause gradations in tone. It is possible to make or see gradations in which no definite boundary between light and dark can be perceived, for example some of the shadows on the photograph of snow in Figure 4.6, and Figure 4.5b which was produced by a computer. Two attempts to make gradations of tone are shown in Figure 4.3, using pastel rubbed with a finger (a) and poster paint diluted progressively (b). In both cases the horizontal gradation is in strong contrast to the sharp boundaries of the rectangles. Producing even, textureless gradations of tone is quite difficult with traditional materials and is a classic technical exercise, but again is not very interesting as a starting-point for experiments.

Variations in tone are much more visually interesting and effective when they are not even and show texture or pattern. Making varied gradations of this kind in different media is a good starting-point for children's investigations.

| Figure 4.3 | Gradation, texture and contrast |

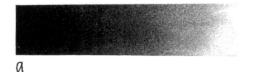
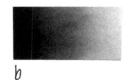

a *b*

**Figure 4.3
cont**

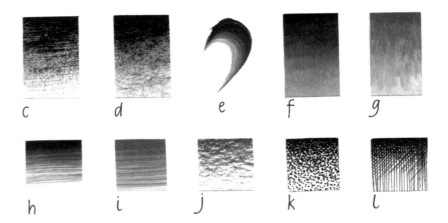

c d e f g

h i j k l

**Textured
gradations
of tone**

Children can make textured gradations of tone by spraying paint or ink (Figure 2.3), and painting with brushes in a wide variety of ways, a few of which are shown in Figure 4.3c–i. Examples (c) and (d) are made using a bristle brush with very little black paint in it, so that it is nearly dry. Different strokes give different textures and quite a lot of control is achievable. Gradations can also be made by mixing two contrasting paints which are not too runny. A good way to begin is to dip one corner of a flat brush into each paint and make a single stroke. The same stroke can then be brushed over again several times until the paint has mixed as much as required (Figure 4.3e). The degree of contrast can be varied either by using different paints, or by varying the amount of over-brushing. Another way to mix on the paper is to start with black, then add white progressively, mixing it in with tiny brush-strokes to produce a gradation, as in Figure 4.3f. The contrast can be reduced by starting with grey to give a softer effect (g). Brushing the other way while adding white to black or grey gives a streaky texture, as in (h) and (i).

Textured gradations of tone can also be drawn, as shown by Figure 4.3j–l. Example (j) is made by rubbing a soft graphite pencil on cartridge paper, and a pen is used to build up tone from points in (k) and lines in (l).

Developing experimental samples

**Artwork
without colour**

When children have made samples which combine variations of value, gradation, texture or pattern in different ways, these can be cut into shapes and assembled. In this way it is possible to produce visually interesting and beautiful artwork without using any colour at all, a challenge to which most children respond positively and imaginatively. Some simple examples of cut and assembled papers, which could act as starting-points for children to develop their own ideas, are shown in Figures 2.3e, 3.4, 8.7a–f, 8.9a–c, 9.2–9.4 and 12.7.

4.3 The perception of tone

Investigating a range of tone-making materials will enable children to observe properties of tone such as value, contrast, gradation and texture in examples they have made for themselves (pp. 30–2; Figures 4.1–4.3). In order to understand how tone is used more widely in artwork, we need to investigate some of its properties a little further, to find out more about the way in which different tonal values are arrived at and how tone itself is perceived.

How to get the grey you want: the Weber-Fechner law

Grey surfaces are most commonly arrived at by adding a black medium to a white one in some way. This can be done by adding black paint to white, by rubbing a pencil or pastel on to white paper, or by drawing with a pen (Figures 4.1, 4.3). When experimenting in this way, it quickly becomes apparent that making exactly the tonal value one wants is not a simple process.

Progressive mixing

As children experiment, they will find that only a very small amount of black medium is needed to make white paper or paint very obviously grey, but if darker (lower-value) tones are needed, greater and greater amounts of black medium have to be added to make a difference which can be seen. This is an example of an effect which is both simple and precise, known as the Weber-Fechner law. In order to darken a tone progressively in steps which appear equal, the amount of black added has to be doubled with each step. Although this is true of any medium, the easiest way to investigate the effect is by mixing paint, because the amount of black used can easily be measured by adding diluted paint with a dropper.

Controlling mixing of greys

Figure 4.4 shows the results of two simple experiments which children can do for themselves. Drops of diluted black paint are added to a quantity of white and a little of the mixture is used to paint a sample on paper before more black is added. The numbers under each sample square show the number of black drops added to make that particular grey. Row A shows that if the same amount of black is added each time, the difference it makes to the value of the grey becomes less and less: the three right-hand greys (4, 5 and 6) appear much more like each other than the three left-hand ones (1, 2 and 3). In row B, the amount of black added was doubled at each step. This results in a much more even progression of tone, with the difference between each square and its neighbour appearing to be about the same.

| **Figure 4.4** | Mixing greys: the Weber-Fechner effect |

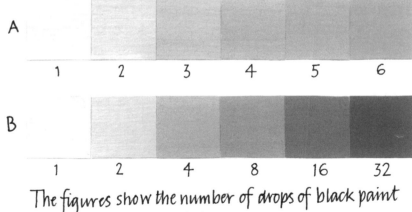

The figures show the number of drops of black paint added to make each mixture.

The same Weber-Fechner effect is experienced when mixing colours; for example, when adding blue to yellow to make green. A practical understanding of it can make children's paint mixing much more precise and much less wasteful. In particular, it explains why paint mixing can usually be controlled better by adding black or a darker (low-value) colour to white or a lighter (high-value) one, rather than the other way round.

Perceiving tone: the role of contrast

How light or dark flat grey surfaces are can be measured precisely using a photometer, but without such a measurement the only way we have of assessing how light or dark samples of grey are is by comparing them with a prepared grey scale of values (Colour figure 4). Our eye-brain system cannot measure tonal values: it can only compare and contrast, so how dark or light a surface appears will depend not only on its value as determined by comparing it with a grey scale, but also on tonal contrasts between it and whatever is around or beside it.

For example, look at the square marked 8 in row B of Figure 4.4. If you look at the middle of the square it does not appear to have the same value all over. Contrast with the squares on either side makes the right-hand edge appear lighter and the left-hand edge appear darker. If the squares on either side are covered with white paper, however, it can be seen that the whole of the square is the same grey.

Our perception of tone is an example of a principle which is very important in any understanding of art and the visual elements. The appearance of everything we see depends to some degree, and often very significantly, on what is around it, how we look at it and the light conditions at the time (see also pp. 8, 52, 107, 120–1; Colour figures 5–7). In terms of both tone and colour, the eye-brain system exaggerates differences.

For example, look at Figure 4.5a, concentrating on the point at which the two small squares touch, and see if they appear to have the same value. Both are in fact the same grey, but contrast makes us see this tone as lighter when on black and darker when on white. This is an example of simultaneous contrast, which also affects how we see some colours (pp. 54–6; Colour figure 6a–c). Figure 4.5b demonstrates even more startlingly our inability to measure tone and the degree to which contrast can mislead us. The stripe in the middle is the same grey for all of its length, but few children (or adults) will believe this until they have covered the grey gradations with paper and seen the stripe in isolation.

Relative perception of tone

Figure 4.5 Contrast and the perception of tone

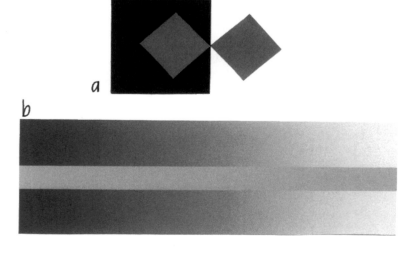

a

b

4.4 Tone in context

Tone in the environment: light and shadow

Tone is always visible around us as a basic and very important part of our visual environment, but it is even more obvious than usual, and easy to observe, on days with some cloud and some sunshine. Clouds lit by sunlight show many different tonal values, contrasts and boundaries, which can introduce the idea of shadows. Children often do not realize that a grey cloud is exactly like a white one, except that it is not in direct sunlight, so less light is reflected from it and it appears dark, especially if there are brightly-lit clouds nearby with which it is in contrast. The same effect is illustrated by Figure 4.5b, and similar observations can be made on white walls and paintwork in sunlight and shadow. A shadow is simply an area from which less light reaches our eyes because less light is falling on it.

Extreme tonal contrasts also affect our perception of colour and form. On days with strong sunlight and deep shadows, colours appear to be less vivid, but three-dimensional forms are enhanced and the overall effect, particularly around trees and buildings, is very dramatic (Figure 4.6). On overcast days, tonal boundaries are softer and contrasts are lower, though both still play a major part in giving a sense of space and distance (Figure 9.5). At the same time, colours are often enhanced and appear more vivid. Tone also makes a very large contribution to our response to buildings when we are inside them. Sunlight through the windows of a great church, for example, can create a sense of space and drama which is comparable with that felt in a theatre when the stage lights go up.

Figure 4.6 Boundaries and contrasts in tone (photograph by Henry Carsch)

Tone in photography

Photography, invented in the middle of the nineteenth century, was a powerful factor in stimulating the development of Impressionism and modern Western art (see pp. 128–9). Until well into the twentieth century all photography was in monochrome,

often mistakenly referred to as black-and-white. Good-quality photographic prints in monochrome may contain not only a very wide range of tonal values, but also subtle differences and gradations between them (Figures 4.6, 9.5).

Children can learn a great deal without going into technicalities from the work of original and creative photographers such as Alfred Stieglitz (1864–1946), an American who helped to establish photography as an independent art-form in its own right. Stieglitz did much to promote modern art as a whole, through exhibitions of paintings and sculpture in his gallery in New York between 1908 and 1914, including work by Henri Matisse, Henri Rousseau and Constantin Brancusi, as well as children's art and African art. He did not simply exhibit avant-garde art, however: he learned from it and applied what he had learned to his own work as a photographer, producing many images in which tone, shape, space, texture and pattern interact in beautiful and intriguing ways. It is particularly useful for children to look at examples of Stieglitz's work (or that of other photographers) which show the very wide range of tonal variation, contrast and boundaries which are possible in the medium, for example *Looking north … NY, Avenue of trees, From my window: New York* and *Later Lake George: weathervane on wooden cottage* (see Appendix 5).

Tone in graphic art: M.C. Escher

The Dutch artist Maurits (M.C.) Escher (1898–1972) worked mostly in graphic art, which means using media in which works are produced by some method of printing, and most of his work is in monochrome. He is perhaps most famous for his ingenious use of space, shape and optical illusions, and most children find these aspects of his work fascinating (p. 149). A great deal can also be learned about tone and how we perceive it by looking at the way Escher achieves and uses intermediate tonal values and gradations using different methods of printing. His woodcuts, such as *Dream* and *Development 1* (see Appendix 5) are literally black-and-white, with sharp boundaries and no intermediate greys. At first sight, however, and especially from a distance, the viewer may be unaware of this, because Escher creates what appears to be a complete range of tonal values by very skilful manipulation of point and line.

In much of his later work Escher used lithography, which enables the artist to achieve a complete range of tone with any kind of boundary, from sharp edges to soft gradations. Lithography is a method of printing in which the artist draws on a flat surface of stone, metal or plastic with a greasy crayon or special ink. The drawing is treated so that the ink clings only to the marks which have been drawn. When the inked surface is printed the original drawing is reproduced in reverse. One of Escher's most interesting lithographs is *Three worlds* (see Appendix 5), in which he uses tone and other depth-cues (p. 95) to give a remarkable illusion of space. Particularly noticeable are the ways in which intermediate greys and soft gradations make the image of the fish appear to sink, whereas the high values and sharp edges of the leaf-shapes combine with overlap to give them an appearance of floating up and forward on a surface, towards the viewer (see also pp. 00; Figure 9.6b–d). The 'third world' of the title is suggested by reflections of trees, in sharp black silhouette, as if they were reaching up into the air.

Sharpness and contrast in portrait painting: chiaroscuro

In paintings, as in buildings and wider environment, high tonal contrasts and deep shadows give a dramatic effect and a stronger illusion of three-dimensional form. It is

also noticeable that shapes with sharp outlines appear to float forward from a contrasting background (Figure 9.6b–d), giving an illusion of depth. These tonal effects capitalize on humans' perceptions of contrasts as more extreme than they really are (p. 33; Figures 4.4, 4.5). Such effects were extensively used in European painting between the fifteenth and nineteenth centuries to enhance the illusion of space experienced by a person looking at the flat surface of a picture, and are sometimes still used today. From the late sixteenth century onwards, dramatic lighting and contrast were used to such effect that chiaroscuro, Italian for 'light-dark', became a standard term in art criticism for this style of composition and painting. Although chiaroscuro was used in many kinds of painting, much can be learned about its effects by looking at portraits, the medium in which it had its origins.

Strong tonal contrast was used in some early paintings and it is interesting to compare two portraits (see Appendix 5): *Man in a turban* by Jan van Eyck (died 1441) and *The Doge Leonardo Loredan* by Giovanni Bellini (died 1536) (see also p. 69). In the van Eyck portrait, strong tonal contrast between the face and the background makes the face stand out, helping to give the portrait a presence and the viewer the illusion that it might speak at any moment. In the Bellini, though there is a contrast between warm and cool colours, the tonal contrast between face and background is much less, so that the portrait appears flatter and more decorative and we feel that the personality of the doge is more remote.

Portraits by Rembrandt van Rijn (1606–69) show the effects of chiaroscuro in a highly-developed form and his *Jacob Trip* and two *Self-portraits* (see Appendix 5) are superb examples. When compared with the van Eyck the contrasts are stronger, the shadows deeper and more of the faces are in shadow, so that the character, age and experience of the sitter and the artist himself are powerfully portrayed. Chiaroscuro was never overdone by Rembrandt (though it was by some later painters), and it is useful to compare his portraits with another in the same gallery, that of *Susanna Lunden* by Peter Paul Rubens (1577–1640, see Appendix 5). Rubens used a completely different set of tonal contrasts, resulting in a flatter and more decorative portrait, because he wanted to communicate the happiness of youth and beauty, not the darker drama of age and experience.

The tonal contrast which makes the face stand out in chiaroscuro portraits can also work when the contrast is reversed. This effect was used to create a sense of theatre by Salvator Rosa (1615–73) in his *Self-portrait* and by Joseph Turner (1775–1851) in *The fighting Téméraire* (for both see Appendix 5), in paintings which otherwise are quite different in character.

Seurat: manipulating contrast to give an illusion of depth

Chiaroscuro helps to give an illusion of depth and a sense of excitement by imitating and exaggerating the lighting effects which we often see in the world around us. Some artists, however, have created illusions of depth using tonal contrast in ways which are never seen in reality. One of the most skilful was Seurat, whose work is also discussed on pp. 50–1, 128. In his first great painting *Bathers at Asnières* (see Appendix 5), Seurat wanted to convey the sense of a very hot, lazy day and the coolness of the river. To do this, there could be no sense of tension, so shadows had to be softened: the only very low-value tones are clothing, a hat and the hair of one of the figures.

To help give an illusion of depth Seurat set up contrasts of tone between the figures and their background. In the case of the clothed figure lying on grass in the foreground

this is no problem since he is dressed in black and white. To make the bathers appear more three-dimensional Seurat had to manipulate the background, giving the figures haloes of tone in tints of blue, gently graded into the overall tone of the river: dark on one side of each figure and light on the other. This ingenious device was used by Seurat even in his early monochrome drawings for the painting, showing how thoroughly he thought out his technical methods. Though effective, it may be criticized for being a little too obvious, and when Seurat used tone in similar ways in many of his later paintings, for example *Le Bec du Hoc, Grandcamp* of 1885 (see Appendix 5), he did so with rather more subtlety.

Tone and colour: fauvism and cubism

Sometimes working in tone, with little or no colour, can be as significant in the development of art as the use of a full colour range. Between 1905 and 1910 two very different kinds of painting were developed by artists working in France. These styles, though short-lived in themselves, had a significant effect on art for the rest of the twentieth century. The first, known as fauvism, explored the use of vivid colour in paintings which were far more energetic in colour terms than anything which had preceded them (see pp. 60–2).

The second movement, known as cubism, was jointly developed by Pablo Picasso (1881–1973) and Georges Braque (1882–1963), who invented a new way of representing three-dimensional forms on flat, two-dimensional surfaces. They did this by trying to show, in a single painting, what an object looks like from several different viewpoints at once. Although both painters had previously used a wide range of colour in their work (Braque had been one of 'Les Fauves', the wild beasts, see p. 60), this technique caused them to concentrate on shape, form, light and shade to such an extent that colour became an irrelevance. Both painters abandoned vivid colours and for some years worked almost entirely in tone, using only dull browns and greens in addition to black, white and greys. Only when they were free from the complexity of colour could they work out faces, edges, angles and corners sufficiently clearly in terms of light, shade and tonal gradation.

Among the more easily understood early cubist paintings are Braque's *Violin and palette* and *Violin and jug*; and Picasso's *Seated nude* and *Lady in a black hat* (see Appendix 5 for all these works). Only when they had mastered this revolutionary way of seeing and representing objects did Braque and Picasso return to using vivid colour in their painting.

5 Mixing and Controlling Colour

Colour is the visual element to which people respond most strongly and immediately, and for which they have the most definite likes and dislikes. Colour is highly significant in our lives and is the subject of much research in science, technology, industry and marketing, as well as art history (Zelanski and Fisher, 1989). It is a large, complicated subject and there is a great deal of literature about its nature, how we perceive it and how it affects us, but there is still much about colour which is not well understood. In order to help children understand and use colour effectively, however, complex theory is unnecessary. A few basic principles coupled with first-hand observation and experiment are what is required.

Developing a basic working knowledge of colour and its role in art can be approached in three stages. The first, undertaken in this chapter, is to learn the language of colour together with some of the ways in which it can be varied and controlled, so that we can communicate about it clearly and obtain the colours we want. The second stage (in Chapter 6) is to investigate the perception of colour and how we see it under different circumstances. The third (in Chapter 7) is to observe and experiment with our responses to colours, how they affect us singly and in various groupings.

5.1 The concept of colour

Colour is a property of objects and materials which affects how they appear to us when we see them. It is a complex property because, unlike tone, it has to do not only with the amount of light we see and how dark or light the object appears, but also with the quality of light. For example, blocks of colour of the same degree of lightness or tonal value appear quite distinct from each other (Colour figure 4).

Observing colour with a CD or foil

A good way to begin investigating colour is to observe a CD or a piece of 'rainbow' (diffraction) foil in bright daylight, but not in direct sunlight. Hold the disc or foil horizontally so that you look down on it at an oblique angle and tilt it slowly. A spectrum of rainbow colours will be seen on the flat surface of the disk or foil and the colour reflected from any one spot changes as the object is tilted. The different qualities (wavelengths) of light which appears to us as coloured bands are always present in daylight, though we cannot usually distinguish them. What the CD and foil do is to reflect the different parts of daylight at slightly different angles so that we can see them separately, as a range of colours.

Coloured lights and coloured objects

We see things when light travelling from them enters our eyes and is focused into an image. Some of the things we see are sources of light, such as the sun, electric lamps, flames, televisions and computer screens, which give out light energy. Most of the other objects we see, like the moon, houses, trees, people, paint and paper, do not give out light but reflect it. The only light sources children are likely to use in artwork are computer monitors (pp. 47–8). All the other materials, such as paints, papers, crayons,

inks and dyes, are reflectors of light. We can see objects which are not sources of light only because light is reflected from them into our eyes. Children may think that reflection occurs only from mirror-like surfaces, but ordinary objects without shiny surfaces also reflect light and this is how we see them.

CDs and 'rainbow' foil are not coloured and we see the coloured light reflected from them only when they are viewed at certain angles. Coloured objects and materials, like books, paints pictures and clothes, are different. They appear coloured when viewed from any angle, though their colour may seem to change under some circumstances (p. 52). Unlike a CD they are, as it were, coloured in themselves; being coloured is one of their properties.

Why objects and materials are coloured

In daylight, a piece of white paper reflects all parts of the spectrum equally, so it appears white. A clue to why some objects and materials appear coloured can be found by making marks on paper. If a mark is made with an ordinary graphite pencil, less light is reflected from the mark than from the paper, so the mark is darker and has a lower tonal value (p. 30). The light not reflected from the mark is absorbed, but the mark is grey rather than coloured, so all parts of the spectrum are still being reflected equally by the marked paper.

When a coloured mark is made with paint, crayon or ink on white paper, the change in appearance is different. Whatever colour the mark is, it is always darker than the paper (unless special fluorescent paint is used), so again less light is being reflected and some is being absorbed. Now, however, the reflection and absorption vary across the spectrum: not all colours are being reflected to the same degree.

It is important to understand that all coloured materials and objects reflect all parts of the spectrum and therefore all colours to some degree, but do so unequally. The colour the mark on the paper appears to us depends on which part or parts of the spectrum it is reflecting most strongly, and no object or material is a pure colour, reflecting one colour only. For example, green paint or an object such as a green leaf absorbs most of the red, blue and violet light falling on them, reflecting some orange, a lot of yellow and even more green, so appears green to us. Most orange objects, in contrast, reflect a lot of red and some yellow as well as orange, but absorb green, blue and violet very strongly.

The spectrum and the colour-wheel

Although the spectrum which we see on the surface of CDs is a good starting-point when investigating colour, its usefulness in artwork is limited because it does not include the range of vivid colours, both natural and man-made, which are produced when materials reflect both red and violet very strongly. If the spectrum is bent round and drawn as a circle, colours such as purple, cerise and magenta can be included in their natural position between red and violet, completing an arrangement usually known as a colour-wheel (Colour figures 1, 2). Ordering colours in this way has the additional advantage that it helps us group and relate them in different ways (pp. 42–4, 53–4, 64–6).

Describing colours: hue, chroma and value

In order to communicate clearly about colours we need an agreed way of describing them. An effective and simple way to help children to communicate about colour is to

adopt a modified version of the system originated by the American colourist A.H. Munsell, in which each colour is classified and described in terms of three properties, known as hue, chroma and value.

Hue describes what kind of colour it is: in the case of vivid colours, where on the colour-wheel it belongs. Usually six basic hues are identified, which are also the six colours most people distinguish in a rainbow or spectrum: red, orange, yellow, green, blue and violet. Descriptions of particular colours can be made more exact by modifying these basic terms to include a range of hues in each part of the colour-wheel, for example yellow-green, blue-green, blue-violet, red-violet, red-orange and yellow-orange, which may be abbreviated as YG, BG, BV, RV, RO and YO (see Colour figure 2). Variations in red, blue and yellow are especially important in understanding colour mixing and are discussed on pp. 42–5.

Chroma is a measure of how intense or vivid a colour is, a property also sometimes known as saturation. Colour-wheels are made up using the most vivid and intense (high-chroma) hues which can be obtained in the medium being used. Colour figures 1 and 2, for example, have been made using school poster-paints (see Appendix 1). More vivid hues than these can be obtained, but only from paints which are more difficult to use and also very much more expensive. At the other end of the scale of chroma are black, white and shades of grey, whose chroma is zero: they have no colour at all, only value (see below and p. 29).

Using the terms high and low chroma to describe colours is precise, unambiguous and technically correct, but nevertheless may be unhelpful in teaching and learning. Children may find it easier to think and talk of colours as being strong and vivid, or weak and dull. These substitute terms are useful but should be used with care, and the terms 'bright' and 'light' should be avoided, as they may be confused with terms such as 'pale', which can be used quite legitimately to describe colours of high tonal value (see p. 29). Experimenting with and understanding different ways of reducing the chroma of hues is an important part of learning to mix colours in a controlled way (pp. 43–4, 46–7).

The third property that describes a colour is its value, which is a measure of how much light it reflects in total, and so is closely related to tone (p. 29). Value is usually measured by comparing colours with an 11-point 'grey-scale' in which black has value 0, white has value 10 and values 1–9 are increasingly pale shades of neutral grey (Colour figure 4). With younger children especially it may be helpful to refer simply to darker and paler colours, rather than to higher and lower values, but when older children want to mix and match colours accurately, comparison with a grey-scale may be useful. From the beginnings of their learning with colour, however, children should be helped to observe and realize that colours, even when at their most vivid, have very different values; yellows being the palest (highest value) and some blues and violet the darkest (lowest value). These differences in value greatly affect the ways in which colours interact and so the ways in which they can be used. The values of nine of the hues in Colour figure 2 are shown in Colour figure 4, each one being placed at its level of value in comparison with the grey-scale on the left.

Relating colour to the other visual elements

The most obvious relationship is between colour and tone (Chapter 4), since colour is in effect an extension of tone through the addition of the properties of hue and chroma. A colour photograph may tell us more than a black-and-white one of the same subject, but the basic information in both will be the same. Colour has connections with all the

other visual elements, because its use will change the appearance of any artwork and is likely to alter our response to it.

A less obvious relationship is that between colour and shape (Chapter 8). The two are inseparably linked because colour does not exist in isolation. Coloured light and shadows make shapes on surfaces, and coloured objects have their own shape or form. Although shape is not at the forefront of discussions on colour here and in Chapters 6 and 7, it will become evident that shapes and boundaries have a profound effect on the ways in which we perceive colours and respond to them.

The relationships between colour and pattern are particularly subtle and significant, because a great deal of pattern-making depends for its effects not only on the range of colours and shapes, but also on the ways in which these interact when viewed at different distances. These issues will be discussed further in Chapters 7 and 12.

5.2 Colour mixing

Looking round a classroom where children have been using colour imaginatively is likely to reveal a large number of different colours, far more than are available ready-made in whatever media they have employed (see, for example, Colour figures 9–12). In most media, the range of colours available can be greatly extended by mixing. To be effective, colour mixing should enable children to obtain the colours they want, every time; but this can be achieved only through first-hand experience and experiment, based on knowing how colour mixing works. The experiments on colour mixing discussed here can all be carried out using ready-mixed school poster-paint.

Subtractive colour mixing

In the eighteenth century printers discovered that a wide range of colours can be obtained by mixing three hues: yellow, red and blue. Because these hues could not themselves be made by mixing they were at first called primitive and later by the name they still have today, primary colours. Early researchers on colour thought that all hues could be obtained by mixing three primaries, but this is not true. To obtain even a moderately wide range of colours with fairly high chroma we need to select our primaries carefully.

Looking for primary colours

Children can find a clue about which hues to use in the centre margin of a colour newspaper. There, dots or squares of colour are printed to help the printer keep the coloured images in exactly the right place. In addition to black there are three primary hues: a lemon yellow labelled Y, a purplish red known as magenta (M) and a greenish blue called cyan (C). Paints similar in hue to these can be mixed to produce a colour-wheel, as shown in Colour figure 1. Details of the paints used in Colour figures 1–8 are given in Appendix 1.

Controlled mixing

When mixing colours the process can be controlled much more effectively if the darker hue is added to the paler one, rather than the other way round. Cyan added to lemon yellow produces greens; magenta added to lemon yellow produces oranges; magenta added to cyan produces purples or violets. As when adding black to white to make greys, only a very small amount of the darker colour has to be added to alter the lighter hue significantly. If mixing is carried out progressively, however, the amount of darker colour added has to be doubled at each stage to make

what appear to be equal steps in the colour series. This is known as the Weber-Fechner effect (p. 33; Figure 4.4). The lighter colour should be added to the darker only to make an adjustment or if a hue close to the darker of the two primaries is required, such as a very blue violet, a slightly green blue or a very red orange.

Mixing paints, dyes and pigments makes colours appear which cannot be seen in unmixed materials. This can happen only because any coloured material, however pure its colour may seem, reflects significant amounts of colours other than the ones we perceive. For example, cyan blue absorbs yellow, orange and red very strongly, but reflects a lot of green and some violet as well as blue. Lemon yellow absorbs blue and violet very strongly and also some red, so as well as yellow it reflects a lot of green and orange, together with some red (Figure 5.1a). When cyan and lemon yellow are mixed, yellow light is absorbed by the blue pigment and blue light by the yellow, so the blue and yellow in effect cancel each other out. The result is that the mixture appears green, which is the only colour both pigments reflect strongly (Figure 5.1a). In similar ways magenta and lemon yellow produce orange, and magenta and cyan make a purplish violet (Figure 5.1b, Figure 5.1c).

Figure 5.1 Mixing secondary hues. Each mixture reflects the hue which neither primary absorbs strongly, so that is the colour it appears.

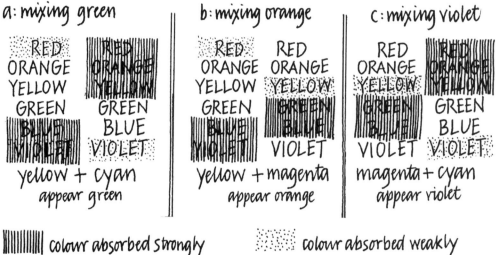

Because it works by absorbing some colours and so cancelling them out, this kind of colour mixing is known as subtractive mixing. The principles of subtractive mixing are the same for all coloured media children use: pencil crayons, wax crayons, pastels, inks and felt-tip pens, though some are more difficult to mix successfully (see below). Colour mixing in colour printing and computer print-outs using three primaries plus black is also subtractive, though the colours are mixed in different ways. Computer monitors are light sources, not light reflectors, so their colour mixing is of a different kind (pp. 47–8).

Secondary and tertiary hues

Colours made by mixing two primary hues are known as secondaries. In Colour figure 1 the primaries have been mixed in varying proportions to give a range of secondaries: three each of green, orange and purple-violet. Ideally, secondaries are no less vivid than

the primaries from which they have been mixed and if they are, more or different primaries may be called for (see below).

Any colour in which all three primaries are mixed is called a tertiary colour. Typical tertiaries are browns, olive-greens, khaki and many varieties of grey, some of which have been used in Colour figures 10b and 11b. Unlike secondaries, tertiary colours always have lower chromas (are duller and less vivid) than the primaries or secondaries from which they have been mixed, but they are also subtle and quieter visually, so it is useful to be able to mix them in a controlled way (pp. 56–7). In some art manuals, intermediate secondary hues such as yellow-green or blue-violet are still called tertiary colours, but this misuse of the term is both incorrect and unhelpful.

Mixing tertiary colours

There are two main ways of mixing tertiary colours. Children can learn a lot from trying both, using quite small amounts of paint to start with and painting samples as they go. The first way is to mix any two secondary colours together: green with orange, orange with violet and green with violet. The second way is to take any hue and mix it with increasing amounts of the hue opposite it on the colour-wheel. If either of these is done in gradual stages a range of colours is produced which becomes increasingly dull as the first hue is cancelled out, then increasingly vivid again as the second hue begins to dominate the mixture. Even from the hues in a simple colour-wheel such as in Colour figure 1, hundreds of subtly varying colours can be produced. As long as children know which two colours they have mixed together, these can usually be replicated quite accurately.

Three-primary and six-primary colour mixing

Observing the results of three-primary mixing

As Colour figure 1 shows, the three primary colours lemon yellow, cyan and magenta can be mixed to produce quite a good range of hues, but not a full one. The greens are good and the oranges acceptable, though rather dull and brownish. The purple-violets are also rather dull, especially at the blue end of their range. The main problem, however, is that there is no vivid scarlet red and the only vivid blue (cyan) has a strong greenish cast. All these difficulties can be resolved by using additional primary hues as the basis of colour mixing.

Selecting primary hues

Two primary hues can produce a vivid, high-chroma secondary only if they both reflect a lot of that colour. For example, lemon yellow and cyan both reflect green strongly, so they produce vivid greens when mixed and have a bias towards green. To make oranges and violets as vivid as possible we need to select primaries which are biased towards each other and the colour we are trying to mix. Magenta is biased towards violet but cyan is biased towards green, so to mix vivid violets we need a blue which is violet-biased, a hue usually called ultramarine. Neither magenta nor lemon yellow is biased towards orange, so to mix vivid oranges we need a scarlet red and a slightly orange yellow.

In selecting primary hues for children to use it is essential to know what their colour-bias is, and to test unknown colours by mixing if their bias is not obvious. If this is not done, mixed colours may well be drab and disappointing. As well as referring to primary hues by name, it is also useful to label them so that their bias is indicated. This can be done by writing the bias in brackets; thus lemon yellow with its green bias would be labelled Y[g].

Observing colour bias

Children need to look at the differences between pairs of primary colours to see their colour bias. To make three sets of vivid secondary hues we need six primaries: R[o] (scarlet), R[v] (magenta), B[v] (ultramarine), B[g] (cyan), Y[g] (lemon yellow) and Y[o] (orange yellow). These and the range of secondaries they produce when mixed are shown in the colour-wheel in Colour figure 2, which shows how scarlet and ultramarine not only enable us to mix a full range of vivid secondaries, but also meet the need for the red and blue missing from the three-primary colour-wheel (Colour figure 1). The small areas of colour round the outside of Colour figure 2 show the complementary position of each hue (pp. 53–4).

Pairing up primary hues

The six-primary system can be used with any colour medium and, once understood, can help children mix colours effectively in any area of artwork. It has only one potential problem: to obtain vivid, high-chroma secondaries it is essential to select and mix the correct pairs of primaries. Investigating this can be done cooperatively, each pair or group of children mixing two primaries to make a progressive series of secondary colours and then sharing their results.

These are illustrated by Colour figure 3, in which six colour mixings are shown in three pairs of vertical columns. In each column the primaries are at the top and bottom, with three secondaries obtained by mixing them in between. For example, in column 1 the primaries are lemon yellow and cyan blue. In the first column of each pair (columns 1, 3 and 5), the mixing is done using primaries biased towards each other and the secondary hue, as in Colour figure 2: Y[g] + B[g] (lemon yellow + cyan), Y[o] + R[o] (orange yellow + scarlet) and R[v] + B[v] (magenta + ultramarine). In the second row of each pair (columns 2, 4 and 6) the primaries are biased away from each other: Y[o] + B[v] (orange yellow + ultramarine), Y[g] + R[v] (lemon yellow + magenta) and R[o] + B[g] (scarlet + cyan). Comparison of the pairs of colour-rows shows that mixing primaries biased away from each other always produces less vivid secondaries, and sometimes unexpected ones.

This effect can be explained using the principle of subtractive colour mixing. For example, neither orange yellow nor ultramarine reflect much green, so when you mix them so that the yellow and blue are cancelled out, a dull, dark, greyish mixture is produced which is only slightly tinged with green. The dull colours made by mixing opposing primaries may of course be very useful; but the main point to be learned from this experiment is the importance of selecting and pairing up primary hues correctly if high-chroma secondaries are called for.

Mixing colours in materials other than paint

The two main kinds of colour media other than paint which children are likely to use are solutions of dyes (inks and felt-tip pens) and solid sticks (pencil-crayons, wax

crayons and pastels), all of which can be mixed by superimposing one layer of colour on another. The principles of colour mixing using paints apply equally to these media, but the performance of some of them can be significantly affected by the order in which the colours are applied.

Felt-tip pens and inks The dye layers are transparent, so the order in which the colours are applied usually makes little difference to the appearance of the mixture; but better results are likely if the first layer is allowed to dry thoroughly before being covered by the the second.

Pencil crayons and wax crayons The transparency of colour layers is variable, but if the first layer is applied heavily the second will not lie evenly over it. The best and most even colour-blends are usually obtained by putting on a thin layer of the darker colour first, then overlaying this with a thicker layer of the lighter one, applied with greater pressure.

Pastels Pastel marks are more opaque than those made by pencils and crayons. If you blend pastels by rubbing, the colours should be applied lightly rather than heavily, but it makes little difference which colour is applied first. If marks are to be left distinct, however, there may be significant differences between light-over-dark and dark-over-light, because the last colour to be applied affects the mixture most.

5.3 Tints and shades

When primary hues are mixed to give secondaries such as orange or violet, the aim is to change their hues and produce new ones. When secondaries and primaries are mixed to produce tertiaries such as browns, olive greens and greys, the aim is twofold: first, to change their hue, and secondly to reduce their chroma, making colours which are more subtle and subdued. If a hue is changed by being added to white or by having black added to it, a third kind of change occurs, shown in Colour figure 4. Mixing in this way reduces the chroma (p. 47) and changes the value of the colour, making it darker or paler, but does not aim to change its hue.

If a hue is added to white the resulting paler colour is known as a tint. Pink, for example, is a tint of red. If black is added to a hue the resulting darker colour is known as a shade; navy blue, for example, is a shade of blue. Children are likely to be familiar with pale tints of various hues because they see them in the interior decoration of their homes and schools, and they will be familiar with shades of red, green, blue and perhaps other hues from their own clothing.

**Mixing tints
and shades**

When mixing tints and shades, as with other kinds of colour mixing, the darker paint should always be added to the lighter. Add the hue to white for tints, and black to the hue for shades, in both cases starting gradually and increasing the amount of paint added each time as the mixing proceeds (p. 33). If each pair or group of children mixes tints and shades for one hue in the colour wheel and shares their results, a complete range can be obtained fairly quickly.

Colour figure 4 carries this process one stage further. All the hues, tints and shades have been mixed in progressions which approximately match in value the grey-scale at the left of the chart. The various hues have different values, so they are placed at different levels on the chart. This in turn shows that there are significant differences in the number of distinct tints and shades which can be mixed from the various hues. R[o]

(scarlet), for example, is exactly in the middle of the scale with a value of 5, so on the chart it has four tints and four shades, whereas B[v] (ultramarine) and Y[g] (lemon yellow) have contrasting values and positions. The low value of the blue means that it has only one shade but seven tints, whereas the high-value yellow has seven shades but only one tint. It is unlikely that children will need to mix tints and shades in this very controlled way, but a chart of this kind can be very useful for classroom reference and as a source of ideas for producing the colours they need, in the same way as carefully mixed colour-wheels.

Vividness of tints and shades

When a hue is added to white or mixed with black, its value is changed and at the same time its chroma is reduced. The loss of vividness is obvious in the case of shades, but may be less evident to children as they look at tints because these are lighter (paler). The critical property is vividness: although a tint is paler and therefore in one sense brighter than a hue, it is less strongly and vividly coloured, so it has lower chroma. This lowering of chroma is significant when we come to investigate how we respond to colours, both singly and in groups (Chapter 7).

Mixing tints and shades changes the value and chroma of the hues used, but in theory the hue itself remains the same: pale green, for example, is still green. In practice, there are changes of hue when mixing tints and shades. Most of these are very subtle, but one change is often noticed by children: the greenish cast which appears when a very small amount of black is mixed with lemon yellow. This change happens because most blacks have a blue bias: they absorb red more than blue and green, so that when black is mixed with lemon yellow it exaggerates the green bias which the yellow has already.

5.4 Optical colour mixing

All the colour mixing children will do in their own work is subtractive (pp. 42–3) and most of it involves blending opaque pigments in paint, pencils and pastels, or overlaying transparent dyes, as when using felt-tip pens and crayons. There are, however, two other kinds of colour mixing which children see every day. What these have in common is that they depend on a way of seeing usually known as optical colour mixing.

Colours are mixed optically not on the paper but by the eye and brain. This is achieved not by physically blending them as when mixing paint, but by using separate dots or points of colour so small that they cannot be distinguished individually when viewed normally, and so are seen as a single, larger area of colour. If the points are of more than one colour, the eye and brain perceive them as a single colour, more or less the mixed colour they would have produced had they been blended or laid over each other. Children are very familiar with two kinds of optical colour mixing (though they are unlikely to know this): in colour TV screens, computer monitors and colour printing, including computer printers.

Colour TV and computer monitors

TV screens produce colour in quite a different way from all other art media children are likely to become familiar with, because they are light sources, not light reflectors (p. 29). Optical mixing can be observed using an art program on a computer monitor or teletext on a TV to hold images and view a range of colours, together with a good

hand-lens to look very closely at the screen. The screen is illuminated by a regular pattern of very small coloured dots or short lines. Using the hand-lens and looking at an area which is red, green or deep (ultramarine) blue, it can be seen that in each case only one colour is being emitted, so these three colours are unmixed: they are the colour-light primaries.

When the light-emitting dots are activated in pairs, they make colour-light secondaries by optical mixing: red + blue appear magenta; blue + green appear cyan; green + red appear yellow. The appearance of yellow as a mixture of red and green is usually a surprise to children, who may also notice that the secondary hues in colour-light mixing are, coincidentally, similar to the primaries in paint mixing. A more significant point is that the colour-light secondaries are lighter than the primaries, whereas in paint mixing they are darker. This is because this kind of colour mixing works by adding coloured light to the screen, rather than cancelling it out and subtracting it from white paper as mixing paint does, so when all three light primaries are being emitted at full intensity the screen appears white, the lightest colour of all.

Colour printing

Children will encounter two kinds of colour printing, which work in similar ways as far as optical colour mixing is concerned: colour printers for computers and commercial colour reproduction in newspapers, books and magazines.

Observing optical mixing in print

Optical colour mixing used in commercial colour printing can be observed by looking at a page from a magazine using a good hand-lens which magnifies to × 8 or more. High-quality printing on glossy paper shows the effects most clearly and it is helpful to start by looking at fairly pale areas rather than dark or vivid ones. It will be seen that the coloured areas are made up of very small points of unblended colour. These are similar to the dots used in half-tone reproduction (p. 12) but in printer's primary colours of lemon yellow, cyan and magenta in addition to black. Having seen the colour-points in focus and still looking with the hand-lens, optical colour mixing can be experienced by moving the page away slightly. The points become blurred and the differently-coloured dots appear to merge into a single colour, as they do when the page is viewed normally.

More vivid colours are reproduced by increasing the size of the dots until they merge into a network so that an increasing proportion of the area is printed over. For maximum chroma a complete layer of colour is printed. In these denser areas, the transparent printing-inks lie over one another much as layers of dye do when mixing colour using felt-tip pens and with similar results (p. 46). The green, orange and violet which appear as secondaries show that this kind of optical colour mixing is a subtractive process, similar in principle to that of three-primary paint mixing.

Computer printers

Looking at a colour print-out in a similar way shows that computer colour-printers rely on optical mixing of a similar set of transparent dyes, but the colour-points are always of the same size and distributed at random rather than in a pattern. Variations in chroma and value are achieved by changing the density with which the dots are printed.

Painting small points of colour, known as divisionism or pointillism, also relies on optical colour mixing, but is much more complex and rather different in its effects because opaque pigments rather than transparent inks are used (see pp. 50–1).

Investigating optical colour mixing

Children can experiment with optical colour mixing in two ways, either of which may give them useful ideas for their own creative projects. Both require the use of a magnifying-glass or hand-lens to view the work out of focus. This gives the same effect as viewing the tiny points of colour-printing from a normal reading distance and allows us to see optical colour-blends even if the individual areas of colour are several millimetres across.

Optical mixing with felt-tip pens

The first experiment involves making a regular pattern of parallel lines or a chequerboard of small squares in two primary colours, so that the areas of each are roughly equal, with no overlaps. The maximum width of lines or squares should be about 4mm and the pattern about 5×5cm overall. Felt-tip pens with broad chisel-edges are useful for this. For the second experiment, use poster paints in pairs of primary colours. Paint a layer of the paler colour and when this has dried, spray diluted darker colour on to it by using a finger to flick it from a stencil brush or disused toothbrush. When the drawn patterns or sprayed colours are viewed with a magnifying-glass close to the eye so that they are out of focus, the colours will blend optically to give secondary hues. Depending on the size of the individual colour areas and the lens being used for viewing, ideal viewing distances may vary from a few centimetres to a metre or more.

Having experienced optical colour-mixing in this simple and artificial way, children can be encouraged to look for and enjoy examples of the effect both in artwork and the environment. The colours in many paintings and textiles change their appearance radically when viewed from different distances (pp. 12, 50–1, 128, 147–8). Learning to reverse the process and to see the diversity of colour in the environment is an important part of visual education (pp. 6–7, 51).

5.5 Colour range and mixing in context

Colour and history

Productive links can be made between art and history by working with the range of colours known to have been available to artists during historical periods the children may be investigating. Overall, from ancient times to the present, there has been a great increase in the range of colours available, their vividness and the ease with which they can be obtained. The following notes are simply outline examples which may be useful as starting-points for children's work based on historical traditions.

Ancient Egypt The same basic range of colours was used for a very long period, both on wall-paintings and papyri. This consisted of red, yellow and brown earth-colours (ochres), white from chalk, black from soot (lamp-black) and blue. Blue was sometimes obtained from a mineral (azurite), but mostly from grinding frit, a blue glass-like material which has a greenish tinge. This, mixed with yellow ochre or the yellow mineral orpiment, produced a range of greens, mostly bluish in cast. None of these colours is very vivid, but Egyptian painters were very skilful in placing colours so that their apparent vividness was enhanced by what we now call simultaneous contrast (pp. 54–5, 58).

Ancient Greece It was long believed that the ancient Greeks used only four colours, the tetrachrome palette: red ochre, yellow ochre, black and white. Nearly all their best ceramic art does indeed show no more than these four colours and sometimes only two. But on sculptures, buildings and interior walls they used many more, including vivid reds, greens and blues, though surviving examples of these are rare. A palette very similar to the Greek tetrachrome is used in many contemporary Australian aboriginal paintings (pp. 13–14).

Anglo-Saxon and mediaeval Britain In addition to earth colours such as red ochre, yellow ochre and green earth, which is a weak bluish green, surviving manuscripts on calfskin vellum from the eighth to the fourteenth centuries show the use of a wide range of colours, some of them very vivid. Naturally occurring minerals, some imported from lands as far away as modern Afghanistan, were ground into pigments: lapis lazuli gave ultramarine blue, malachite a blue-green and orpiment a yellow. Man-made colours included a white compound of lead and the vivid orange-red of vermilion, but the most important one was black made from soot, or lamp-black, which was used for writing-ink, as it still is by Islamic scribes today. Crimson, a dye obtained from insects, was also used and the most elaborate manuscripts were lavishly illuminated with burnished gold-leaf. With these resources Anglo-Saxon illuminators mixed a very wide range of hues and tints, often grouping them to maximize their vivid effects (p. 59). (See also Backhouse et al., 1984: Plates IV–XV.)

Primary, secondary and tertiary hues

Between 1910 and 1930 the Parisian painters and designers Robert and Sonia Delaunay explored combining vivid colours with simple shapes (see also p. 13). Many of their paintings reveal the effect of colour mixing and intriguing colour placement. Robert's *Windows* series uses rectangles and triangles with primary and secondary hues and only a few tertiaries, to create static, prismatic compositions which have a lot in common with early Cubism but are much more vivid and varied in colour (Düchting, 1994: 35, 36, 39). Later, he and Sonia used primaries, secondaries and tertiaries with circular and other flowing shapes to give even more dynamic effects in which the colour placement helps to produce a sense of movement. Examples (see Appendix 5) include Sonia's *Flamenco singer, Le Bal Bullier* and *Electric prisms*; and Robert's *Circular forms, sun no. 2* and *Rhythm: joy of life*.

Graded mixing, tints and shades

Many of the flower paintings of the American Georgia O'Keeffe (1887–1986) show subtle gradations of tints and shades. The *Iris* series (Benke, 2000: 34–7) and her *Oriental poppies* (see Appendix 5) in particular show how she maximized the effect of a very limited palette: tints or tints and shades of only one or two hues (p. 71; see also pp. 101–2 for a discussion of the use of space in these paintings).

Optical colour mixing

During the second half of the nineteenth century a group of French painters, often called the Post-Impressionists, began to experiment with a kind of optical colour mixing called pointillism or divisionism. The theory was that by placing points of different unmixed hues alongside one another, these would blend optically and produce colour mixtures more vivid and luminous than if they had been mixed on the palette.

The painter who explored this method most thoroughly was Seurat, and though the colours did not mix optically in the way he anticipated or in the way in which modern colour printing does (p. 48), he created soft colour-blends and gradations of great subtlety with beautifully-textured, luminous surfaces (see also p. 128). Most of his paintings have a calm, static quality with very little sense of movement. Examples to study include *A Sunday afternoon on the island of La Grande Jatte*, *Le Bec du Hoc, Grandcamp* and *Young woman powdering herself* (see Appendix 5). Seurat's great painting *Bathers at Asnières* (see also Appendix 5) contains some divisionist style but in the context of learning about the visual elements it is more remarkable for its tone and the placement of colours (pp. 37–8, 70).

Optical colour mixing in reverse: learning to see natural colours

Optical colour mixing is a natural and inevitable part of the way we view our everyday visual environment and is so commonly experienced that for most of the time we simply accept it. Bricks are reddish-brown, stones are brown or grey, leaves are green – or so we think, but in reality most natural or weathered things we see show rich varieties of colour. A great part of developing visual literacy and learning to see as artists do is to break the habit of seeing things unthinkingly and without curiosity. Children can be encouraged to explore visual colour mixing in reverse; to undo it, as it were. By looking at things closely they can observe the great diversity of colour which blends into what seem to be single hues when we see things from a distance, or merely look at them casually in passing (pp. 6–7).

Colour mixing in series

During the years 1921–3, Klee worked on colour mixing in progressive series as part of his teaching at the Bauhaus design school in Weimar, Germany. Most of these experiments were carried out in the form of beautiful small watercolours, painted in many overlapping layers of transparent colour, mostly based on just two colours in what Klee called false colour-pairs. These are pairs of colours which are far apart on the colour wheel but not quite complementary (pp. 53–4). Examples of Klee's pairings include blue-green with red-violet, blue-green with orange, green with crimson and violet with orange-yellow, so most of these paintings are dominated by subtle variations on tertiary colours. *Crystal gradation* and *Fugue in red* are outstanding examples (see Appendix 5). These works are also remarkable for the way in which Klee makes simple repeating shapes interact (p. 87).

Compositions using controlled mixing

Klee's technique of painting in layers of dilute colour, known as glazing, calls for the paper he used (quite lightweight) to be wetted and dried many times, which would cause sugar or cartridge paper to buckle and fall apart. Similar experiments with controlled mixing can, however, be carried out in poster-paint by drawing the shapes first (as Klee did), then mixing the two hues in varying proportions with differing amounts of white and black, working from the palest tints to the darkest shades.

6 Perceiving and Observing Colour

If children are to use colour effectively they need the ability not only to control and manipulate media as discussed in Chapter 5, but also to observe colour both in their artwork and the world around them. To observe colours, to see them with understanding, we need to learn something about the theory of colour. This, like the nature of colour itself, is a major research field with many unsolved problems (Zelanski and Fisher, 1989: Chapter 3), but children's awareness of and response to colour can be heightened through simple investigations leading to creative uses of the colours they find and make.

6.1 Colour constancy and colour interaction

When we perceive colours and objects around us we neither measure them nor record them objectively, as a camera does. Our perception of colour is relative, being strongly affected by the visual environment. The colours of the objects and materials we see are constantly interacting not only with other colours around them but also with the light falling on them, whether natural or artificial, bright or dim. As a result of these interactions, the way colours appear to us is constantly shifting and changing, though for much of the time we are unaware of this.

Colour constancy

Part of our experience seems to contradict the idea that our perception of the colours and light around us is constantly changing. We see the same objects at different times of the day, in natural and artificial light, yet usually have no difficulty in recognizing either them or their colours, unless the light is so dim that colours cannot be distinguished at all. The ability to see colours in this apparently stable way is called colour constancy, and though it helps us to recognize colours under changing conditions, it does so only in a broad way. For example, we might recognize a particular car in the street outside as being green both at midday and at dusk, but in dim light or in differently coloured surroundings we could be certain that another car was exactly the same kind of green only if we knew its colour already.

Colour constancy is important in everyday life, but in most artwork it is the subtle shifts and differences we see as colours interact which are likely to demand more attention and understanding. When we start to look at colours critically, for example when trying to find an exact match or a colour to harmonize with a paint, fabric or yarn, the unreliability of our colour perception easily becomes apparent: the colour which looked just right in the colour environment and lighting of the shop may look all wrong when we get it home. By a curious paradox, however, to find out how colours interact and why their appearance changes in subtle ways, we have to begin by investigating the strongest colour contrasts of all: those between colour opposites, or complementary colours.

After-images and colour reversal

To be effective, investigations into colour perception have to involve children (or adults) in first-hand experience. A good strategy is to start with ready-made examples, then ask the children to investigate images they find or make for themselves. If possible, carry out the following observations in bright daylight, with a sheet of white paper beside you or a white wall in front.

Observing colour after-images

Look at Colour figure 5a, concentrating your gaze on one place, for example where the red-violet, magenta and orange meet. Look at it for 30 seconds without moving your eyes, then look at the white paper or wall. You will see a coloured image, known as an after-image, but the colours will be different from those in the figure. After a few trials it should be possible to see that the after-images of magenta, red-violet, orange and cyan blue are green, yellow-green, blue and yellow-orange respectively. The formation of images of this kind is known as successive colour contrast. When it occurs, the after-image of each hue is constant and predictable: it is of the colour which contrasts most strongly with the hue and usually lies more or less opposite it on the colour-wheel (Colour figure 2). In Colour figure 5a it is also noticeable that the cyan blue circle and the yellow-orange around it are an opposite colour-pair of this kind, so that in the after-image their colours are reversed. Colours related in this way are said to be complementary (see below).

Predicting colour after-images

Before looking at Colour figure 5b in the same way, try to predict what colours you will see in the after-image. One of the colours is also in Colour figure 5a and two of the others are complementary. Notice also that the reversal in the after-image is seen in terms of value as well as hue: the black in the figure appears white in the after-image. Creating similar simple images with bold colour-blocks in vivid hues will enable children to conduct their own experiments with after-images and learn to predict complementary colours.

Irradiation of colour

Observing irradiation

In looking at colours to see after-images, children may also notice that if they look at sharp boundaries between colours for a minute or more, especially in very bright light, the edges of the colour areas start to shimmer and new, brighter or darker colours appear. This is known as the irradiation of colour and it happens because in normal vision our eyes are constantly scanning: they rarely stay still looking at the same spot for very long. Even if we try to look at the same place they move slightly, so that the after-image of one colour is superimposed on the edge of the one next to it. In Colour figure 5b, for example, irradiation will make the boundary between the blue-green and violet show bright green (blue-green + lemon yellow after-image) on one side and vivid red-violet (violet + orange-red after-image) on the other. Observing irradiation is important chiefly because many artists in the past had to find ways of suppressing it in order to make colours work in the way they intended (pp. 59–60).

Complementary colours

Successive colour contrast as seen in coloured after-images is significant in learning about colour, because it enables children to experience colour reversal and so see for

themselves in a very direct way what is meant by a complementary colour. The concept of complementary colour is a very important one in art, yet it is also confused, since there are at least three rather different ideas in use.

The simplest idea is a purely theoretical one: that complementaries are opposite each other on the colour-wheel. In a colour-wheel made with actual paints, however, as Colour figure 2 shows, this idea is only very approximately true and complementaries are unevenly distributed around the circle. As usual, the world is much more complex than the theory and does not obey its rules.

A second concept is based on colour mixing: two colours are complementary if they can cancel out each other's colours completely and produce a neutral grey when mixed in the right proportions. This principle is very important for some aspects of colour mixing, for example in industry, but it is less useful in art (although it is often quoted in art books) because it does not always match what we see. For example, the complementary of the violet in Colour figure 2, judged by its after-image, is a very slightly greenish yellow, but when it is mixed a very different hue, a rather bluish green, is needed to cancel out all its colour and produce grey. This shows that this particular violet reflects a lot of red, although we do not see this when looking at it (p. 40).

The idea of a complementary colour which works best in art is the one we can experience visually for ourselves. The complementary of a hue is the hue of its after-image, which to the viewer is the colour with which it contrasts most strongly. The complementary colours arrived at in this way are not entirely objective: they depend on the individual's colour vision and so are to some extent personal. This may not be appropriate for science but is entirely appropriate for art, since our sense of which colours contrast most strongly is part of our personal perception and use of colour.

Judging complementaries

Judging complementaries by looking at after-images is much easier if the colours are assessed in groups rather than singly. Set out the hues being used in a colour-wheel or a row of squares. Take white paper and cover most of them, look at three together (e.g. scarlet, magenta and red-violet), concentrating on the middle one. Look at their after-images and note down the results. Then move along one place and look at the next group of three (e.g. magenta, red-violet and violet). Working in this way over the whole colour range the complementaries can be plotted, and the results for Colour figure 2 are shown by the small colour-panels in the outer circle.

Having experienced colour reversal and so arrived at a practical and personal idea of complementary colour, children can then investigate some more colour interactions and the subtle changes they bring about.

Observing colour interaction: simultaneous colour contrast

How to use the colour figures

As when developing a concept of complementary colour, the subtle changes brought about by colour interaction can best be understood by experiencing them for oneself. Colour figure 6 consists of four examples, each of which shows a different aspect of the kind of interaction known as simultaneous colour contrast, and all of which are important in the effective use of colour. It is helpful when looking at any one figure to cover the remainder of the page with white paper to prevent the other figures intruding visually. Colour figures 6a, 6b and 6c should be looked at in bright daylight to compare the appearance of the smaller areas within each pair of colour-panels. The actual colour of these is in each case identical. The

apparent differences between them will be seen more clearly by looking at the point at which the small squares meet in examples (a) and (b), and at the black dot in examples (c) and (d).

In Colour figure 6a, a tint of violet is placed on tints of cyan blue and orange, all of about the same value. The violet appears more pink when next to the blue and more blue when next to the orange. This illustrates an important principle in colour interaction: in each case the background colour appears to shift the violet tint towards its own complementary. The orange causes us to see a shift towards blue, while at the same time the blue causes a shift towards red-orange.

Observing simultaneous contrasts

In Colour figure 6b, the small squares are a red-orange. The crimson and blue-green of the larger squares are almost complementary, so simultaneous contrast with each of them alters our perception of the orange. The blue-green tends to make the orange appear more vivid and red, whereas the crimson, itself a very high-chroma hue, makes it look both duller and more brown. This example shows two results of simultaneous contrast which are very important in colour placement. First, if two complementary or near-complementary hues are placed together, each will enhance the apparent vividness of the other. In Colour figure 6b, this is shown by the effect of the blue-green on the smaller red-orange square. Secondly, if two similar colours are placed together, simultaneous contrast exaggerates the apparent differences between them. The effect of putting crimson and red-orange together is that the crimson appears more vivid and the red-orange appears duller.

In Colour figure 6c, a green and a cyan blue panel each has a stripe of blue-green across it. Look at the dot in the centre and you will see that the stripes appear to be different, though they are in fact the same colour, made by mixing the cyan and green together. The apparent difference in the hue of the two stripes is another example of simultaneous contrast exaggerating the difference between similar colours placed next to each other. In this case the blue background makes the stripe appear more green, while the green makes it appear more blue.

Making colours look more different

Simultaneous contrast can also have the opposite effect and make colours look more alike. Look at the dot in the centre of Colour figure 6d, in which stripes of the three hues in example (c), one each of blue and green and two of blue-green, are placed on a slightly brown scarlet. The contrast with the red minimizes the differences between the hues, making them appear much more similar than they do in (c).

Making colours look more alike

These two effects make a point which is important in colour work of any kind. If strong contrasts of hue are avoided or limited to very small accents of colour, a limited colour range can be made to appear varied, and subtle differences of hue, chroma and value can seem much greater than they otherwise would appear. But if pairs of complementary hues are placed next to each other, colour variations may have to be quite bold to make much impact.

Contrasts of value between colour and background

Colours interact with their background even if it is not coloured, often resulting in alterations to their appearance through contrasts of value. Three examples are shown in Colour figure 7. Look at them from different distances, and you will see

Looking at contrasts

that the three coloured stripes vary not only in the degree to which they stand out or are conspicuous in relation to their background, but also in their apparent vividness and value. Seen from a distance of 2m or more, for example, both scarlet red and lemon yellow appear paler on black than on white, but whereas the scarlet seems more vivid on black, the lemon yellow appears washed out. Seen from close up, these differences may seem much less striking. But in Colour figure 12a the high-value hues and delicate tints do not look washed out even when seen from a distance, because tonal contrast between them and their background is low.

Colour figure 7c shows that when placed on a medium grey, the hues of all three stripes can be compared much more effectively than when they are placed on black or white, because contrasts of value are minimized. This effect is also shown by the grey centres of Colour figures 1 and 2 and the background of Colour figure 3. It is significant because it points to a way of minimizing colour interaction in order to assess what is generally known as the local colour of an object or material.

Local colour

Having experienced some shifts and inconstancies in the appearance of colours, children may ask what colour something 'really' is. What they are asking about is usually known as the local colour of an object or material; the colour it appears when our perception is not disturbed by other colours or light conditions.

Observing local colour

Assessing the local colour of a flat coloured surface is fairly easy: place a sample on a grey background of about the same value and look at it in bright daylight but not direct sunlight. If a range of colours of varying values needs to be compared, this can often be done more effectively by placing samples on a mid-value neutral grey than on white, as in Colour figures 3 and 7c.

The idea of local colour and this technique for assessing it can be useful when finding, matching and mixing colours, or if children wish to make accurately coloured studies of natural objects. Most people, for example, paint leaves in greens which are much more vivid than natural ones, but on the other hand many flower hues are of such high chromas that they cannot be matched in vividness by any painting or drawing medium.

6.2 Finding, matching and mixing colours

Children's investigations into colour perception have to concentrate on effects which they can observe for themselves, because there is no satisfactory theory or explanation of why we see colours in the ways we do. Perception and observation of colour, as of anything else, are skills which are learned and can be improved by practice. Children can do both simply and enjoyably, in ways which lead directly into creative work of their own. An effective strategy to develop children's perception and enjoyment of colours is to set up a two-way learning process, using colour in the environment as the basis for work in one direction, and the children's own skills in mixing and controlling colour for work in the other.

Finding objects to match colour samples

Matching colour in the environment

A good introduction is to ask children to find natural or man-made objects and materials in their environment which match as closely as possible colour samples they have chosen or been given. A very useful source for colour samples are the shade-cards for custom-mixed paints which can be obtained from displays in DIY and hardware stores. A full range of these includes hundreds of colours, grouped on cards in subtly varying series. These can be used both in school grounds, parks and gardens by selecting a few cards and finding materials to match, and in the home or classroom by selecting a material and finding a card to match it.

> SAFETY NOTE: Children looking for materials around them should be reminded that litter is potentially hazardous and should not be picked up. Permission must be sought from the owners to remove garden plants and samples of materials such as yarns and fabrics.

Colour matching and colour vision

Children are likely to find that while similarities between specimen colours and found materials are frequently seen, exact matches are remarkably difficult to come by. What this will demonstrate is the children's own ability to discriminate between colours. It is thought that most humans, even without special training, can distinguish several million different hues, tints and shades. Learning about colours by finding them in plants, buildings, machines and artefacts such as packaging and fabrics can productively be linked to the many stories and myths from all over the world which account in different ways for the origin of colour.

Mixing colours to match found materials

A second way to develop colour perception is to ask children to mix colours to match, as exactly as possible, coloured materials given to or chosen by them. A useful strategy is to ask children to find or select three favourite colours which they think go together especially well, and make these in any medium of their choice. The exactness of the final colour-match is, of course, far less important than the close observation and exercise of skill which go into trying to achieve it.

Using matched colours

If enough of each colour is mixed, they can be used to prepare sheets of coloured paper. These can then be cut or torn, assembled and glued into combinations of shapes or a simple pattern, so that the three colours are shown in what the children feel is a pleasing way, as in Colour figures 10a and 10b (see also Appendix 3). It is also helpful to glue a small sample of each on to grey paper to see its local colour for comparison. The finished work can then be used to observe colour interactions, basic colour groupings and to discuss how colour communicates sensation and mood (see pp. 61–4).

Classifying colours

This activity is usually less complicated in practice than it may appear, because most children choose colours which are easier to identify and mix (primaries, secondaries and tints) more often than those which are more difficult (tertiaries and shades). Because of this, the activity generates excellent opportunities for children to use their knowledge of colour and develop their colour vocabulary, in order to classify the colours they choose and so arrive at possible ways of mixing them.

6.3 Perceiving colour in context

Children's activities and investigations can show them clearly how their perceptions of colours are altered by different kinds of colour interaction. Artists have been solving problems and exploiting opportunities offered by colour interaction for thousands of years, and having carried out some investigations for themselves, children are usually surprised and very interested to identify in other peoples' artwork examples of effects they themselves have observed. Observations of this kind not only give them a deeper understanding of colour and its uses, but also emphasize the important historical point that artists of the past, however different their culture and artistic expression, were very like ourselves in fundamental ways like colour perception.

Simultaneous contrast and complementary colours

The way in which complementary pairs of colours placed together enhance each other's vividness has been known for a long time. Ancient Egyptian painters made their red ochre appear less brown and more red by placing it next to their rather weak blues and greens (p. 49), which themselves appeared more vivid and less greyish by simultaneous contrast. Similar contrasts are seen in the rare survivals of ancient Greek wall-paintings, but more surprising is the extensive use made of very similar colour combinations in many of the late landscapes of Paul Cézanne (1839–1906).

Cézanne used very vivid greens, blues and reds in many of his still-lifes and portraits. In most of his paintings of rocks, trees, mountains and sky, however, he used a basic palette very like that of the ancient Egyptians: yellow and red ochre, blue, green and black, though he mixed them much more into subtle shades, tints and mixtures. Though these are mostly quite subdued in themselves (Local colour, p. 56), they interact to bring each other and the paintings to life in a way which more vivid hues would not have achieved. Among many examples are *The forked pine tree in the park of Château-Noir and Le Château de Médan* (see Appendix 5).

Simultaneous contrast using vivid, high-chroma hues has also been exploited by many European artists throughout the last millennium. Two outstanding examples, which are highly contrasted in almost every other way, are the illumination of Anglo-Saxon and mediaeval manuscipts, and the late works of Henri Matisse (1869–1954). The Anglo-Saxon and mediaeval illuminators enhanced the vividness of their mineral pigments (p. 50) by placing them in complementary pairs, such as blue-green malachite against orange-scarlet vermilion and, most sumptuous of all, violet-blue ultramarine against burnished gold leaf. An example of this second pairing can be seen in the anonymous fourteenth-century *Wilton Diptych* (see Appendix 5). Most illuminators also made use of fine dark or black outlines to separate pigments which might have reacted chemically and become discoloured if they had been in contact (see also pp. 59–60).

In extreme contrast to the small scale and delicate art of the monastic iluminators are Matisse's late cut-out paintings, which use a medium which will suggest many ideas to children in work of their own (Néret, 1994). Matisse, who could no longer paint at his easel, had sheets of paper specially painted with his chosen colours, mostly very vivid, using gouache which is rather like poster-paint. He then cut shapes from these, arranged them and had them assembled to his precise instructions by his assistants. Most of the completed collages, many of which are very large, use simultaneous contrast in a variety of ways to enhance the effects of the colours still further. Good examples to study are *Flowering ivy* and *Zulma* (see Appendix 5).

Colour and shadow

It has long been realized that in some conditions shadows appear not merely darker but also coloured. This can arise in a variety of ways but is always caused by simultaneous contrast. The most commonly seen effect is when shadows are cast in sunlight on snow or white buildings. Winter sunlight in temperate countries is yellow-orange even at midday, and when it falls on snow the shadows are strongly tinged with blue, its complementary hue. In the 1890s Claude Monet (1840–1926) worked on several series of paintings which show changes in the colours of shadows in the varying colours of sunlight throughout the day. The most well-known series is *Rouen Cathedral* (see Appendix 5). There are many other colour-shadow effects, and the most easily seen is the blue or violet tinge of shadows cast on a yellow surface, which was used by van Gogh in his *Still-life with onions* (see Appendix 5).

Successive colour contrast

Athough many painters have been intensely aware of coloured after-images and have been influenced by them, few have used them deliberately as the main focus of a painting. One who has is Jasper Johns (1930–) whose 1965 painting *Flags* relies entirely on creating an after-image in complementary colours, and is an example whose effect children can observe even in reproduction (Zelanski and Fisher, 1989: 96).

Irradiation

Irradiation sometimes blurs sharp edges where vividly contrasting colours meet, making both the edges and the colours themselves less distinct; a kind of partial optical mixing (pp. 48, 53). Many artists have been acutely aware of irradiation, but most have been concerned to reduce or prevent it rather than to exploit it. Irradiation can be prevented and the colours intensified if areas of vivid colour are separated by a line or area of black or white. This can be seen in many Anglo-Saxon and mediaeval manuscripts in which areas of vivid colours are separated by fine black or dark outlines. From the mediaeval period onwards, the most widely seen and successful examples of the same black-line technique are in stained-glass windows. Because the composition is made up of areas of coloured light, the problem of irradiation is much more acute than it is in a painting. The lead bars used to hold the pieces of glass appear as quite thick black lines in the composition, separating the areas of brilliant colour and preventing their edges becoming blurred through irradiation.

Georges Rouault (1871–1958) used the same effect in his work. As a youth he was apprenticed to a restorer of stained-glass windows, and this experience can be seen in his *Three judges* (Appendix 5), though he mostly used more muted colours, as in *Duo: two brothers* (see Appendix 5). Many other twentieth-century painters used black outlines to separate areas of colour in a variety of ways, for example Patrick Caulfield (1936–) whose flat colours and hard-edged lines are in strong contrast to Rouault's painterly textures and visible brush-strokes; see for example his *Pottery* (Appendix 5). Even where colours are too similar to irradiate, separating them with black lines will enhance their vividness, and a thin pencil line may be sufficient to emphasize high-value hues and tints on a white background (Colour figures 9b, 12a).

Irradiation can also be prevented by leaving white areas of unpainted paper or canvas between brush-strokes or areas of vivid colour. This technique was used early in the twentieth century by a group of painters nicknamed 'Les Fauves' (the wild beasts, see also p. 38) because of the way they painted using visible brush-strokes of vivid,

often unmixed colour which was then considered savage and uncivilized. Clear examples of the effect can be seen in works painted in the summer of 1905 by Matisse, for example his *View of Collioure* and *Open window, Collioure* (see Appendix 5). Though these paintings are sometimes referred to as pointillist, Matisse's technique is in a sense the reverse of Seurat's divisionism (pp. 50–1). By keeping the strokes of unmixed colour separated by white, unpainted canvas, he was preventing the kind of optical colour-mixing which Seurat was attempting to create. Working in this way allowed each stroke of colour to keep its own identity, so that complementaries such as scarlet and blue-green could be placed alongside each other and appear even more vivid through simultaneous contrast, while not blending at all. This resulted in paintings of great vividness and visual excitement. Matisse's friend André Derain (1880–1954) also used this technique, but carried it one stage further. In some of his paintings he combined areas of distinct brush-strokes separated by white, with solid colour areas separated by black lines, as for example in his *Mountains, Collioure* (see Appendix 5).

7 Responding to Colour

Human responses to colour are numerous and very complex, and though only a minority of them are directly relevant to art education, as teachers we need to have a wider awareness of their cultural and psychological significance. As in most areas of the curriculum, children think and communicate most readily about colour as they experience it: the red of this paint, the green of that leaf, the blue of the sky. They may, as many adults do, find it difficult or impossible to remember colours accurately or to think about colour in the abstract, dissociated from particular objects, yet like everyone else they respond to colours intuitively and often very strongly. In trying to become aware of children's responses to colour as these affect their work in art, it is helpful to begin by investigating the effects of individual colours and then move on to consider groups of colours (pp. 64–7).

7.1 Responses to individual colours

In thinking about how children are likely to use and respond to colours in art, it is necessary to distinguish between three different kinds of response: psychological, cultural and individual or subjective. Psychological responses are the most fundamental, experienced by everyone regardless of their race or cultural background. The psychological response most likely to be important in children's art is the sense of colour energy and the associated distinction between warm and cool colours. In contrast are the many responses to colour which are learned as part of the individual's cultural or social heritage. Of these, colour symbolism is likely to be the most significant. The third kind of response is individual and subjective, and includes personal colour preferences as well as some different kinds of colour association.

Colour energy: warm and cool colours

Observing colour energy

Most if not all people respond to colours as if they have different levels of energy. Vivid, high-chroma reds and oranges are stimulating and felt to be highly energetic, warm or hot; whereas blues and greens are calming and experienced as less energetic and cool or cold (Colour figures 9a, 9b; see also Appendix 3). These effects can be sensed even when looking at small colour samples, for example by comparing Colour figures 8b and 8d, but are much more marked in big areas or an entire room of colour. The sense that a colour is energetic can also be enhanced by contrast of hue. In Colour figure 8f, for example, the scarlet red in contrast with a cool blue-green, its complementary, looks even more energetic than it does next to orange and yellow in Colour figure 8b.

Comparing warmer and cooler colours

Beyond the basic warm-cool response there is likely to be quite a wide variation in children's feelings for warmer or cooler colours. Talking about this can help them not only to observe colours more closely, but also develop their colour language and ability to communicate. Some people experience violet and yellow as being neither

warm nor cool; others feel that yellows are warmer than violets. Within hues also, individuals may feel significant differences of colour energy and visual temperature. Comparing the six primaries in Colour figure 2, for example, the blues are the coolest pair and the reds the hottest, with the yellows in between, but within each pair most people regard lemon yellow as being cooler than orange yellow, cyan as cooler than ultramarine and scarlet as hotter than magenta.

Hottest and coldest colours

Vivid, high-chroma reds or red-oranges are usually regarded as the hottest colours of all, but if they are mixed with black or white to make shades or tints, any of the mixtures seems less warm than the full hue, particularly if both are seen together (compare Colour figures 8b and 8c). This cooling effect also occurs when blues and greens are mixed with white, intensifying their coldness, so that the colours which seem coldest of all to most people are pale tints of blue, blue-grey and blue-green (compare Colour figures 8d and 8e). Again these effects can be accentuated by contrasts of hue, as in Colour figure 8l whose small, hot areas of scarlet make the tints of blue and green appear both cooler and paler than they would do alone.

More subtle warm-cool variations

In a similar but less marked way, mixing tertiary colours can produce warmer and cooler variants. When mixing scarlet and green, for example, a brown dominated by scarlet will appear warmer than one dominated by green, and the difference will be exaggerated if the two are seen side by side, an example of simultaneous colour contrast (pp. 54–5). This last observation is another example of the point that the warmth or coolness of a colour can be greatly modified by interaction with the colours around it.

Colour symbolism

In most cultures at least some colours have symbolic meaning. Even if we disregard history, the symbolic role of colour in modern cultures is extraordinarily wide and varied. They represent human qualities, events and phases of life; they express loyalties and allegiances to anything from a nation-state to a football team and even, in particular contexts, act so as to give orders and control behaviour. In European and North American countries, for example, traffic-lights issue orders in a sequence of symbolic colour-codes with which children are likely to be familiar.

These colour associations are entirely arbitrary and culturally determined, so that a colour-message in one culture may mean something quite different, or nothing at all, in another. In the United Kingdom, for example, brides often wear white, whereas in China white is the colour of mourning. To Muslims green has a special religious significance, whereas in Western culture it signifies a concern for environmental issues and conservation. In mediaeval painting in the tradition of the Roman Catholic Church, violet blue (ultramarine) was very widely associated with the Blessed Virgin, the mother of Christ; a symbolism which it has now largely lost.

In our multicultural society it will be productive to ask children to find out and compare the meanings of colours in their different ethnic and religious communities. This again offers opportunities to stimulate the development of language and communication in relation to art and colour.

Individual responses to colour

Many tests have shown that, in a very broad way, peoples in most parts of the world have similar colour preferences. Blue is the most preferred and popular hue, followed in order by red, green, purple, yellow and orange. Overlaying this basic order of colour preference, however, are the responses of individuals, which of course vary widely and may also be very powerful. Children are likely to have strong preferences for some colours and aversions to others, but sometimes will not admit to them, since outside factors may be influential in determining both colour preferences and the way that they are expressed or suppressed. Current fashions in clothes and accessories, gender-stereotyping and peer-group pressure may all play a significant part. Boys in particular may be reluctant to admit to any strong preferences for colours other than those of favourite football teams, because colour awareness may be regarded by their peer-group as feminine.

Investigating responses to colour

If such inhibitions are encountered, exercises in mixing, controlling and matching colours can be helpful in breaking them down, especially if these are introduced as investigations (pp. 42–5, 46–7, 56–7; Colour figures 9, 10). They can then lead on, once the children's interest has been engaged, to more open-ended and creative work. Patterns which divide up space provide excellent opportunities to compare different colour groupings, personal responses and preferences (pp. 142–6; Colour figure 9b). At all stages it is worth emphasizing that in selecting and using colours there are no right and wrong answers and it is one's own personal preference which should be the guide; a point which is taken up again on pp. 67–8.

Most people's responses to colour are much more complex than simple liking or disliking. Individuals may respond in markedly different ways to the same colour or variations of it, depending on their own mood and how the colour is used. Blue, in particular, can evoke a wide range of responses. Pale tints of blue may suggest space and freedom, perhaps because they resemble both the sky and the blue of distant landscapes, but they can also be very cold (Colour figure 11a). Deeper blues may be calming, but this can be the negative, apathetic calm of depression and despair ('the blues'); dark shades of blue or blue-violet can be threatening and oppressive.

Colour in art does not exist in isolation and at least part of our response to it is likely to depend on the form in which it is presented. This can be seen in the interaction between colour and shape (p. 80; Figure 8.8). For example, jagged shapes or zig-zags make hot reds and oranges appear even more energetic, whereas tints of blue and green will be more restful, but avoid monotony, if they flow gently in smooth, overlapping curves. In Colour figures 11a and 11b the shapes and colours reinforce each other in both examples, which helps to communicate positive moods (p. 68). But part of the interest of Colour figures 9a and 9b comes from the way in which shape energy and colour energy work against each other: high-energy shapes and low-energy colour 9a and the reverse in 9b.

When assessing children's responses to colour the individuals who show an ability called synaesthesia are especially interesting. This means that when they are stimulated in one sense-mode, they have a sensation in another mode. An example would be that particular musical instruments would have not merely characteristic sounds but also colours or tastes. Experience suggests that synaesthetic responses are much commoner than is usually realized. To many children and adults music evokes sensations of colour; for others the days of the week or numbers each have their own

colour. Talking to children who have particularly strong responses to colour and use it imaginatively is quite likely to reveal that they are synaesthetic. Encouraging them to look at work by artists such as Wassily Kandinsky (1866–1944), who are known to have been synaesthetes, may help them to focus on and express their own colour sensations more fully and creatively (see Becks-Malorny, 1999).

7.2 Colour groupings and responses to them

For many centuries and in many cultures the grouping of colours has been governed by theories, rules and ideas of what is or is not harmonious or appropriate for different uses and situations. Although these rules and theories are useful to historians of art and culture, for children and their teachers there is today only one rule: that there are no combinations of colours which of themselves are bad or good. The most one can say is that different colours in differing proportions produce a variety of responses in different people. The only 'bad' colour combination is one which does not contribute to the effect the artist sought to create, and so does not fulfil her or his intentions. In grouping colours there are no hard-and-fast rules or guaranteed results. What can usefully be done is to discuss some basic ways of combining colours and indicate what effects these commonly have on viewers, bearing in mind that someone else's colour groupings can never be more than starting-points for children's own explorations and creative work.

Colour groups illustrated

A range of colour groupings is shown in Colour figure 8. The colours used, all of which can also be found in Colour figure 4, are listed here for reference.

a (monochromatic): hue, one shade and three tints of violet

b (analogous, warm): hues of scarlet, orange and orange-yellow

c (analogous, warm): one shade and two tints of scarlet; two tints of magenta

d (analogous, cool): hues of cyan, blue-green and green

e (analogous, cool): hue and two tints of cyan; two tints of green

f (complementary): hues of blue-green and scarlet

g (complementary): hue, one shade and one tint of cyan; hues of orange and red-orange

h (complementary): hue, one shade and one tint of orange; hue and one tint of cyan

i (complementary): one shade and two tints of green; two tints of magenta

j (split complementary): hues of violet, magenta and yellow-green

k (split complementary): two tints each of violet and magenta; hue of yellow-green

l (colour accent): two tints each of cyan and green; hue of scarlet

Monochromatic colour groups

A monochromatic colour scheme is limited to one hue, together with its tints and shades, as shown in Colour figure 8a. Black and white may be added for increased variety and tonal contrast. Monochromatic schemes work best with darker, lower-value hues such as blues, violets and greens. As Colour figure 4 shows, these yield many attractive tints which contrast well both with the hues and the few shades that can be mixed from them, whereas high-value hues, especially yellows, are usually less effective because few tints can be mixed from them and their shades tend to be muddy. In contrast, tints and shades of rather dark, earthy secondary and tertiary colours such as red-browns and dull purples can be very successful.

Using monochromatic colour

Because they vary only in value, monochromatic colour groups can appear boring and monotonous, so they need to be used imaginatively if they are to be brought to life. One way to do this is to use the hue, with graded tints and shades, to make progressions and patterns of shape and colour, for example by simple, repeated and overlapping block-printing. It may be worth remembering that the sky and sea, or the leafy canopy of a tree, are often more or less monochromatic, yet they are rarely dull or boring to look at. Children can learn a lot by printing a simple motif such as a leaf shape in its natural green with tints and shades, then making a second print similar in design but based on a strongly contrasting, unnatural hue such as cyan blue or magenta. Another line of development is to make a monochromatic composition and then add small areas or accents of vivid, contrasting colour to it, to see how they interact. The effect of colour accents is shown by Colour figure 8l, though there the background is not monochromatic.

Analogous colour groups

Any hues which adjoin or are near each other on the colour-wheel (Colour figure 2) can be combined, together with their tints and shades, to form an analogous colour group. Colour figures 8b, 8d and 9a, 9b show analogous groups of warm and cool hues. Analogous colour groups include at least some contrast of hue as well as value, so they can be more varied than monochromatic ones, and the range of variation can be greatly extended by using tints and shades as well as hues (compare Colour figures 8c and 8e with 8b and 8d).

Using analogous colour groups

Analogous colour groups never include strong contrasts of hue or conflicting colours, so most people see them as harmonious, but they can produce a wide variety of responses. A good way to begin working with analogous colour groups is to use them descriptively in compositions of shapes, both natural and man-made. For example, greens are restful (vegetation), pale blues are liberating (sky) but very cool (ice and shadows on snow), and blues and greens combined may suggest water or the ocean (Colour figure 9a). At the other end of the scale, scarlet, crimson and orange-reds are the hottest (fire; Colour figure 9b), and yellows, red-browns and oranges give a hot, dry impression (desert). Perceived in this descriptive way and so related to their own experience, children may find analogous colour groups the easiest to use. They certainly minimize risk: having settled on a range of colours, choice and colour mixing are easy and results are usually harmonious. But analogous schemes may become a refuge for the insecure and unadventurous, who may need coaxing to use bolder, more varied and more strongly contrasting colours.

Complementary colour groups

Using complementary colours

Simple complementary colour groups are, as their name suggests, based on only two hues, which are complementary (pp. 53–4) and therefore as highly contrasted as possible. Complementary hues enhance each other's vividness by simultaneous contrast (pp. 54–7), so schemes based on them are usually highly energetic, often conveying a feeling of excitement and restlessness (Colour figures 8f, 12b). Experimenting with complementary colours can begin with developing compositions of intersecting lines (Figure 3.7f–h, Figure 3.8a–d), shapes (Figure 8.8b, c, e) or patterns (Figure 12.3e, f, Figure 12.5h, Figure 12.12d–f).

Complementaries, like analogous groups, can be diversified by introducing some tints and shades. These usually make the colour contrasts seem less extreme, though the overall effect still tends to be energetic (Colour figures 8g, 8h). Taking this a stage further, complementary schemes can be based entirely on tints and shades with no full-chroma hues at all. A common example is a plant with pink flowers, whose colour grouping is similar to that in Colour figure 8i; leaf-greens slightly paler or darker than the full hue, with tints of magenta. The contrast between Colour figures 8i and 8f, both of which are based on complementary pairs of green and red, emphasizes the point that though complementary groups are based on two hues only, they can be developed in a great variety of ways by the imaginative use of mixtures.

More complex colour groups

Colour theorists have identified a range of more complex kinds of colour grouping. Most of these are more relevant to product design than to the teaching and learning of art, but one has proved very useful as a starting-point for helping children to choose effective sets of colours, for example when making decorative patterns (pp. 135–46). This is a colour grouping based on a set of three hues known as a split complementary.

Finding a split complementary group

Starting with any hue, for example yellow-green, find its complementary, which is red-violet (Colour figure 2). To complete the three-hue set, choose colours one or two places on either side of this complementary on the colour-wheel, which in our example would be magenta and violet. When put together, as in Colour figure 8j, the three hues form a split complementary group. The formula is not rigid: one could use blue-violet and crimson instead of violet and magenta, but the results are usually very lively and can be startling. Try red-violet with lemon yellow and green, for example. The aim is to achieve a colour grouping which fulfils the maker's intentions and achieves the effect she or he is seeking. Split complementaries can be varied and made more gentle by using tints and shades as well as hues, just as analogous and complementary colour groups can (compare Colour figures 8j and 8k, for example), but because each group is based on three hues the range of possible adaptations is very wide.

Colour accent

Observing colour accent

Colour accent is a device related to split complementary grouping. It has been used by many artists and is fashionable with interior designers, but can also be used effectively by children. Analogous colour groups, though harmonious and often restful, may be bland. They can be livened up and their positive qualities emphasized by introducing very small areas of intense, highly contrasting colour. Colour figure 8k is a split complementary, but if the yellow-green areas were reduced to a quarter of their size, they would become cool colour accents in a fairly warm analogous colour set. Colour figure 8l shows the reverse: small areas of scarlet act as energetic colour accents, not only adding visual interest but also emphasizing the coolness of the blue and green tints around them, an effect which can be compared with that in Colour figure 8e.

Colour balance

Colour balance is a concept which is sometimes formulated in a complex set of rules, but which in its basic form is simple and useful. Usually when colour is used, the artist wants each colour to maintain its character and identity so that it can contribute fully to the work as a whole. Because they interact in a variety of ways which change their appearance (pp. 52–6), colours maintain their identity when placed alongside each other only if there is a balance between them. To achieve this we need to consider both the vividness of each colour and how light or dark it is (chroma and value, pp. 40–1). In general, paler and more vivid colours need to occupy smaller areas in relation to darker and duller colours around them if colour balance is to be maintained.

Observing colour balance

An example of balancing by value can be seen in Colour figures 8g and 8h, which use almost the same complementary colours. In example (g), the oranges are paler than most of the blues, but neither dominates. The colours are in balance and each maintains its identity, even though the area of orange is less than a quarter that of the blue. In example (h) these areas are reversed and the colours are not in balance. This can be seen by looking at the figure from a distance and concentrating on the two squares of darker blue. They are dominated by the paler oranges, appearing duller and darker than they really are, whereas the paler blue square still looks vivid and keeps its blueness. A similar effect can be seen by looking at Colour figure 10b from a distance. The smaller dark green and blue areas which are adjacent start to lose their identities and the whole composition begins to divide itself into darker and lighter areas.

Colour figures 8f and 8l show colour balances in which chroma plays a larger part. In example 8f, three small squares of vivid, high-chroma scarlet are in balance with over four times their area of duller, darker blue-green. If there were the same amount of red in example 8l, the pale tints of blue and green would be dominated by it and appear washed out and insignificant. The very small accents of scarlet liven up the cool tints and, though darker, are vivid enough to maintain their visual identity so that colour balance is maintained. Colour figure 12b offers more examples of colours which can be seen clearly from close to, but which start to lose their identities as the viewer moves away. This, however, does not detract from the sense of energy and movement conveyed by the painting as a whole (see also Appendix 3).

Experiments in communicating with colour

The strength of response which most people have to colours, both singly and in groups, makes colour a good means of communication. Colour responses are widely exploited in the design of advertisements and packaging, but can also form the basis for experiments by children, enabling them to investigate the effects of colours and colour groups not only on themselves, but on others as well.

A useful approach to communicating with colour is to start with straightforward colour associations, for example by asking children which colours they think belong to or suggest different seasons of the year. These colours can be combined with simple shapes such as leaves, flowers and snowflakes to make small compositions (not pictures) in any medium, which communicate the idea of the season to the viewer.

Moods and feelings in colour

The next stage is similar, but concentrates on moods and feelings. Children usually respond readily to the idea that moods have different colours, but using these to communicate can be more difficult, because in order to make a message the colours have to be given shapes, textures and patterns. As in Colour figures 11a and 11b, the children may decide quite spontaneously how they can achieve this, but if they do not it can be helpful to ask some simple questions about the mood they have decided to communicate (see also Appendix 3). Is the mood energetic and active, or quiet and passive? Is it a 'good', positive mood or a 'bad', negative one? For example, feeling joyful is usually energetic and positive, but even if the energy is bottled up, feeling angry is energetic and negative. Feeling at peace is quiet and positive, but being unhappy and depressed is quiet and negative. This simple analysis gives clues to the shapes which could be used to make the chosen colours communicate effectively. For example, diagonals, zig-zags and rapid strokes with a brush or crayon suggest energetic movement and activity; upright branching shapes are associated with growth, but vertical and horizontal shapes (standing and lying) suggest a lack of movement and passivity (see also p. 80 and Figure 8.8).

When the experiments have been completed, as in Colour figures 11a and 11b, children usually find it stimulating to look at the work of others in the class and to guess what moods they are trying to convey. Here again, questions about whether the mood is positive or negative and active or passive are useful, in order to establish the broad kind of mood being communicated before more specific guesses are made. It may also be useful to consider how shape and colour interact to reinforce the mood communicated.

These and other experiments with communication through colour can also help to develop children's ideas about success in art. In particular it is worth emphasizing, as the children exchange arguments and observations, that there are no right or wrong answers in art, as there are in science or mathematics. For example, few people might immediately associate the energetic colours and shapes of Colour figure 12b with being sleepy, but to the artist this was a successful way to communicate his experience of dreaming in colour (see Appendix 3). Therefore the first question to ask is, whether the artist succeeded in doing what she or he set out to do. If so, the work is successful, at least in part. If not, what could have been done differently to make it better?

7.3 Colour responses in context

The more children know of colour and their responses to it, the more likely they are to use it effectively to express and communicate their ideas in art, craft and design. A knowledge of different colour properties and combinations is likely to be an important part of this process. Colour is all around us in clothing, packaging, landscapes, buildings and interiors, as well as on the walls of art galleries. While one would not wish anyone's observation and enjoyment of colour to be bound by rules and formulae, recognition of the many ways in which colours appear and are combined, both in art and the wider environment, is for most people an essential step in developing their visual understanding.

Colour figure 1

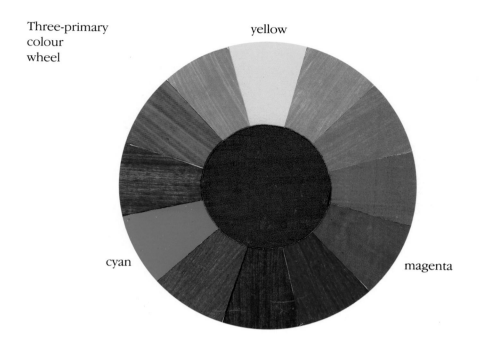

Three-primary
colour
wheel

yellow

cyan

magenta

Colour figure 2

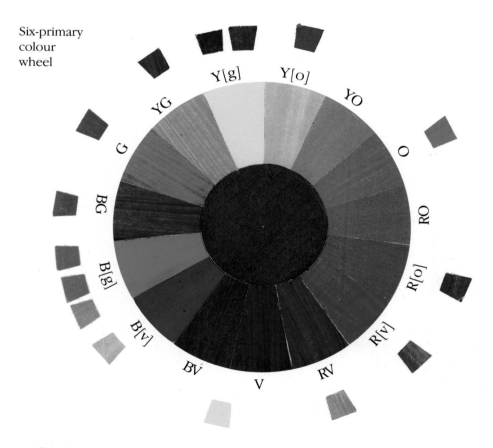

Six-primary
colour
wheel

Y[g] Y[o]

YG YO

G O

BG RO

B[g] R[o]

B[v] R[v]

BV RV

V

The small colour panels show the complementary position of each hue.

Colour figure 3: Pairing-up primary hues

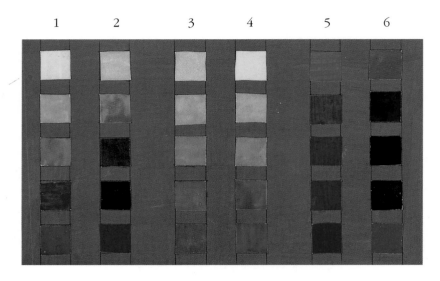

1 2 3 4 5 6

Colour figure 4: Tints, shades and values

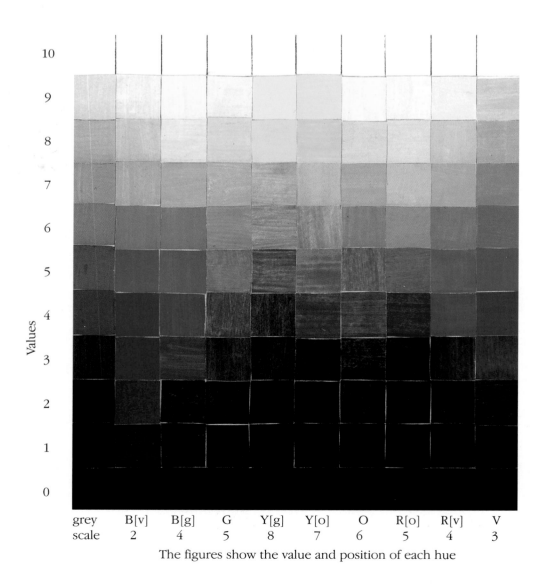

| | grey scale | B[v] 2 | B[g] 4 | G 5 | Y[g] 8 | Y[o] 7 | O 6 | R[o] 5 | R[v] 4 | V 3 |

The figures show the value and position of each hue

Colour figure 5: Successive colour contrast and irradiation

a

b

Colour figure 6: Simultaneous colour contrasts

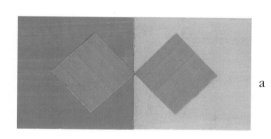

a

c

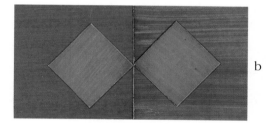

b

d

Colour figure 7: Contrasts of value between colour and background

a

b

c

Colour figure 8: Colour groupings

a monochromatic

b analogous, warm

c analogous, warm

d analogous, cool

e analogous, cool

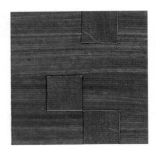

f complementary

g complementary

h complementary

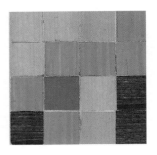

i complementary

j split complementary

k split complementary

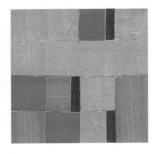

l colour accent

Colour figure 9a: *Mixing cool colours* **by Max, age 6**

Colour figure 9b: *Hot colour pattern*, **by Isabella, age 6**

Colour figure 10a: *Seaside collage* **by Mollie, age 7**

Colour figure 10b: *At the seaside I saw …* **by Hannah, age 7**

Colour figure 11a: *Peaceful* by James, age 9

Colour figure 11b: *Angry* by Zoë, age 9

Colour figure 12a: *Ffrwythau (Fruits)* **by Bethan, age 8**

Colour figure 12b: *Sleepy* **by Robin, age 9**

Colour energy and clothing

Children will already be familiar with many ideas and conventions on colour energy and communication through observing their own clothes and those of others. Here awareness can be improved by thinking about the clothes worn in different social situations, which reflect not only social usage but also the wearer's own sense of identity and the self-image which she or he wishes to project.

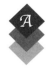

The meaning of colour in clothing

In the classroom the subject of colour and clothing may be approached in a variety of ways. Children could discuss the clothes they wear in different situations, but when even the young are fashion-conscious there is always a risk that this may cause embarrassment or distress to some. A lower-key and more impersonal approach is to use magazines as a source of photographs of adults and children in many different outfits, to look at the people, discuss what they are doing if this is not obvious and relate their activities to the colours they are wearing. For example, think about a man in a dark-grey suit, white shirt, blue tie and black shoes working in an office, and another in a brightly-coloured shirt, shorts and sandals on a beach. What is each man saying to people around him by wearing those clothes and colours? Would wearing bright colours in an office, or a grey suit on a beach, be considered out of place, and why?

Colour energy in two portraits

A successful portrait communicates something about the person portrayed which she or he, or the artist, wishes us to know. The way in which warm and cool colours can influence what a painting tells us is seen clearly by comparing what we are told by two portraits, both over 500 years old, in the National Gallery, London. The first was painted in 1433 by van Eyck, and though usually known as *Man in a turban*, is thought to be a self-portrait. Everything about the face is sharp and alert. The sitter looks, with his eyes turned slightly inwards, directly at the viewer, giving the impression of a highly intelligent man with a decisive character. This is reinforced by his crimson head-dress, the only strong colour in the painting. Together with the way the fabric is folded and knotted, the red gives an impression not only of energy but also of movement and restlessness. This indeed agrees with what is known of van Eyck, since he not only perfected the technique of oil-painting but was a secret diplomat as well as a painter.

The other portrait is of *The Doge Leonardo Loredan* by Bellini (see Appendix 5), and was probably painted in 1501. The sitter, portrayed as a wise old man, was the head of the government of Venice. The face is calm and very dignified, alert but with the eyes turned slightly outwards so that the sitter looks into the distance, not at the viewer. Everything about the portrait suggests stillness and calm, an impression strongly reinforced by the cool blue background, which is itself balanced by the warmer colours of the face and the orange-brown of the cap-band and foreground. This is a man who is powerful even when he is quiet and still. Reversing the warm and cool colours in either of the portraits would go against the characters the artists sought to portray and greatly weaken their effect.

Warm and cool colours

When warm and cool colours are placed alongside each other, they not only enhance each others' vividness by simultaneous contrast but also emphasize the difference of colour temperature between them (pp. 61–2; Colour figures 8f, 8g). Most of the

examples discussed on pp. 54–5 are also useful when looking at warm and cool colour effects.

A particularly clear and attractive example of warm-cool contrast can be seen in *Bathers at Asnières* by Seurat (see Appendix 5). By far the greater part of the painting is in cool blues and greens. These are accentuated by much smaller areas of hot colours, particularly the red hat of the boy in the water, which makes the viewer feel the coolness he is enjoying. To a lesser degree the coolness of the grass is accentuated by the warm browns of the dog. Colour balance is also important in creating these effects. The areas of red are small, but are so vivid that they are in balance with the greens and tints of blue (compare Colour figure 8l). This painting is also remarkable for its use of tone to create an illusion of depth (pp. 37–8).

Warm-cool contrast is the central colour theme of a famous painting by Turner, *The fighting Téméraire tugged to her last berth* (see Appendix 5). Here the main colour contrast is between the warm reds, oranges and yellows of sunlit cloud and smoke, and the cool blues of sky and mist. The warm colours in the right-hand half of the painting are not very vivid, but they are balanced and made to look warmer by the strong blue just above and below the horizon. Because the blue is not dark and is more vivid than the oranges the two are in balance, even though the blue is smaller in area. The same effect can be seen in Colour figure 8h, where the paler blue square looks much more vivid against the oranges than the darker ones. This balance in the colours of sea and sky is set against the stark light-dark tonal contrast between the old ship and the tug, which is discussed on p. 37. Nature is in harmony, Turner is telling us: it is man who is brutal.

Monochromatic colour groups and responses to blue

Although many forms of drawing and print-making are based on tone and so have no colour, few artworks are truly monochromatic, based on only one hue. Some of Klee's graded watercolours appear monochromatic, though they were made by overlapping layers of two colours (see p. 51). Examples to give children ideas for monochromatic works of their own include *Fugue in red* and *Hanging fruit* (see Appendix 5).

Among the best-known truly monochromatic works are some of the paper cut-outs by Matisse, in a particular cobalt blue which he loved, including *Blue nude III* and *Woman with amphora* (see Appendix 5). Matisse was attempting to communicate the solidity of the human form simply by cutting and assembling shapes of coloured paper. This technique is discussed further on p. 88 and other cut-outs are discussed on pp. 58–9.

Another of Matisse's much larger cut-outs also helps us to explore our varying responses to blue. The background of *Polynesia, the sky* (see Appendix 5) consists of 10 alternating rectangles in two blues, a fairly pale tint and a deeper hue. On these are glued white cut-paper shapes of nine large birds, with smaller seaweeds and animals. The whole work seems very simple, but Matisse built up the bird-shapes from small pieces of paper, making many adjustments until he obtained just the effect of freedom and movement he wanted. The blues of the background are both serene and liberating: the blues of a cool sky and a warm tropical sea.

In total contrast is the effect of blue in many of the paintings by Picasso from the period 1900–4. Among many examples, two portraits, *Self-portrait* and *La Celestine* (see Appendix 5) are especially powerful. Like the Matisse cut-outs discussed above, both are almost monochromatic and the blues are the colours of low energy, but here

they do not give a sense of tranquillity or liberation: the mood is deeply negative and we are left with a feeling of coldness, depression and despair.

Analogous colour groups

Analogous colour groups can be seen in many places, both natural and man-made. Old brick walls and the leaves of trees, are examples of what we find harmonious and restful in the world around us, mainly because their colouring is gentle but not monotonous; subtly varied, but lacking in startling contrast. Analogous colour groupings are also found in works of art from many periods, but they are usually balanced and invigorated by contrasting hues. Few works are based solely on colours from a small part of the spectrum, but those which are can provide valuable examples from which children can learn a lot. These include several of the flower paintings of O'Keeffe, particularly *Black iris III* and *Oriental poppies* (see Appendix 5).

Many of the paintings of Stanley Spencer (1891–1959) also use a restricted range of colours to great effect. Spencer's paintings of stories and miracles can be difficult to understand, but his paintings of everyday subjects are much more accessible, often using analogous colour-sets such as warm browns, reds, greys and ochre yellows. His portrait of *Daphne* and his very large paintings of *Shipbuilding on the Clyde: welders* (see Appendix 5) show beautifully how this restricted range of colours can be made interesting and full of variety. The paintings of shipbuilding were part of Spencer's work as an official war artist during the second world war, and so may be linked to children's work in history.

Complementary colour groups

Examples of these groupings in art are discussed on pp. 58–9 and 69–70. Once children have a clear concept of complementary colour they will identify such colour pairs in their own visual environment. Obvious examples seen every day are packaging and advertisements, but complementary colour is also used more directly. One common and intriguing case is the display of fruit and vegetables, especially on market stalls. Stallholders are skilful at using simultaneous colour contrast to suggest the freshness and ripeness of their produce, for example by placing lemons or grapefruit next to purple-black grapes, oranges or carrots next to blue-green cabbages or leeks, lettuce or brussels sprouts next to deep-red plums or apples, and bananas on deep-blue wrapping paper.

Colour accent and balance

Colour accent and balance are both shown clearly in much of the work of Nicholson. His *1945 (still life)*, for instance, shows how many of his paintings were built up. His subjects are usually simple: one or more bottles, mugs and jugs on a table which appears to be tipped towards the viewer at an impossibly steep angle. The objects, drawn in very clean, taut outlines, are usually quite recognizable, but the paintings are treated as colour compositions with large areas of subdued greys and browns beautifully balanced by small areas of much more vivid colours. Other good examples to study are *1934 (Florentine ballet)*, *1953, February 28 (vertical seconds)* and *1952, June 4 (table form)* (see Appendix 5). In the latter, the use of colour accent is very evident, with the predominantly cool blue background enlivened by one tiny area of red.

8 Shape

8.1 The concept of shape

In the vocabulary of art, the name 'shape' is given to any area on a surface which can be distinguished visually by a boundary or edge from the space which lies around it. We humans have an inbuilt ability to perceive, identify, learn and communicate about shapes in our environment. This is so important for our survival that our perception of shape often overrides other properties, so that we learn to see and classify both objects and marks on surfaces as being the same shape when they are in other important ways very different.

In Figure 8.1, for example, (a) and (b) were drawn with a pen, (e) is a mark made with the edge of a card strip dipped in ink, (d) was torn from black paper and (c) was cut from it with a knife. The only square object is (c), though (d) is an object with a square-shaped hole in it. Example (e) is a square-shaped mark and (a) is an outline drawing of a square, but (b) is a set of lines which only suggests a square. In spite of these differences, most people would perceive a square in all five figures. The importance of this for children's learning in art is that shapes are different kinds of things, including flat objects, marks and drawings. Although we may at first think of these as being alike, many of their properties are different and children need to learn about all of them.

Figure 8.1 Seeing shapes

Making shapes with marks

If a line which can make a mark is moved over a surface at an angle to its length, the trace of its path will be a shape. All the marks in Figure 8.2 were made with the end of a strip of card dipped in ink. When the edge of the card is placed on paper it prints a line (a). If this line is moved across the paper in a straight path at right angles to its length (b), it makes a mark (c). If the length of this mark is about equal to its width, the mark approximates to a square (d); if it is shorter or longer the mark is rectangular, with a vertical (e) or horizontal (f) emphasis. Of course any of these marks can be made at any angle in relation to the edge of the paper. If the line is rotated around its own mid-point (g), the resulting mark is circular (h), and if it is moved in a straight path at an oblique angle (i), the mark is a parallelogram (j).

Figure 8.2 Making shapes with marks

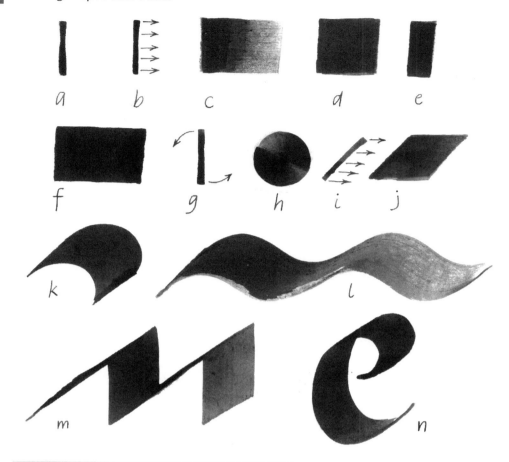

More complex shape-marks

Figure 8.2a–j shows marks which are simple geometrical shapes, but if the mark-making line is moved in a curved or zig-zag path (k,l,m), more complex shapes result. Shapes made in this way, coupled with some of the simpler marks, are the basis of broad-pen writing and calligraphy in the Islamic, Judaic and Christian traditions (n), and are useful for developing children's understanding of motif or pattern. Further reference to letters as shapes we can read is made on pp. 83–4.

Making shapes by drawing

Varieties of drawn shapes

If a point which can make a mark is moved over a surface, the trace of its path is a line (see also pp. 15–18). The process of drawing shapes is illustrated by Figure 8.3. If the point (a) is moved in any direction (b), it makes a line. If the line changes direction so that it returns to its starting-place, the outline of a shape is drawn (c). Different ways of changing direction give differently shaped outlines (d, e, f). These are simple shapes, but in contrast to mark-making (Figure 8.2), any shapes, including complex and irregular ones (g) can also be drawn. Allowing the line to cross over itself makes shapes which join or intersect (h); the shape of a figure 8 is also an example of this. The development of lines into shapes is discussed on pp. 22–4; see also Figures 3.6–3.8. It is often interesting to view line drawings such as Figure 3.9 as complex developments of interrelated shapes, and the intersection and overlapping of shapes is investigated on pp. 79–80.

Figure 8.3 Drawing shapes

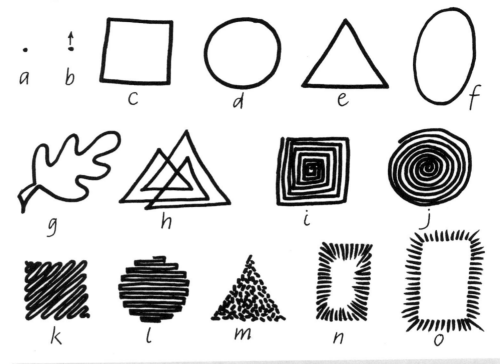

Building up drawn shapes

As well as outlines, shapes can be built up from lines and points. For example, spiralling outwards from a central point and changing direction in a consistent way gives simple geometrical shapes composed of a pattern of lines (Figure 8.3i and 8.3j; see also p. 22 and Figure 3.7a–e). By using them to fill up an imaginary outline, points and lines can be made to suggest a shape rather than drawing it directly. This can be done in many ways, creating patterns, texture or both, and shapes can also be suggested by marks moving inwards or outwards from the imaginary edge (Figure 8.3k–o).

Developing drawn shapes

All drawn shapes can be developed in a great variety of ways. The greatest scope is offered by filling in outlines, as in Colour figure 9b. Tone, colour, texture and pattern can all be used in any combination, but line-patterns and textures which suggest shapes, such as those in Figure 8.3k–o, can also be created with colour.

Making shapes by cutting

The edge of a knife and the blades of scissors both cut at a point which is moving through the material. If the material is in the form of a flat sheet, shapes can be cut from it, but unlike the shapes made by marks or drawn with lines, these are actual flat objects which can be picked up and manipulated in many ways. In addition, cutting out, if it is done carefully, produces not one shape but two: one 'positive' flat object and an identically-shaped 'negative' hole (Figure 8.1c, 8.1d). As when drawing outlines, the cutting point of a knife-blade or scissors can, at least in theory, produce any shape, but cut shapes can be used in even more ways than drawn ones.

Developing cut shapes

A few ways of developing cut shapes are shown in Figure 8.4. The basic shape (a) can also be cut from printed (b), patterned or coloured paper. If it is cut from thin card, the flat shape can be used to reproduce the original drawn shape in a number of ways. For example, use the shape as a template and draw round to produce outlines both the right way round and in reverse (c). Alternatively, spatter paint from an old toothbrush over it, so that a negative image is produced when it is removed (Figure 8.4e; see also Figure 2.3b–e). The hole from which the shape was cut can be used as a stencil; paint brushed through it can reproduce the shape in tone (d) or colour. If the same shape is reversed and cut from plastic foam with a very sharp craft-knife, colour can be brushed on to it and the shape printed, which usually produces interesting visual textures (f). All these simple methods of reproduction have great potential for pattern-making because they make repetition of shapes very easy (pp. 136–7, 140–2; Figures 12.5, 12.8 and 12.9).

Figure 8.4 Cutting shapes

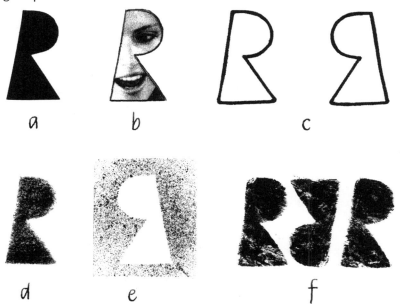

Soft-edged shapes

The different kinds of shape discussed so far in this section all have more or less well-defined hard edges, but both in nature and in art children will come across shapes whose boundaries are much softer and less well-defined (tonal gradation; pp. 31–2; Figures 4.1, 4.3). Such shapes can be made in various ways, but the methods children are most likely to use are drawing or brush-strokes with paint or ink. These are illustrated in monochrome in Figure 8.5, but any of them could equally well be done in coloured media, giving even greater variety. Soft-edged, fuzzy shapes can be built up by drawing using points (a, b), lines (c, d) and tone (e–h). Both charcoal (e, f) and soft pencil (g, h) can be used, and the final effect will depend partly on the texture of the paper and partly on the extent to which the drawing is rubbed. Soft pencil has the advantage that it is easy to make some edges of the shape soft and others hard (g, h). In liquid media, highly textured, soft-edged shapes can be made most easily by using a bristle brush with so little paint or ink that it is almost dry (i, j, k). All the methods shown create distinctive visual textures (pp. 122–6; Figures 11.1–11.4), as well as soft-edged shapes.

Figure 8.5 Soft-edged and torn shapes

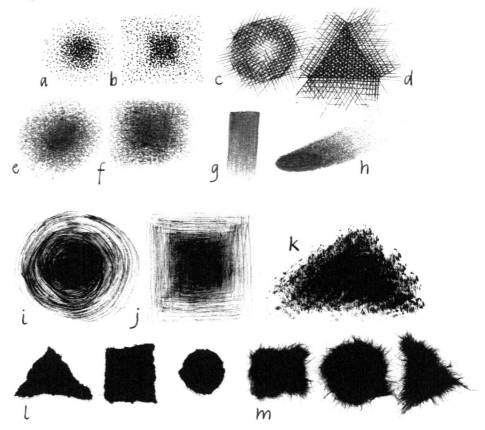

Torn paper shapes

Shapes torn from paper usually have irregular edges unless the paper is scored or folded to avoid this. Depending on the kind of paper the edges may be irregular but fairly sharply defined, or ragged and whiskery. For example, coated display paper was used for Figure 8.5l and a high-quality tissue for Figure 8.5m. Good control is needed to tear paper in this way, but the results are still somewhat unpredictable. A successful method is to hold the paper between the forefingers and thumbs of both hands, with the fingers and thumbs almost touching. Move one hand towards and one away from you to make a short tear, up to 1cm, reposition your hands and repeat. It is possible to tear shape-stencils using brown wrapping paper and starting with a hole in the middle. Sponging dilute colour through these and overlapping the shapes produced can make delightfully subtle and varied decorative effects.

Relating shape to other visual elements

The different ways of making shapes through mark-making, drawing, cutting and tearing show, in a direct and concrete way, the relationship between shape, point and line. The relationship between shape and tone, colour and visual texture is in some ways even closer but also less obvious, so that it is very easy to forget about it. The tones, colours and visual textures which children see, create and manipulate do not exist in isolation. Apart from coloured light, colour as we see it always has shape, the shape of the coloured object or image, and so do tone and texture. This is important, because shapes significantly affect how we perceive and respond to objects and images, especially when these are coloured (see Chapters 6 and 7; Colour Figures 5–8).

In a similar way, any shape and the space around it are two parts of the same thing, but only by considering them apart can we reach any understanding of the ways in which they affect us as we look at art objects and create artworks of our own. The relationship between shape and space is discussed more fully in Chapter 9, but it is also important when shapes interact (see below) and are used as elements in pattern-making (Chapter 12).

The relationship between shape and form is, in theory, simple: shapes exist in two dimensions (on flat or plane surfaces) and forms exist in three dimensions. As usual, the real world is more complex and less well-defined. For a mathematician a circle cut from paper or card is a very short cylinder, but in art we take the view that it is a flat object with a certain shape. For art education this is more than a convenient evasion because, as Chapter 10 shows, a useful way to introduce form to children is to start with flat shapes and manipulate these to move into the third dimension.

The wider significance of shapes

Reference has already been made to the survival value of our ability to recognize shapes and communicate about them. In the primary-school curriculum shapes also have a wide significance, to which work in art can contribute. The two most obvious areas are the symbolism of shape and mathematics.

Shapes as symbols

Shapes act as symbols in cultures throughout the world. Familiar examples are religious symbols such as the six-pointed star of Judaism, the crescent and star of Islam and the cross of Christianity, the last two of which have been adopted by the international aid agencies of the Red Crescent and the Red Cross. It is also worth observing the local environment to see how shape-symbols and icons are used. Trade-marks and logos, particularly those on sportswear and other clothes, are likely to be recognized, but some of the most familiar examples are road-signs. The general shape-symbolism of road signs in the United Kingdom is that circular signs give orders, triangular signs warn and rectangular ones convey information. Within the three classes, particular signs use shape iconically rather than symbolically, as simplified pictures, for example arrows show direction, and red and black cars mean 'No overtaking'.

The need for children to develop an understanding of shape and space is as important in mathematics as it is in art. Work in these two parts of the curriculum can be coordinated closely when learning about symmetry, pattern-making and tessellation, where movement, repetition and the interaction of shape and space are used systematically (pp. 142–6).

8.2 The interaction of shapes

On pages 72–7 shapes are considered in isolation, but they are seen like that only rarely. Much more frequently, both in art and the environment, shapes are seen close together, in contact, overlapping, intersecting or even squashing each other. In all these, shapes interact to create many different sensations and visual effects. Children will already be familiar with many of these but can learn to widen their awareness and experience through investigations (pp. 81–5).

Interactions between shapes in proximity

Shapes near each other may appear to interact visually in different ways depending on the shapes involved, their orientation and the distances between them. Observing these interactions systematically is unnecessary, but it is helpful for children to have some awareness of them, because they can be used to give life and tension to any composition or pattern which is built up from simple shapes (Figures 8.7–8.11, 12.5–12.14). Some simple examples of interaction between pairs of shapes are shown in Figure 8.6.

Figure 8.6 Shapes in proximity

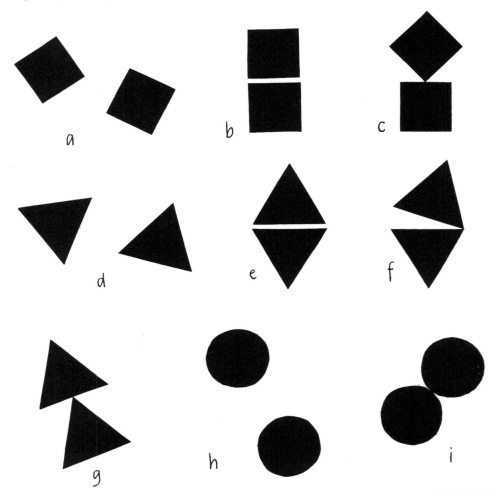

Interaction of squares and triangles

Cut simple shapes about 5cm across from dark paper. Move them around on a pale background to observe their interactions. Squares or triangles which are not very close together (a, d) do not interact visually, though they may appear to be tumbling down (a) or about to move around (d). When closer together, however, the space between the shapes becomes much more visually active, so that the viewer has the impression either of forces acting between the shapes, or of movement, or both. When close together, both squares and triangles appear to be repelling and pushing each other apart (b, e). If these shapes touch at a point, the space near the point of contact becomes even more active, giving an impression such as that of forces in balance (c) or an opening and closing movement (f). Two triangles in line give a strong feeling of movement in a particular direction (g).

**Interaction
of circles**

Circles interact visually in a different way because, unlike triangles, they seem to pull in towards each other rather than push apart. Even when quite a long way apart (h), two circles seem to have a force attracting them together and this seems much stronger when they are almost in contact (i), so that they look as if a large force would be needed to pull them apart. Here again, as in all shape interactions, the nearer the shapes are, the more visually active the space between them appears.

Interactions between overlapping and intersecting shapes

If parts of two (or more) shapes occupy the same space, they interact so that new shapes appear which were not there before. This can happen in two ways. If the shapes are opaque (for example, made of cut paper or opaque paint), they overlap so that some hide parts of others (Figure 8.7a–f). If the shapes are or appear to be transparent, such as drawn outlines or shapes cut from transparent coloured material, all their outlines remain visible and they intersect (Figure 8.7, g–i).

Figure 8.7 Shapes overlapping and intersecting

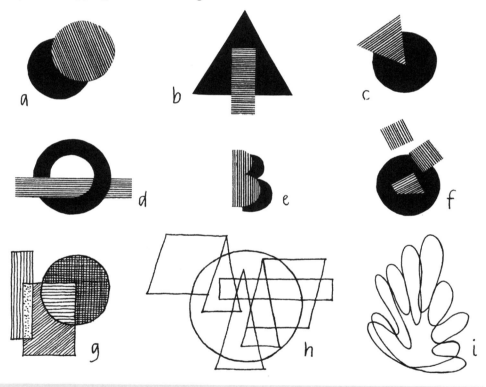

**Overlapping
shapes and
illusions**

Some properties of partly overlapping shapes are shown by Figure 8.7a–f. When two simple shapes overlap, one is partly hidden by the other so that a new shape is produced (a–c). Some overlapping shapes can also cause spatial illusions (p. 97; Figure 9.6). The overlapping shape may not only appear to be on top of the other, but also nearer to the viewer. Good examples include threading one shape through another (Figure 8.7d), the shadow effect which seems to make the upper shape float up from the paper (e), and the illusion of one shape falling into another (f). All these effects are most convincing when the shapes have sharp edges, so cut paper is a good medium when investigating them. If, however, the overlapping shape lies completely within the larger one under it, there is much less illusion of depth or none at all, as in Colour Figures 10a, 10b.

Making new shapes

Intersecting shapes are usually more visually complex than overlapping ones. This happens because the original shapes can still be seen, but new ones are produced in addition. Children can learn a great deal about how shapes and spaces interact by drawing simple compositions and developing them in a tone or a variety of coloured media. In Figure 8.7g, for example, three shapes intersect, making five new shapes, in addition to the circle and two rectangles. Unlike overlapping shapes, a set of intersecting outlines appears flat (Figure 8.7h, Colour figure 9b), but illusions of space can be created by colouring the shapes in different ways or by erasing parts of the outlines (p. 97; Figure 9.6a). The most obvious colour effect is that small areas or accents of vivid, warm colour will appear nearer to the viewer than cool coloured shapes around them, especially if these are darker (see, for example, Colour figures 8f and 8l).

For the sake of simplicity, attention has been confined so far in this section to the interaction of simple, geometric shapes, but there is no reason why children's investigations and projects should be limited. Natural organic shapes, especially when they suggest growing things, can interact in ways which are dynamic and visually exciting (Figure 8.7i).

Shape and communication

We are familiar both with written language as a code of shapes we can read (pp. 83–4), and with shapes as representations of objects and people which we read in another way, but shape can also speak to us more directly and intuitively. Isolated shapes can have meaning, for example when used as symbols (p. 77), but when they interact, shapes can communicate in a wider and more complex way. When they are allied with colour, for example, interacting shapes enable us to create impressions of differing levels of energy and movement, which in turn make possible much of our visual communication of mood and emotion (pp. 67–8). In Colour figures 11a and 11b, for example, shape and colour combine to communicate moods effectively. In many drawn shapes, the suggestion of energy and movement is directly related to how much the drawing hand moves, its speed and the way in which it changes direction (pp. 17–18; Figures 3.2, 3.3).

Shape, colour and movement

Children should investigate simple contrasts of the kind shown in Figure 8.8a–c, which could be enhanced by the use of colour, like cool tints for the gentle movement of example (a) and hot, vivid hues for the vigour of (c). The reverse, however, also works well, as Colour figures 9a and 9b show. The more dynamic shapes in less energetic blues and greens and the static shapes in very hot reds and oranges create interesting tensions in both paintings. The other examples in Figure 8.8 show a different kind of contrast, between the upright, isolated shapes in (d) which suggest lack of movement, and the appearance of oblique movement created by the interacting curved diagonals in (e). Here again the effect could be strengthened by the use of colour and contrast; perhaps grey-brown shapes with a cool green background in (d), and yellow-green and lemon yellow shapes with a deep blue-violet background in (e).

| Figure 8.8 | Shape, energy and movement |

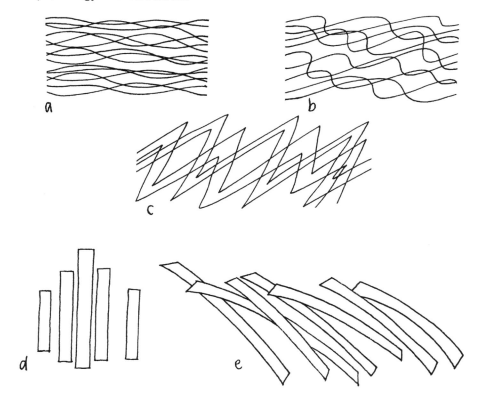

8.3 Investigations of shape

Almost any drawing and painting is concerned in one way or another with shape, but children's knowledge and understanding can be better developed by carrying out some investigations in which shapes and the ways in which they interact are the main focus of attention. What follows is a small selection of open-ended investigations which have proved successful in the classroom. In all of them it is advisable to work on quite a large scale (i.e. with starting shapes of 20cm or more across) and to begin simply before moving on to more complex projects.

Working with cut and drawn shapes

Making shapes intersect

A good starting-point is to make a very simple composition using intersecting drawn shapes, as in Figure 8.7g, and develop it with colour in any medium. To begin with it is best to use only two kinds of basic shape, for example rectangles (including squares) and triangles, or triangles and circles, and to draw the composition twice and develop it with contrasting colour-sets (Colour figure 8). These will usually make the shapes interact visually in different ways, changing the role which each plays in the work as a whole. It is worth remembering that it may not be necessary to fill all the shapes with colour or tone to complete the composition, and that the work should be examined critically as colours are added, to decide whether the next colour is likely to have the intended effect. This is a very good opportunity to begin learning the important principle that a good artist knows when to stop.

Developing drawn-shape compositions

Simple compositions of this kind can be developed in many different ways. If the class works cooperatively, the children will together produce a great diversity from which everyone can learn. Three of the possibilities are to:

1 use a wider variety of shapes and more of them (e.g. compare Figures 8.7g and 8.7h). What differences are made by adding a shape from a different 'family'?
2 use cut and/or torn paper shapes instead of drawn ones. Tearing shapes often gives interesting white edges and the paper can be coloured with paint or pastel before use (see also pp. 56–7 and Colour figures 10a, 10b).
3 combine overlapping shapes (cut or torn paper) with intersecting (drawn) ones in the same composition.

Cutting into shapes

A wide variety of experiments may be made quite quickly by cutting up simple shapes and rearranging the pieces. These generate excellent opportunities for children to create and observe the interactions of shapes and spaces, particularly the ways in which the space between shapes becomes visually active when the shapes are near each other (pp. 91–5; Figures 9.2–9.4). They also develop the skills of cutting, glueing and working systematically. It is instructive to begin with quite large geometrical shapes, because children will see how complexity can be generated and appearance completely altered by a few simple changes.

Making cut-paper compositions

This activity is rather like a visual spatial game, with only two rules. First, every cut should completely separate one or more pieces; secondly, nothing should be added or taken away. There are two main ways of arranging the pieces produced by cutting up. The first is to move them apart; the second is to turn them over but not to move them apart. In both, the pieces can be fixed temporarily with small pieces of Blu-tack and the final arrangement glued on to the background paper to make it permanent.

Cutting and moving pieces apart

When cutting up and moving apart, the pieces stay the same way up and can be moved in any direction and distance, or rotated. Examples are shown in Figure 8.9 a–c. In example (a) the starting shape is a circle and the pieces are moved apart in a straight line to differing distances but with no rotation. In example (b) the starting shape is a square. This is cut in two with an oblique line, then both halves are cut across with three curved lines and the eight pieces moved and rotated outwards. Example (c) begins as a triangle. Three pieces cut from it are simply rotated clockwise; the fourth at the upper left is moved left and then rotated. Notice how, in all three examples, the visually active space between the shapes gives the impression either of forces acting, or of movement, or both. A special case of cutting and rotating the pieces occurs when making some kinds of tessellation (p. 145; Figure 12.13).

Cutting and turning over is a little more difficult, requires paper which is coloured on both sides and is illustrated by Figure 8.9d and 8.9e. Example (d) shows the basic principle. Pieces are cut from the starting shape, in this case a triangle, turned over but not moved away or rotated, so that the shape of the cut piece and the hole from

Cutting and turning over

which it was removed are exactly symmetrical. Having cut a piece and turned it outwards, a smaller piece can be cut from it and turned over again, either outwards or inwards, as in the bottom centre of example (d). Example (e) is a little more complex. The upper shapes are made with two cuts and turns outwards; the lower ones in a similar way but with an extra cut and turn inwards. Children usually enjoy this activity but may find it difficult to keep track of the shapes. One way to reduce confusion, which can also produce visually interesting results, is to make and use paper which has different colours on each side. This activity has obvious connections with learning about line symmetry in mathematics.

Figure 8.9 Cutting into shapes

Both methods of working give children the opportunity to experiment freely with shapes which they have produced for themselves, observing interactions between them which can quickly be changed until a satisfactory arrangement has been made. They are also useful as a creative way of developing children's understanding of the interaction between shape and space, especially the alternation between figure and ground (pp. 91–5).

Letters as shapes

Letters are shapes which can be combined into words which we can read. Conventional written and printed letters are mostly rather complex and difficult to use in a purely visual way, but children can combine simplified drawn capital (upper-case) letters into exciting combinations of interacting shapes. A full alphabet, based on the work of the German designer Hans Schmidt, is given in Appendix 2. To begin with at least, children should draw their letters at least 20cm high, using a thick, soft graphite pencil.

A good starting-point is to use names as words, as shown in Figure 8.10. These could be the children's own names (a), or those of sports teams (b), or media stars. In these examples the letters are mostly touching each other, so that the spaces between them make shapes as interesting as the letters themselves. When they have been drawn, the letters and spaces can be developed with colour. One simple and effective way is to use sets of warm colours inside the letter-shapes and cool ones in the spaces between, or vice versa (pp. 61–2; Colour figure 8). Texture and pattern can be added for increased liveliness and diversity, but need to be used with care because they can easily dominate the composition. One way to avoid this, and to keep the shapes more distinct, is to fill either the letters or the spaces with flat colour and confine texture and pattern to the other.

Using letters as shapes

| **Figure 8.10** | Letters as shapes |

Visual complexity can be increased and the letter-shapes made to interact much more strongly by overlapping them so that the drawn outlines intersect (Figure 8.10c and 8.10d). This makes the words harder to read, but introduces an element of puzzle and challenge which children usually enjoy. Names with a lot of horizontals and verticals (e) can be made more energetic and exciting by overlapping the letters and tilting some or all of them (f). When letters are intersecting and creating complex interlocking shapes, they can be used to experiment with different colour groups to great effect (see Colour figure 8 for ideas on groupings). It may be necessary to remind children that the main aim of these experiments is not legibility: if the words cannot be read instantly, this is not a problem as long as the composition is visually exciting.

Intersecting letter shapes

Shapes from everyday life

In the investigations above, the shapes being manipulated are simple and limited. A much more open-ended approach to finding out about interaction is to start with shapes which the children see around them, in groups which have something significant in common. The basic technique is shown in Figure 8.11. The shapes and forms of the real objects are reduced to outlines which are still recognizable: one group of shapes (a) is associated with football, the other (b) is of common vegetables. The outlines, which need not be drawn to scale, are then arranged and

superimposed so that they produce a stimulating composition of intersecting shapes. This may require several trials, for which tracing-paper should be used.

Other sets of objects which may be tried include fruits, leaves, musical instruments, and equipment from sports and hand-tools, but flowers are less easy. As in the other activities, the composition of outline shapes can be developed with tone, colour or texture in any way. One entertaining and instructive idea, where the real objects have distinctive colours of their own, is to use complementary colours in the composition, as shown in Colour figure 5b: scarlet and black for blue-green and white leeks, blue-grey for orange-brown onions and vivid blue-green for bright orange carrots.

Figure 8.11 Shapes from everyday life

8.4 Shape in context

Shape is all around us. Colour and tone cannot exist in isolation: they are always allied to point, line, shape, form or all of them. In both art and the wider environment, shapes and their interactions are often so varied and complex that they are difficult to interpret and learn from. In trying to develop an understanding of shapes, therefore, it is not enough simply to observe them. Children should always be encouraged to record the shapes they see in their sketch-books and use them, so that their visual properties and the ways in which they interact can be learned through first-hand experience. Colour figure 9b is an example of work based on shapes noted in this way.

The examples discussed below have been selected with this in mind. It is perhaps relevant to add that the omission of traditional decorative arts from this selection is deliberate. Though many traditional artefacts from all over the world do employ shapes and their interactions in interesting ways, these are almost always used as part of patterns which dominate the visual impact of the finished workpieces, so discussion of them is reserved for pp. 146–8.

Identifying shapes in the environment

The ability to perceive and understand shape is an essential part of the complex group of skills known as visual literacy (pp. 6–7). When trying to develop this it is helpful to start, especially with young children, by looking for and identifying simple, hard-edged geometrical shapes in the environment, and distinguishing the natural from the man-made. Most of the straight-line, angular shapes we see are man-made, for example the squares and rectangles of bricks, doors, windows and paving, and

the triangles of roofs. Circular shapes are common in both the natural and the man-made environment. The full moon appears circular and so do some bubbles, spherical fruits and the iris and pupil of the eye; but also play-balls, plates, the tops of cups and the plug-hole in the bath. Spirals are found in screws and shells, but other simple curved shapes such as ellipses and crescents are much rarer.

Natural shapes in art

When children can identify simple shapes confidently and have learned something of their visual properties through working with them, they can progress to looking for more complex shapes, both in the environment and in art, in order to gain ideas on how these can be used in their own work. Natural shapes have always been a major feature of art. The ancient Egyptians, for example, used stylized but usually quite recognizable images of plants, animals and people in a half-naturalistic, half-decorative way in which many of the shapes are arranged and interact so that they become patterns, a form of drawing similar to that used in Figure 3.9.

A painter whose use of natural shapes has much in common with that of the Egyptians is Henri Rousseau (1844–1910). He was an amateur painter, nicknamed 'Le Douanier' (the customs officer) because he held a minor customs post at one of the gates of Paris. Rousseau was untaught in art and painted in a so-called primitive style, but since his death he has been recognized as a major artist because of the mysterious, dreamlike quality of his best work. This quality is created partly by Rousseau's beautiful use of natural leaf-shapes, which he studied in the botanical gardens of Paris and combined into interacting groups which, like those of the Egyptians, form patterns. Particularly rewarding examples are *Tropical storm with tiger (surprise!)* and *Snake charmer* (see Appendix 5). It is interesting to note that, according to the teacher-guides, the former is far and away the most popular painting with children in the National Gallery's collection; it is discussed further on p. 103.

Soft-edged shapes

In complete contrast to the sharply defined, hard-edged shapes of Rousseau and the ancient Egyptians are the soft-edged, often misty shapes of Impressionist painters. Good examples are to be found in the works of Monet, some of which are discussed on pp. 59, 128–9. The conditions under which shapes appear soft-edged are in mist and fog, which Monet painted many times, for example in his series *Morning on the Seine, Giverny (mist)* and *Charing Cross Bridge* (see Appendix 5).

Interaction of natural and man-made shapes

The ways in which natural shapes interact with man-made ones has long been a preoccupation of artists, from Japanese garden designers to European and American painters. In Western art, this interest has been expressed most clearly in the kind of painting known in English as still-life, but confusingly in French as *nature morte*. Essentially, a still-life is a painting or drawing of objects arranged so that their forms in three dimensions (pp. 104–5) allow the artist to show the interactions of shape and space on the flat surface of their painting or drawing.

Many artists' work shows how they investigate and discover the world around them. One painter whose still-lifes show this very clearly is Cézanne. Most often it is the simple forms of fruits such as apples, pears or melons which he contrasts with pottery,

folded cloth and the rectangles of furniture, as in *Kitchen still-life* and *Still-life with ginger jar and melons*, but sometimes more complex shapes are used, for example the leaf-shapes in *Still-life with fruit and vase* (see Appendix 5). In all these paintings, the interaction of shapes can be regarded as the structure on which the subtle effects of tone, colour and texture depend. This, and indeed Cézanne's whole way of working, can be seen most clearly in some of his incomplete paintings, of which *Still-life with water-jug* (see Appendix 5) is a particularly instructive and beautiful example.

Interaction of drawn shapes

A major trend in the development of Western art at the end of the nineteenth century and throughout most of the twentieth was the move away from art as mainly concerned with representation (i.e. pictures of people, plants, animals, landscapes, etc) and towards the exploration of shape, space and form as things in themselves. This was the origin of so-called non-representational or abstract art (see also pp. 128–9; Whitford, 1987).

One artist who throughout his working life bridged the gap between the real and imaginary worlds was Klee, whose use of line is discussed on p. 28. In much of his work Klee built up groups of intersecting shapes using continuous lines (see also Figures 3.7f–h, 8.3h, 8.7i) in the most ingenious and interesting ways, as for example in *They're biting!* and *A young lady's adventure* (see Appendix 5). He also often used overlapping shapes in outline, developed with colour, as in the graded-colour paintings discussed on p. 51. Perhaps because most of his paintings are small and many show a child-like fantasy and inventiveness, Klee's work was for a long time undervalued in the United Kingdom, but a study of any of the works mentioned will show that he controlled shapes and their interaction, as well as tone and colour, with the utmost skill and an unerring sense of balance.

Interaction of geometric shapes

During the first three decades of the twentieth century many artists tried to break free from observation of the real world, in order to investigate the possibilities of an art based entirely on the imagination. Two of the earliest of these were Sonia Delaunay and her husband Robert, some of whose work is discussed on p. 50. Though neither of them ever concentrated exclusively on abstract art, both produced many works based entirely on overlapping shapes, for example Robert's *Rhythm: joy of life* and Sonia's *Rhythm colour* (see Appendix 5), which are good examples to study.

The same basic means were used by Malevich in his *Dynamic suprematism* and *Suprematist composition: airplane flying* (see Appendix 5), but he achieved completely different effects. Whereas the shapes of the Delaunays fill their paintings completely, Malevich's simple overlapping and opaque shapes are surrounded by what seems an enormous amount of space. The result is that, although the composition is perfectly balanced the shapes are visually free, so that they look as if they are about to move around. A different effect is achieved by László Moholy-Nagy, using shapes which both overlap and intersect. In his *K VII* (see Appendix 5), the shapes have plenty of space around them, but because only horizontal and vertical straight lines and rectangles are used, some of which run out to the edges of the painting, there is no sense of movement (see pp. 80–1; Figures 8.8d and 8.8e). As in much of Moholy-Nagy's work, the smaller repeated motif gives a feeling of depth and an illusion of space

(pp. 89–91), but the interacting shapes appear to be locked into it, not about to dance around on the flat surface of the painting as those of Malevich are.

Complex interactions of shapes derived from real objects, a kind of highly simplified still-life, dominate the later work of Nicholson. Children can get many ideas for work of their own from a study of the examples discussed on pp. 28, 71, 101.

Cut shapes and their interaction

The compositions made by Mattise from cut paper (see pp. 58–9, 70) provide opportunities to observe the interaction of hard-edged shapes as they touch and overlap. One of the most intriguing is *The snail* (see Appendix 5), which unlike most of his work is almost entirely abstract, made up of large, brightly coloured areas, mostly four-sided, curling round in a spiral which conveys a mysterious sense of clockwise movement. This sense of movement is generated because the variety of shape and colour, coupled with the way in which the shapes interact by touching and small overlaps, makes the white spaces around them very active visually (pp. 78–9). At first sight this very large composition, which is nearly 3m×3m, may appear simple and even childish, but both shapes and colours are exactly balanced and their interactions are beautifully controlled.

9 Space

9.1 The concept of space

Of all the fundamental elements which contribute to the visual arts and are combined in them, space is the most elusive concept. It may be defined as the area around or adjacent to shapes and forms, separated from them by some kind of boundary or surface. The boundary between shape and space may be one of colour (e.g. Colour figures 5–7, 9), tone (e.g. Figures 3.4, 4.2, 4.5, 8.4d–f) or line (e.g. Figures 3.7, 3.8, 8.3c–h); and it may be sharply defined and hard (e.g. Figure 8.6) or fuzzy and soft (Figures 4.3, 8.5a–k). It is difficult to discuss space other than in this rather negative way, yet it is an essential part of most drawing, painting, sculpture and craft, because it is within space that shapes and forms interact, and it is this interaction which gives life and significance both to images in a picture and three-dimensional objects in an environment. The interactions between objects in three-dimensional space are in some ways easier to understand than those between shapes on a flat surface and are discussed in Chapter 10. This chapter is concerned with space on the flat surface of artworks such as drawings, paintings and collages.

Space in two-dimensional art can usefully be thought of as being rather like a football or hockey field. If we watch a match as spectators, we are for most of the time aware only of the players and the ball, but in critical situations such as corner kicks or hits, goal-mouth scrambles and offside decisions, we become much more aware of the field itself, its boundaries and the shifting spaces between the players. However, the players themselves have to have a sense of space and position all the time. In a similar way, as viewers of pictures we are likely to be much less aware of space than of shapes such as human figures and trees in a landscape, objects in a still-life or the face in a portrait. But the artist is aware of space and considers it at every stage, because it plays a significant part in the work. Some of the roles which space can play in paintings and drawings are discussed on pp. 100–3.

Objective and illusory space

When seeking to develop children's understanding of space in two-dimensional artwork one should distinguish between two different effects or uses of space: objective space and illusory space. The flat surface of a painting or drawing is properly known as the picture-plane. Space is the area on the picture-plane around and between shapes, and in that sense it is always objective and real: there is actually an area of paper, canvas, paint or some other material which we see and read as space between images.

When shapes are near each other or overlap, they interact so that the space between them becomes visually active. If the shapes are near each other or just touching, the visually active space between them often gives an impression of movement or of forces acting, but the shapes still appear to be at the same distance from the viewer and on the picture-plane (pp. 78–9; Figure 8.6). In this situation the

space is still objective because we read it as being flat, as it is. If the shapes overlap, however, one usually appears nearer than the other (Figure 8.7d–f). This is the simplest example of illusory space: we know the shapes are on a perfectly flat picture-plane, but their appearance contradicts this.

Observing illusory space

Illusory space is created when shapes and images interact with the spaces around them to give an illusion of depth, so that the shapes no longer appear to be on the picture-plane, but seem to be at different distances from the viewer. Some simple examples of objective and illusory space are given in Figure 9.1. When looking at each figure it may be helpful to cover the remainder of the page with white paper. Figure 9.1a shows a pattern which appears quite flat. The black shapes all appear on the picture-plane, so that we read the white areas between them simply as objective space. In a similar way the marks in (b) appear to be on the picture-plane, but in (c) they do not, since the different sizes and placing of the marks makes some appear much further away than others, so the space between them appears to have a depth which is wholly illusory. Example (d) gives most people an even stronger illusion of depth and also the impression that the marks are being viewed from their own level, whereas (e) gives an illusion not only of depth, but also of ambiguous differences in level. Are the two rows of squares sloping upwards away from the viewer, or is the viewer above them, looking obliquely downwards? Either interpretation appears possible.

Figure 9.1 Objective and illusory space

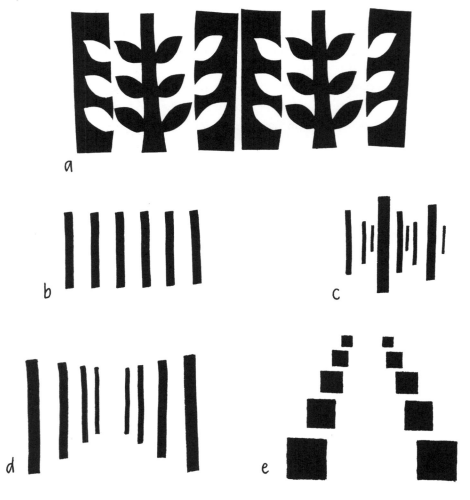

If we stop to think about it, we know that all the spaces in Figure 9.1 are simply white areas between black shapes, but because our eye-brain system interprets them differently they are visually active in different ways and produce different effects on us when we look at them. Objective space is investigated further below and illusory space on pp. 95–100.

9.2 Objective space: figure and ground

When shapes are arranged on the picture-plane so that they give no illusion of depth, the space between them is objective space. Figure 8.6 shows a variety of shapes which have relatively large spaces around them, whose only boundary is the edge of the page. The shapes interact with each other, as discussed on pp. 78–9, but there is no obvious interaction between the shapes and the space around them. In contrast, Figure 9.2 shows shapes inside spaces which are restricted by definite boundaries. Here shape interacts with space in many ways which are often referred to as the relationship between figure (shape) and ground (space).

Figure 9.2 Interaction between figure and ground

The relationship between figure and ground is important in much of art, craft and design, but is perhaps most obviously significant in the graphic design of products such as magazines, posters and packaging. If children are to use shape and space with confidence and understanding they need to observe and experiment with two aspects of the figure-ground relationship: alternation and balance. These are rather formidable

names for visual properties which children are likely to see in everyday artefacts, and are quite easy to understand. They can also learn a lot about how shape and objective space interact by making shapes move outwards and invade the space around them (see pp. 94–5).

Alternation between figure and ground

Developing an understanding of the ways in which figure and ground interact may begin with observing some simple examples such as those in Figures 9.2 and 9.3, which can also be the basis for children's own investigations. Although the examples given are in black-and-white, children should also look at the effects of similar experiments using colour, for example by cutting and assembling coloured papers. When observing figures like these it may be helpful to view the examples one at a time, covering the remainder of the page with white paper.

Figure 9.2a shows a black circular shape within a square white space defined by a frame. The area of the circle is much less than that of the space around it, and at first sight most people are much more aware of the circle than of either the space or the frame. In Figure 9.2b the circle is larger: its area is equal to that of the white space around it. One result is that the visual relationship between figure and ground is **Observing** much more uncertain: we perceive them either as a black circle on an enclosed **alternation** white space, or as a white hollow square on a black background. Most people when looking at an arrangement like this one find that it seems to change or flip spontaneously from one appearance to the other. This is known as alternation between figure and ground. Returning to Figure 9.1a, it will be found that while it is possible to see it as a hollow white square on a black background, this requires a positive effort of concentration: alternation occurs most readily when the areas of figure and ground are about equal.

In Figure 9.2c, the area of the circle is much larger than that of the white shapes around it. In this situation, most people perceive figure and ground as having been reversed: the white areas are now shapes within a black space. It is possible to perceive this example as a circle within a square frame with a white background, but as with example (a) the alternation is not spontaneous: we have to think about it to make it happen. Comparing Figures 9.2a and 9.2c makes an important point about the way we perceive shape and space: we tend to concentrate on the smaller areas within a field of view and interpret these as shapes, regardless of whether they are 'positive' (black) or 'negative' (white). When areas of tone or colour are roughly equal, however, for many people there is no obvious way of deciding which is figure and which is ground, so the brain tries out different interpretations and we experience alternation. In looking at Figures 9.2 and 9.3 different individuals may have different experiences of alternation, but few will have none at all.

Shapes or Figure 9.2d–f shows the same effects in a different way, using the same-sized shape **spaces?** each time but reducing the white areas by increasing the width of the border. Look at each figure in turn, concentrating on the white area. Does it appear to be shape or space? Again we perceive the smallest areas in examples (d) and (f) as shapes, regardless of whether they are black or white, and alternation is experienced most readily in example (e), where the areas of figure and ground within the border are

equal. Example (f) also shows how a shape can lose its identity when distinctive parts of it are blocked out. We recognize a square because it has four right-angled corners arranged in a particular way, but when these are hidden it is much more difficult to perceive what is still visible as being part of a square. This points to one of the complexities of the alternation between figure and ground: it depends partly on the distinctiveness of the shapes involved and how easy they are to recognize.

Alternation and a familiar shape

The role of recognition in alternation is illustrated by Figure 9.2g–i. Look at each figure in turn and see whether you experience alternation in any of them. In example (h) the areas of figure and ground are about equal, but there is no alternation. This is because there is no ambiguity: the letter S is so highly recognizable as a shape that we cannot interpret it as if it were background. Even when much of the letter has been obliterated, as in example (i), what remains is so distinctive that we continue to perceive it as a letter-shape when it is upright. If the page is turned through 90°, however, the S-shape is less easily recognized, so attention is focused more on the small white shapes and alternation can be experienced.

Balance between figure and ground

Alternation between figure and ground can produce strong visual effects which, once they are understood through first-hand experiment, can be used in much art and design, particularly in pattern-making. It is, however, equally important to recognize that often alternation should be avoided because it would be a distraction or create the wrong effect. One way to reduce or soften alternation is to reduce tonal contrast. The effect is always strongest in black and white, and the use of colours or shades of grey close to each other in value makes it less conspicuous (Figure 4.2). To control the interaction between figure and ground fully, an artist or designer needs to achieve a balance between them.

Controlling balance between figure and ground

In Figure 9.3a, roughly equal areas of black and white give rise to a very strong alternation between figure and ground. Example (b) is the same design in reverse, and shows alternation equally strongly. If a design such as this were used as a motif in a repeating pattern, this equal balance between figure and ground would give a very restless and unstable feel. This could be an advantage if an exciting, energetic effect was being aimed at, but quite unsuitable if something more restful was intended. The difference can be seen by comparing the patterns in Figure 12.7, which give some sense of movement but do not alternate, with those in Figure 12.8c–e which are static but alternate strongly. So, to avoid alternation it is necessary to create a deliberate imbalance, in terms of area, between the darker and lighter parts of the design, so that the viewer is left in no doubt about which is figure and which is ground. This is shown in Figure 9.3c and 9.3d, in which the layout in (a) and (b) has been modified so that it is much more visually stable and does not alternate, leaving both examples with quite a strong sense of movement.

Space invasion

Once children have begun to investigate the relationships between figure and ground, they can extend their experience and understanding creatively by experimenting with some of the ways in which space can be invaded by shapes. Of the many possibilities, the few suggested here have proved particularly productive in the classroom.

Figure 9.3 Alternation and balance in figures and ground

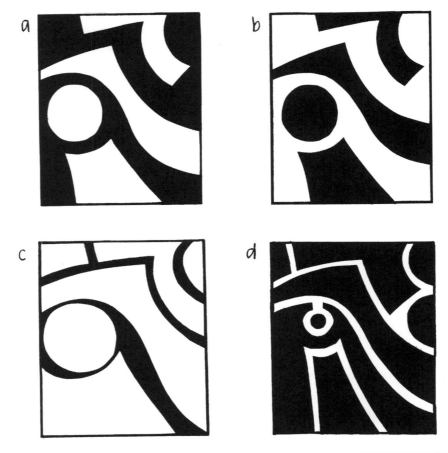

Making shapes move into space

One of the simplest ways to invade space with shape is to cut simple geometric shapes such as rectangles, circles or triangles of differing sizes and proportions and glue these on to a sheet of paper, starting at one edge and working outwards progressively (Figure 9.4a). A variety of shapes can be used, but children may learn more about the visual properties of objective space if they limit their choice. Figure 9.4a, for example, was built up from small rectangles to give strong alternation between black and white where the shapes and spaces interpenetrate. This exercise also provides excellent opportunities for the creative grouping of colours (pp. 64–7; Colour figure 8). A familiar variation using a similar method is to build up a skyline of a landscape or buildings in silhouette by glueing shapes on to painted or marbled paper (Figure 9.4b). In all these activities children will learn most if they are encouraged to look critically at both shape and space as their composition is built up, placing each successive shape exactly so as to work towards the effect they want.

Blowing paint

A complete contrast is to make shapes by blowing thin, runny paint over paper using a straw (Figure 9.4c). The invasion of space by the liquid is to a degree controllable, but in detail the shapes and spaces are much less predictable and the results are often haphazard. Both develop in a complicated, organic and branched way in which the spaces between the invading shapes are as interesting and significant as the shapes themselves. Again any colour combinations or painted background papers can be used.

Cutting up shapes and moving the pieces apart provides more complex possibilities, because shape and space invade each other (pp. 82–3; Figure 8.9). As the pieces are moved outwards into space, space itself invades the area originally occupied by shape, and it is the interactions between the two as this happens which give these compositions their interest.

Figure 9.4 Space invasions

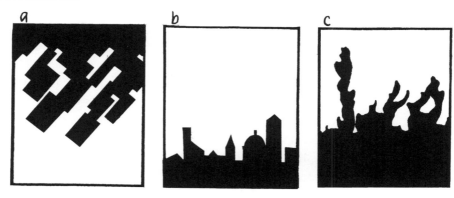

9.3 Illusory space

The creation and perception of illusory space are difficult topics which have been extensively studied both in relation to art (e.g. Gombrich, 1977) and the scientific investigation of perception (e.g. Gregory et al., 1995).

Depth cues

When we look at a real scene in front of us, whether a room, building or landscape, we scan it and use a variety of its visual properties to help us build up a mental map of it in three dimensions. The visual properties which help us to decide the distances of objects in relation to each other and ourselves are known as depth cues. Illusory space is created when depth cues are imitated or represented on the picture-plane, so that we interpret flat images as if they are at varying distances from us. The four main kinds of depth cue which primary-school children are likely to understand are: relative size and texture; overlap; sharpness and contrast of tone or colour; and the use of directional lines (linear perspective). Developing a basic understanding of these and investigating simple ways of using them enables children not only to enlarge their own range of skills but also to appreciate the work of artists better.

Relative size and texture

Size as a depth cue

The way in which size can act as a depth cue is shown by Figure 9.1b–e. We know from experience that in the real world an object close to us appears larger when compared with a similar-sized one which is further away. In example (b) the marks are all about the same size, so they appear to be, as they are, all the same distance away on the picture-plane. When we look at example (c), however, what we see on the paper and what we know of the real world interact in a curious way. The marks are similar in shape and proportion, but differ in size. In the absence of any other depth cues it is very difficult to perceive them as we know them to be: different-sized marks all the same distance away. Instead, we compare and read them as if they were

the same size but at different distances from us. Similar effects are seen in examples (d) and (e). The illusion of space is created in the brain because we interpret what we see on the picture-plane in terms of the depth cues we have learned by looking at and moving through our own three-dimensional world.

Size and texture as depth cues

The role of relative size and texture in creating an illusory space is shown in Figure 9.5. We know that the twigs and needles of a pine tree are much smaller than mountains, so we read their images accordingly: the twigs appear close and the mountains distant, so that we create for ourselves a strong illusion of depth. This photograph also shows the role of visual texture as a depth cue, which is closely related to that of size. The waves in the picture have a visual texture, and we know from experience that they are likely to be about the same size (or height) over most of the lake. In the picture, however, the visual texture is not uniform: the individual waves appear smaller as we look at more distant parts of the lake, so the texture becomes finer. This is read into an image such as Figure 9.5 as a depth cue, contributing to the illusion of space. Children can observe the same effect when repeated elements and patterns such as leaves and bricks are viewed at different distances. It has been extensively exploited in artwork and children can investigate it through drawings and paintings of their own environment.

Figure 9.5 Depth cues and illusory space (photograph by Henry Carsch)

Overlap

From an early age we learn that an object partly obscured by another is more distant from us. When drawn outlines overlap as if the shapes were transparent (Figure 8.7h), we receive little impression of depth. If parts of them are erased (Figure 9.6a, see also Figure 8.8e), the drawing can not only suggests depth and overlap but also causes amusing and puzzling ambiguities. In Figure 9.6a, for example, how do the triangle and parallelogram at the top relate to each other? Such effects have been studied by both scientists and artists and children can experiment with them as part of their work on the interaction of shapes (pp. 81–2; see also Willats, 1997).

Figure 9.6 A variety of depth cues

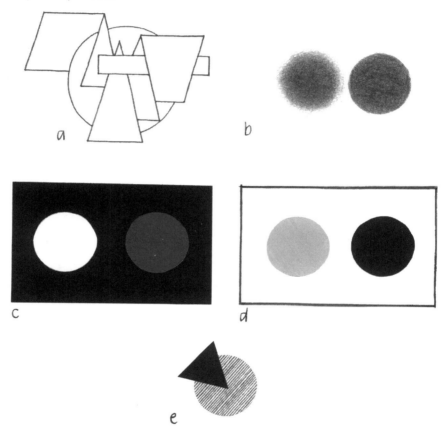

The effect of overlap is strongest when it is reinforced by other depth cues, as in Figure 9.5, in which the interlocking shapes of the mountains, combined with tonal contrast (see pp. 31–2), contribute to the overall illusion of distance and space. Overlap is also likely to be more effective as a depth cue if it mimics effects which we see in the real world and can readily identify. See, for example, Figure 8.7, where examples (d), (e) and (f) give quite strong illusions of depth, whereas examples (b) and (c) are more ambiguous. These are discussed further below, in the context of sharpness and tonal contrast.

Overlap as a depth cue

Sharpness and contrast: aerial perspective

When looking at a landscape, more distant objects appear less defined because the air between them and the observer scatters light, making their edges appear softer and more blurred. Light scattering also reduces tonal contrast and changes colours, making

distant parts of the scene more blue than nearer ones. The overall effect is known as aerial perspective and is shown in Figure 9.5, in which the pine twigs and the nearer hills are sharper and contrast more with the sky than the distant mountains do. These effects of aerial perspective have been extensively exploited in landscape painting in combination with other depth cues, to enhance the illusion of space and distance.

Sharpness and contrast as depth cues

The role of sharpness and tonal contrast in creating illusions of depth can be seen also in arrangements of simple shapes which may be more directly related to children's work in art. In general, as Figure 9.5 suggests, the sharper the edge of a shape and the greater the tonal contrast between it and its background, the nearer it appears (other factors being equal). For example, Figure 9.6b shows two circles of about the same size. When viewed from a distance of about 1.0–1.5m, the sharp-edged one appears nearer than the fuzzy one. In Figure 9.6c and 9.6d the circles are all sharp-edged, but show differing degrees of tonal contrast. In each pair it is the more highly contrasting circle which appears nearer to the viewer, regardless of whether the background is black or white. This effect contributes both to the delightful ambiguity of Colour figure 11a, in which the positions of the 'floating' shapes remain uncertain, and to the aggressive effect of the dark shape in Colour figure 11b.

Combining overlap and contrast

These observations can also be used to explain some of the effects in Figure 8.7b–f referred to earlier. In examples (b) and (c), overlap and tonal contrast have opposing effects and contradict each other so that the overall impression is ambiguous, whereas in examples (d), (e) and (f) the effect of the overlap is so strong that an illusion of depth is created in spite of the tonal contrast being the wrong way round. If the tonal contrast of an ambiguous figure is reversed, as in Figure 9.6e, the triangle appears to float forward from the picture-plane and the depth illusion is much more pronounced.

Colour as a depth cue

The colour effect of aerial perspective, which makes distant parts of a landscape appear blue, has caused the observation that warm colours advance and cool colours recede. The truth of this can be judged by looking at Colour figure 8f, 8g and 8l from a distance of about 1m. Do the three small areas of warm colour in each appear to float in front of the cool coloured backgrounds? Most people find that they do, but warm-cool colour contrasts contribute much more to an illusion of space if they are reinforcing other depth cues.

The use of directional lines: linear perspective

The term 'perspective' properly includes any device used to create an illusion of three-dimensional space on a two-dimensional surface, including the depth cues discussed above. In common usage, however, perspective is usually taken to mean what is properly called linear perspective: geometrical drawing systems which use the directional properties of lines to represent edges, corners and even surfaces in such a way that an illusion of depth is created. There are several ways in which lines can be used to do this, known as projection systems, each of which has its own effects, limitations and advantages (Willats, 1997).

Used on its own, linear perspective can create only limited illusions of depth, so in works of art it is usually combined with other depth cues, especially relative size, overlap and contrast (see examples quoted on p. 102). When trying to see how linear

perspective has been used in a picture, a useful first step is to look for lines, known as orthogonal lines, representing edges which in the real world would be at right angles to the picture-plane. Then look for objects along the orthogonal lines to compare their relative sizes and see how they are arranged in the picture. In one of the commonest projection systems, orthogonal lines converge on a single point, called the vanishing-point: this is known as single-point perspective.

The effect of single-point perspective is shown in Figure 9.7a, a reproduction of an early Victorian engraving. In Figure 9.7b, the main features which contribute to the linear perspective have been traced in outline and the orthogonal lines drawn in, showing the vanishing-point. This church interior had many features which in fact were the same size and regularly spaced. In the picture, those further away are drawn progressively smaller and closer together, much as the marks in Figure 9.1d are. Combined with overlap and aerial perspective, this kind of linear perspective gives a powerful illusion of space and depth. Other projection systems use two or three vanishing-points and yet others none at all, for example in plans and elevations of houses. It is, however, useful for teachers to be able to recognize single-point perspective, because it was used very extensively in European painting after its rediscovery in the fifteenth century.

Figure 9.7 Single-point perspective

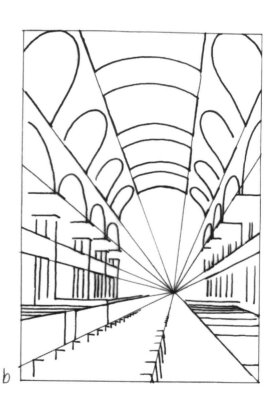

ST BRIDE'S.
Fleet Street.

The development of children's drawing is marked by apparently spontaneous changes in the projection systems they use and their consistency (Willats, 1997). While any attempt to teach linear perspective would probably not be productive at primary level, it may be helpful for teachers to recognize that children of any age vary widely in their use of different projection systems, and that they may use a projection system quite convincingly to represent single objects even though they cannot apply it

consistently to more complex observational drawing. It is also helpful to introduce children to the idea of linear perspective when studying artworks (pp. 102–3), as they can appreciate the skill shown in creating illusions of space long before they are able to achieve the same effects for themselves.

9.4 Objective space in context

If artists working on a flat surface do not create an illusion of depth, space in their work will be objective rather than illusory, but artists in different cultures and historical periods have used this flat space in differing ways. If we set aside the special case of space within pattern and avoid going into too much detail, it can be helpful for children to recognize the basic difference between artworks in which space serves only to separate shapes and make them distinct (passive space) and ways of working which make space play a much more positive role (active space).

Passive space

The use of space as a passive element in design can be found in drawings and paintings from cultures in which perspective was unknown, and appears most clearly when the artistic idiom was narrative or didactic rather than decorative; that is, when the work was intended primarily to tell a story or communicate a message. There are many examples among the wall-paintings and papyri of ancient Egypt and the illuminated manuscripts of the Anglo-Saxons, and Figure 3.9, a child's artwork, provides another (see Backhouse et al. 1994; Appendix 3). All are populated with figures and objects which are skilfully drawn and easily recognizable, but there are few depth cues apart from limited amounts of overlap, so that images appear to be on the picture-plane and the overall effect is very flat. The figures and objects depicted interact with each other visually in ways which reinforce the story or message, but not with the spaces around them, which in both cultures were often filled with writing. Apart from separating the figures and objects represented and allowing them to appear distinct, space has no positive role to play in these designs.

Active space

Objective space plays an active design role in cultures where some kind of perspective is well-known, but artists choose not to use it, concentrating instead on interaction between shapes and spaces on the picture-plane. Used in this way, space plays a positive role both in representational and non-representational, abstract art.

Japanese artists working through the media of brush-drawing and wood-block printing have characteristically used space very dynamically, especially in their studies of plants, birds and insects. In these works, unlike many other kinds of Japanese drawings and prints, there is often very little illusion of depth, but the composition is usually markedly asymmetrical, with shapes counterbalanced against spaces on the picture-plane so that the viewer is given a strong sense of tension and movement. It was these qualities, among others, which led to the strong influence of Japanese prints on European painters such as Paul Gauguin and van Gogh in the second half of the nineteenth century. A masterpiece of the medium, in which shapes and spaces interact very forcibly, is the *Great wave of Kanagawa* by Hokusai, discussed on p. 27 (see also Appendix 5).

A different but related effect is created in the flower studies by the Scottish architect

and painter Charles Rennie Mackintosh (1868–1928). These are more decorative and static than most Japanese prints, with the image placed more symmetrically within the frame, but Mackintosh makes space flow between and around the shapes of flowers and leaves so that they interact, the spaces becoming as active and visually exciting as the shapes (see examples in Billcliffe, 1978).

The interaction between shape and space was also exploited by many non-representational artists during the twentieth century. In his paintings of 1917, Piet Mondrian (1872–1944) experimented with flat coloured rectangles floating in space, for example *Composition in colour B* (see Appendix 5). The shapes are perfectly poised: they interact visually with the space and each other, but there is no sense of movement or depth. Within a year, the shapes in Mondrian's paintings were locked immovably into rectangular grids, but to the end of his life he never stopped experimenting with rectangles of coloured paper, arranged on the white space of his studio wall so that he could study their spatial relationships (Blotkamp, 1994: 160).

It is both interesting and instructive to compare these works of Mondrian with the Suprematist paintings of Malevich, which also use geometric shapes interacting with each other and the space on the picture-plane. Even when using only rectangles, Malevich's effects are more dynamic than Mondrian's because most or all of the shapes are arranged obliquely, as for example in *Suprematist painting: airplane flying* (see Appendix 5). When he uses a variety of shapes, as in his *Dynamic suprematism* (see Appendix 5), the space around and between them becomes still more visually active. The visual activation of space on the picture-plane is also very evident in many of the late cut-outs of Matisse, discussed on pp. 58–9, 88, and it may be helpful to compare the flat compositions of Malevich with those of other artists such as Moholy-Nagy who also used geometric shapes, but in illusory space (p. 103).

Alternation between figure and ground

In all the examples of active space discussed above, shape and space remain distinct. Malevich, for example, avoids alternation between figure and ground by grouping his shapes. Although his compositions overall are dominated by space, within each group shape is dominant over space and there is no ambiguity between them. In contrast, alternation and ambiguity have been deliberately exploited by some artists, notably Nicholson. In many of his paintings, he combines overlap, areas of opaque colour and objects drawn in outline to produce a mosaic whose parts seem to shift subtly on and around the picture-plane. Alternation plays a significant part in creating this effect because the areas are ambiguous, so that they can be interpreted either as shapes or spaces, as in the relatively simple *1934 (Florentine ballet)* and *1944 (three mugs)* and the much more complex *August 1956 (Val d'Orca)* (see Appendix 5).

Shape-dominated compositions

If shapes and the spaces around them are clearly demarcated from each other in a painting or drawing, the composition is most often dominated by space, as in the paintings of Malevich (see above). Some artists, however, have reversed this in ways which can very productively be studied and exploited by children in their own work. Examples include many of the flower paintings by O'Keeffe (for examples see Benke, 2000), and some of the travel posters by the French graphic designer A.M. Cassandre (1901–68). Both exploited the illusion that a shape which almost fills its frame seems to press outwards, giving an impression of size and power. O'Keeffe studied large

flowers, and by making her larger-than-life images of them fill the frames she not only makes them appear even larger, but also draws the viewer's attention to their sculptural qualities and the sense of movement which they convey. It is interesting to compare her paintings with the much more poised and delicate studies by Mackintosh (see p. 101).

Cassandre's real name was Adolphe Mouron. Particularly in his posters advertising ocean liners such as the *Normandie* (see Appendix 5), he began with subjects which were huge and by this same frame-filling technique made them appear gigantic. In the *Normandie* poster, scale is further distorted by the images of seagulls, which are much smaller than they would appear in reality. Although tone is used to indicate form, there is very little illusion of depth in the image: the liner appears to be right on the picture-plane and about to surge forwards out of it. A significant point is that both Cassandre and O'Keeffe worked from first-hand observation and concentrated on unusual views. O'Keeffe takes the viewer right into the flower, and Cassandre's 1935 design was arrived at only after he had visited Le Havre and rowed round the new ocean liner in a small boat to experience its size visually from water-level, something potential passengers were unlikely to do.

In shape-dominated compositions the remaining space is still very important. Look at a shape-dominated picture and observe its effect. Then reduce or eliminate the space by covering the edges with white paper. The visual impact and excitement generated by the composition is very much reduced.

9.5 Illusory space in context

From the Renaissance until the end of the nineteenth century European painting was dominated by illusionistic representation, the kind of painting which aims to give the viewer an illusion of looking through a window at a three-dimensional world beyond. As a result, almost every Western landscape or interior painted between 1450 and 1900 makes use of depth cues and perspective (pp. 95–100) to create an illusion of three-dimensional space.

Observing illusory space in painting

It can be a useful and amusing exercise for children to look at a selection of paintings, to observe the ways in which depth cues and perspective have been combined in them and to assess how successful the resulting illusions are. One interesting way to do this is to select three or four paintings which are widely separated in terms of date, content and style, and see how much they have in common in terms of illusory space. Three examples are: *The martyrdom of S. Sebastian* by Antonio and Piero Pollaiuolo; *The Avenue, Middelharnis* by Meyndert Hobbema and *Bathers at Asnières* by Seurat, all of which are in the National Gallery, London (see also Appendix 5). Although the three paintings vary widely in date, subject, style, composition, size and method of painting, they are remarkably similar in the way that depth cues are used to create illusory space. The artists who painted them were highly trained and had a thorough understanding of depth cues and the rules of perspective, so it is instructive to compare their work with that of a great painter who did not.

An outstanding example is *Tropical storm with tiger (surprise!)* by Rousseau (see Appendix 5). In this painting, also in the National Gallery, London, the artist has used

Inconsistent all the major depth cues, but none is employed consistently. There are, for example,
depth cues obvious anomalies in the overlap between the tiger's hind leg and the grass, and in the
sizes of leaves in the middle of the picture. The overall effect is to reduce the illusion
of depth and to flatten the whole composition on to the picture-plane, making it much
less convincing as a three-dimensional illusion but much more visually exciting and
interesting as a painting. Mocked by the critics of his day, Rousseau was befriended by
Picasso and other young modernist painters, perhaps because they recognized that
along with the dreamlike intensity of his subjects he had found a way to free painting
from the reliance on perspective and illusion which had dominated Western art for
so long.

Illusory space in abstract art

Although much non-representational or abstract art emphasizes the flatness of the
picture-plane, some artists have used illusions of depth in their explorations of colour,
shape and space. A simple and elegant example by Moholy-Nagy is *K VII* (see pp. 87–8
and Appendix 5), in which the foreground shapes are repeated at a reduced scale and
with less tonal contrast in the background to give quite a strong illusion of depth, a
device he used in several other paintings.

Klee also investigated illusory space in a many different ways, as for example in his
Uplift and direction (glider flight) (see Appendix 5). In this and other similar paintings
Klee is playing both with the rules of perspective and with our tendency to try to make
sense of what we see, to create ambiguous and impossible figures. The result is illusions
within a space which is itself an illusion, but because all Klee's construction lines form
part of the painting it is possible to see exactly how he has achieved his effects. This
aspect of Klee's work may also be linked to the puzzling and occasionally disturbing
images of Escher, which children usually find fascinating (see p. 36; Escher, 1992).

10 Form

10.1 The concept of form

The concept of form in art should be a simple and well-defined one, but it is not. This is because critics and art writers have used the term 'form' in two quite distinct but confusing ways.

Two concepts of form

In one of its meanings, form in art is a very broad term, a verbal shorthand for the formal properties of a work of art such as the arrangement of shapes and colours in a painting or line and tone in a drawing; in other words, all the properties which are the starting-points for the discussions in this book. When the term 'form' is used in this way the writer is distinguishing the formal properties of a painting, drawing or sculpture from its content, by which is meant the idea, story or message it is intended to convey. This concept of form is wide, but its usefulness is limited, because it means little if applied to works such as abstract, non-representational paintings or patterned textiles which have no content. It is not the concept of form which is used in this book.

The second concept of form, which is the one used here, can be stated very simply: it is the three-dimensional analogue of shape. Whereas an image on a surface has shape, a solid object has form.

Relating form to the other visual elements

Describing in words the ways in which form is related to the other visual elements is fairly simple, but understanding what it means in terms of experience and practice is likely to be a long-term personal process for anyone. A solid object has surfaces, to which any of the other visual elements can be applied. We can draw on these surfaces with points or lines and use tone and colour in shapes, textures and patterns in any way which can be used on a flat surface, but in addition we can interact with solid objects in a much greater variety of ways. We can not only look at them from many different positions (pp. 106–8), but we may also be able to explore their tactile properties by touching and handling them. What the solid object does is to add, quite literally, another dimension. Our experience of its visual and tactile properties is varied in different ways from when looking at or touching a flat surface, but these variations are not simply or wholly a property of the object. They are something which we ourselves create through the way we interact with solid objects as we look at, touch and move in relation to them.

Form and space

Before looking in more detail at some of the ways in which we investigate and respond to solid objects through vision and touch, it is helpful to think a little about the different ways in which forms interact with the space around them. There are three of these, all of which can be demonstrated very simply using a thin-walled box whose ends can be removed, together with a piece of string. The box can be any shape; a cylinder is just as useful as a cube or cuboid.

Interactions between form and space

The most obvious spatial property of any form such as a closed box is that it occupies space (Figure 10.1a). Whether the box is hollow or solid like a brick makes no difference to the way we perceive it: visually it is a form which occupies space. The second kind of interaction between form and space is seen when one or both ends of the box are removed. The thin walls of the box still occupy a small amount of space, but this is very little in comparison with the space which is contained if the form is hollow, or defined if we can see right through the form (Figure 10.1b). The third kind of interaction occurs when the form moves through space. This can be shown by spinning a box on one corner, suspending it from a string like a pendulum (Figure 10.1c) or attaching it to the string so that it can slide along.

Figure 10.1 Forms in space

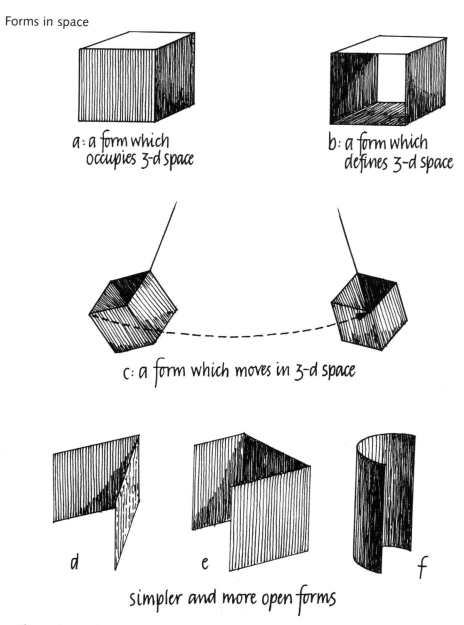

a: a form which occupies 3-d space

b: a form which defines 3-d space

c: a form which moves in 3-d space

d e f

simpler and more open forms

If simpler and more open forms are made, such as two or three plane surfaces joined together or half a cylinder (Figure 10.1d–f), children can see that they still define space, but less emphatically. Although children are likely to be interested mainly in visual effects, this difference between more closed and open forms can be experienced in a very direct and memorable way, by comparing the limited feeling of shelter and

enclosure when standing in the angle between two walls, with the effect of being in a tunnel, cave or doorway and looking outwards.

A simple experiment like this makes the more general point that the visual properties of any object are a result of the ways in which we experience and interact with it. For example, if we are outside a building we usually view it as a form which occupies space, but when we are inside we experience and respond to the space which it contains or defines. Our response also depends not only on the form of the object but also on its scale: how big or small it is in relation to our own body size. We do not respond to a small model of a large building in the same way as we do to the building itself when we are close to or inside it. Visual interest and excitement are likely to be generated when we encounter forms, whether natural or man-made, which we perceive as interacting with the space around them in novel and unexpected ways. Visual perception is not something which happens to us: it is an activity in which we engage, involving interaction between ourselves and objects or images in our environment. To interact fully with three-dimensional forms, however, our activity has to be physical as well as visual and mental: either we, or the object, or both, have to move in relation to one another. Realizing this is a good starting-point for developing an understanding of the visual properties of form.

10.2 The visual properties of form

Much of our everyday lives is taken up with observing and interpreting both two-dimensional images and three-dimensional objects. For most people these activities become habitual, making it easy to forget that shapes and forms have fundamentally different visual properties. Much of twentieth-century sculpture was concerned in one way or another with investigating the visual properties of forms. To do this, sculpture has to challenge our visual laziness, and children can start to do this for themselves by observing images and objects as they move in relation to one another.

Visual differences between shape and form

The most important visual difference between shapes and forms can be perceived by way of a simple thought experiment which can quite easily be carried out in reality. Imagine walking into a rather dimly lit room. On the opposite wall is what appears to be a cube suspended (Figure 10.2a). Even without walking up to it and touching it, it is possible to tell whether it is a three-dimensional object (form) or a two-dimensional image (shape), simply by moving sideways and observing how its appearance changes. If it is a flat image, it will become distorted but what can be seen of it will not otherwise change (Figure 10.2b). If it is an object, not only will the shapes of its faces seem to change as the observer moves round it, but some parts will become hidden and others come into view (Figure 10.2c).

Comparing objects and images

Similar simple observations should be carried out by children, first by moving in relation to large objects and images such as buildings, rooms, trees and posters, observing them carefully all the time to see how their appearance changes. Second, they should hold and turn small objects and pictures in their hands and observe them. In both cases the important point to observe is that while an image becomes distorted as it or the observer moves, an object does not, though what can be seen of it will change. Such observations are important not only because they show the

differences between shapes and forms, but also as a means of exploring the visual properties of the three-dimensional world around us.

| **Figure 10.2** | Object or image? |

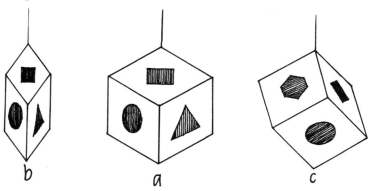

If we move in relation to what we see (a), its appearance changes in different ways, depending on whether it is a 2-d image (b) or a 3-d object (c).

The visual potential of form

Apart from special cases such as trick pictures, advertisements in the open air at televised sports events and lettering on roads, images are designed to be viewed along a line at right angles to their own flat surfaces, known as the picture-plane. If the image is viewed at an oblique angle to the picture-plane, it is distorted (Figure 10.2a, b). But three-dimensional objects can equally well be viewed from any position, or many in succession. As a viewer and an object move in relation to one another the appearance of the object will not be distorted, but in nearly all cases it will change, as shown by Figure 10.2a and 10.2c, the only exception being a perfect sphere of uniform colour with no shadow on it. To put it another way, the appearance of a form or three-dimensional object is infinitely variable without distortion, whereas the appearance of a shape or two-dimensional image is not. What this means is that the visual possibilities offered by most three-dimensional objects are literally infinite: from every position there is something new to be seen.

To become fully aware of the visual possibilities of forms, we have in a sense to reverse the visual habits of a lifetime. Through observing and physically interacting with them we know that objects such as tables, chairs and houses do not change spontaneously, so we learn to identify them, think of them and respond to them as single forms. To perceive the visual and tactile possibilities of the forms around us and those we make, we need to become much more conscious than we usually are of what actually is being presented to our view: to stop seeing habitually and start seeing critically (pp. 6–7). This can be done only through personal, first-hand observation, but to be fully effective the learning process cannot be confined to seeing and touching: it must also involve designing and making.

Investigating the visual properties of forms

Children's own work in designing and making forms is most likely to be productive if they have the opportunity to investigate a wide range of objects, both natural and man-

made, by handling them as well as observing them visually. The objective is not only to give them ideas but also to help them develop their ability to observe critically, which is essential if they are to understand the visual potential of form.

Analysing forms

For some people at least, learning to see forms in this way can be facilitated by looking at them quite analytically to begin with. One way to start is to identify corners, edges and surfaces much as one would do when working with geometrical solids in mathematics. Most natural and many man-made objects are more complex than ideal forms such as cubes and tetrahedrons, so describing them requires a much wider vocabulary, but some of the simpler characteristics to look out for are as follows.

1 Corners: sharp (pointed), blunt (rounded);
2 Edges: sharp (well-defined), blunt (rounded), straight, curved, wavy, zig-zag;
3 Surfaces (form): flat, rounded, undulating, convex (bulging), concave (hollow);
4 Surfaces (texture): rough, smooth, ridged, hairy, slippery, patterned.

Finding and making simple forms

Looking for and talking about the various of characteristics of contrasting forms such as a hen's egg, a cuboid wooden building-block and an irregular piece of broken stone can help children to start developing an understanding of their visual and tactile properties. An egg, for example, is a simple form with one curved smooth surface and no corners or edges, but if it is broken in two, what form does half the shell have? It is hollow, with two curved surfaces, one concave (the inside of the egg) and the other convex, and a sharp, jagged and curved edge between them. It is also much more interesting visually than the intact egg.

In a similar way, children could look at an orange, then remove its peel in four equal segments and observe how the forms, and the visual interest they generate, have changed. What makes forms visually stimulating is the way in which their surfaces, edges and corners seem to shift and change in relation to each other, and the space around them, as our viewpoint is altered.

Investigating forms in the wider curriculum

Very often, investigating visual properties need not be undertaken as a special activity: it can form part of work in many areas of the curriculum, including mathematics (forms of geometrical solids); science (natural forms such as bones, feathers, fruits and rocks; man-made ones such as trolleys, cogs, bicycles and other simple machines); and history (artefacts brought into school or seen in museums). Look at the characteristics of each form and the ways in which it interacts with space (Figure 10.1). Many forms interact with space in two ways, and some in all three ways at once. How does the appearance of the form change as it or the observer moves? If children become accustomed to questioning and observing in this way, they will not only learn a great deal about the properties of forms, but will also be in a strong position to make interesting forms of their own and appreciate the achievements of sculpture, particularly that of the twentieth century (pp. 117–19).

Combining vision and touch

Children's learning about form should involve touch as well as vision. Turning over smaller objects in one's hands, or touching and stroking larger ones, give sensations and information about surface properties which merely looking, however intently,

cannot do. Vision and touch together can give a much more complete experience of a form, and therefore result in much more effective learning about it, than either can do alone. Together, they can also evoke in children a much wider range of response than vision alone is likely to do, though many adults (at least in the United Kingdom) are reluctant to investigate through touch, seeming to regard such a directly sensuous activity as vaguely improper.

10.3 Investigating form: moving into the third dimension

As we have seen, even simple three-dimensional forms can offer a very wide range of visual possibilities. One consequence of this is that starting to work with them can be challenging and even daunting. How does one begin? Detailed instructions on techniques and the use of materials are available in many books, but it may be useful here to suggest a few starting-points. There are many different routes, but one which has been very successful is to begin with shapes and flat surfaces, or even rods and sticks, and in different ways to learn about the properties of the third dimension by moving into or constructing it. This approach has many advantages. While reducing technical demands to a minimum it offers children the opportunity to try out a range of techniques. At the same time it can also help them to understand by many methods the relationships between shape and form, in particular the differences between their visual and tactile properties. To understand how children can make, investigate and learn in this way we need first to look briefly at the three basic techniques used in sculpture.

Three forms of sculpture

The making of three-dimensional forms in art can usefully be thought of in terms of three basic processes: subtraction, addition and construction. A fourth technique, moulding, may be used in addition to any of the three basic ones and is briefly discussed on p. 115).

Subtraction Making a form by subtraction involves starting with a block of material, traditionally wood or stone, and removing material from it. Since prehistoric times, statues and ornamental work in wood and stone have been produced by subtractive techniques such as splitting, cutting, carving, drilling and abrasion. Although it is useful for childen to recognize such techniques, few primary schools are likely to have the specialized equipment and facilities needed to carve materials safely, so subtractive methods are not discussed further here.

Addition Creating forms by addition involves a range of techniques known as modelling. Materials used in modelling are soft solids which have no definite shape of their own but which can be pulled, pushed, twisted and joined into forms, and which do not spring back when released (i.e. they are, in the scientific sense, plastic). Some can be hardened to increase their durability. Examples include modelling clay, pottery clay, salt dough and papier-mâché.

Construction This method has been used for centuries for making buildings, machines and other artefacts, but it achieved prominence in Western art as a means of making sculptural forms only in the twentieth century (p. 118). It is an additive process,

but differs from modelling in that forms are built using materials and objects which keep much or all of their given shapes, though these may be modified by bending, folding, cutting or melting. Children may use materials such as canes, dowels, paper, card, glue, wire, threads, beads and other small objects in their constructions.

Additive sculpture: modelling in relief

The most commonly used materials for modelling are: modelling clay, which stays soft indefinitely; pottery clay which can be hardened permanently by being dried and then fired in a kiln; salt dough which can be baked to harden it and then painted; and papier-mâché which can be hardened by drying and then painted. Forms can be made with hands, fingers and simple tools to press, roll and pinch materials into shape, and pieces can be joined by pressing them together and smearing over the joint.

Pressing and pinching

When working with modelling clay, pottery clay and salt dough a good starting-point is to cut a shape from a fairly thick, rolled-out slab on a modelling board. The surface of the slab is then indented by pressing and raised by pinching, and pieces rolled between hands or fingers or cut from slabs are added to build up the form above the original surface. Pottery clay and salt dough need to be wetted before being pressed and joined on by pressing and smearing over the joint, or they will not adhere. Stiff papier-mâché can be modelled directly on to a board such as stiff card covered with polythene, and has the added interest that the forms produced will shrink and distort as they dry out and harden.

Simple faces or decorative motifs and patterns are good subjects to begin with because they can be elaborated on as the children become more engaged and technically confident. The further the form reaches up and away from the original surface, the greater the possibilities for visual variety and interest. At every stage, children should be encouraged to look at their work from different angles to observe how the visual properties of the form are changing and developing.

Once children have developed some confidence in working with their materials, modelling can be extended in many different directions. A particularly productive route is to move towards making forms which define or contain space (p. 105). This can, for example, be done by building up hollow forms from slabs or coils of clay, and by modelling papier-mâché on to a form made by pasting layers of torn paper over a balloon or plastic box and then drying it.

Construction

Construction offers children greater scope for creative possibilities than any other basic technique available in primary schools. They are likely to learn most effectively if their construction of forms involves many different processes rather than only one or two, and they work with commonly available materials rather than pre-formed kits. Even with materials likely to be easily available the possibilities for constructive sculpture are various, and though only a few of them can be discussed here, some general points may be made.

Decoration and large-scale work

First, it is assumed that children will develop their constructions with colour, using contrasts of hue and value to increase the visual interest and variety of their work. Visual texture and coloured patterns, though they can be lively and interesting, need to be used with caution as they can be distracting and reduce the overall visual effectiveness of the form. Secondly, children need to be given the opportunity and encouragement to work on a wide range of size scales. Large-scale work is likely to be particularly stimulating. If a small form (known to sculptors as a maquette) looks promising, it is usually worth attempting (if materials are available) a greatly enlarged version and comparing the two, since the ways in which viewers interact with each of them visually are likely to be significantly different.

Finally, it should be noted that the construction and display of forms creates excellent opportunities for children to work experimentally and, with the teacher's help, collaboratively. Even more than in other areas of art it may be unhelpful to have too fixed an idea of what form the work will finally take. Children are very likely to perceive opportunities to develop their work in unforeseen ways, but may need positive encouragement to exploit them. It is also often helpful to work collaboratively. Simple forms can be made by individuals who use them to contribute to larger and more complex groupings such as mobiles, in which the forms interact visually with each other as well as with the space round them. Quite small and simple forms such as those shown in Figures 10.4, 10.5a and 10.7 can be very effective when grouped like this.

Construction with rods and sticks

Making forms from rods

Developing forms from rods is the most basic form of constructive sculpture, though not the easiest. A rod is in effect a solid line, so that if two rods are joined at an angle to one another they make, or at least imply, a shape in two dimensions. If a third rod is added at right angles to the other two, a three-dimensional form is produced (Figure 10.5b). Sticks should be tied together firmly, and though string can be used, plastic-covered garden wire twisted and cut with pliers may be more effective. Adult help may be needed and care should be taken when using wire to tuck the cut ends in securely. The basic three-stick form can be free-standing or suspended and can be varied in many ways, for example by using curved, crooked or branched sticks instead of straight canes. Any form made from canes, sticks or dowels can be developed further, for example by fixing wires or hanging objects from the arms, or by glueing threads and shapes between them (Figure 10.5b).

Rods in base-boards

Fixing rods into a base-board in lines or groups can also be a successful method of construction, but requires children to drill the base and glue the rods in with some precision if it is to be effective. Stripped and dried willow stems used for basket-making are a particularly good material for the rods. Yarns and plant materials can be woven between the rods once they are fixed in place.

Construction with sheet materials: folding and bending

Sheets of thin and thick card are probably the most versatile and adaptable materials for constructed sculpture. Five basic ways of using them which are especially successful are: folding and joining, bending and joining, slotting, rotating and

stacking. Thin, flexible card is more useful for folding and bending, but corrugated box-card, which is stiffer and freely available from shops and supermarkets, is better for slotting, rotating and stacking.

Folding and joining

Folding and joining can begin with nets of cubes and other geometrical forms, which children may already have cut and constructed in the context of mathematics. If shapes are cut from the net, the resulting form will become visually much more complex than the basic one if contrasting colours are applied inside and out before it is finally assembled (Figure 10.3). If these forms are suspended they can interact with space in all three ways shown in Figure 10.1, occupying, containing and moving through space as they swing or rotate. Make much larger versions by using thick box-card.

Figure 10.3 Making a form by folding and joining

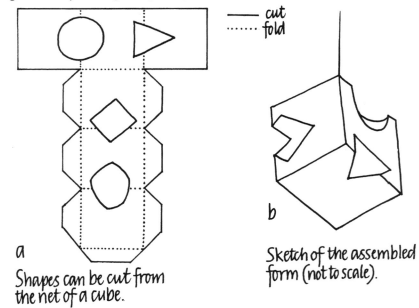

— cut
······ fold

a

Shapes can be cut from the net of a cube.

b

Sketch of the assembled form (not to scale).

Bending and joining

In contrast to the angularity of folded forms, those made by bending and joining, as shown in Figure 10.4, have beautifully curved surfaces and edges. To make these, thin card or even thick paper should be used because thicker card will not bend evenly. The best results are usually obtained by starting with simple geometrical shapes; those illustrated in Figure 10.4 were all made from squares. Corners can be joined with a thread and glue as in Figure 10.4a; edges with paper strips and glue, as in (b) and (c). A great variety of forms can be produced, depending on the angle of bending and the extent of the joints and overlaps, but those made from the same shape will usually retain a family resemblance and are likely to combine very well in groups, for example suspended as a mobile. Here again, strongly contrasting colours can make the forms visually very stimulating, but it is usually easier to do any coloured decoration before the sheet is bent and glued.

Figure 10.4 Simple forms made by bending and joining

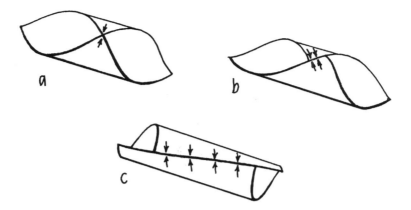

Construction with sheet materials: slotting, rotating and stacking

The other three methods require thicker and stiffer card, such as corrugated box-card, cut with some precision using a craft-knife.

Slotting

Slotting Slotting is a method of joining, in which slots of equal length are cut in the two pieces to be joined. The width of each slot should be just less than the thickness of the card, so two parallel cuts are usually needed. The shapes are then joined by sliding them together more or less at right angles, as shown in Figure 10.5a, so that they make a three-dimensional form. The shapes, number of components, direction of the joints and forms which they produce are of course extemely variable, and children can experiment with different arrangements before fixing the pieces in place with spots of glue. A basic form such as that shown in Figure 10.5a can be free-standing or suspended, and can be coloured or have threads stretched between its edges and objects hung from or glued on to it.

Figure 10.5 Basic forms made by assembly

Broken lines show how threads and card shapes can be glued on.

a: slotted card shapes

b: canes tied together

Rotating

Rotating Constructing sculptures by rotation requires short lengths of plastic-covered garden wire and stiff card, paper and glue. If shapes are cut in the card within each other, as shown in Figure 10.6, they can then be attached to the wire with paper and glue so that they can be rotated in either direction to make an infinite variety of forms. The way in which something flat and visually simple turns into a complex, three-dimensional form as the shapes are rotated is almost like a conjuring trick, the nearest one can get to instant sculpture. Again a basic form can be developed in many ways using colour and applied materials such as threads, beads, small stones, shells and seeds, but this method is particularly suited to scaling up. Making a large-scale construction on the basis of a small one which looks promising may produce quite spectacular results.

Figure 10.6 Making a form by rotating shapes

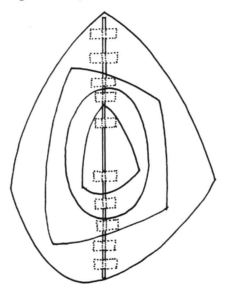
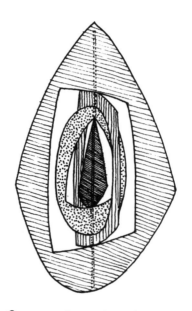

a: Shapes cut and attached to wire with paper & glue.

b: Shapes coloured and rotated around the wire.

Stacking

Stacking Making a form by stacking need not be technically demanding, but it does require patience to draw and cut at least ten similar shapes from thick, stiff corrugated box-card. These are then stacked so that the shapes reach into the third dimension and a form is built up (Figure 10.7). Interesting forms may be produced if the shapes are simply stacked vertically, but more exciting results are likely if each shape is moved slightly in relation to the one under it in a systematic way. To produce the form shown in Figure 10.7b, for example, the shapes were rotated. Different arrangements can be tried out before glueing the shapes in place permanently. If large forms are made in this way it is possible to cover their sides with glued-on paper pieces and so produce fairly smooth surfaces which are easier to paint.

Figure 10.7 Making a form by stacking

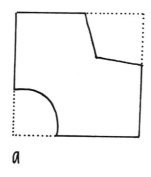

a *b*

Moulding

Moulding is not really a basic method of form-making. It is, rather, a method of reproducing a form made by carving, modelling, or construction, using a material which starts as a liquid and then becomes permanently solidified. In most moulding the original form is used to make a hollow negative form (the mould), traditionally in clay or special sand. Materials used for casting since ancient times include metals (especially bronze and lead) and plaster; modern ones include plastics and synthetic resins reinforced with fibre-glass.

SAFETY NOTE: Care should be taken when mixing the plaster not to inhale any of the powder.
■ Waste plaster must never be put down a sink.

Small-scale moulding and papier-mâché

Children can carry out small-scale moulding by pressing forms such as shells and fossils into modelling clay and pouring liquid plaster into the impressions. Dental plaster or plaster of paris stays liquid only for a few minutes and solidifies very quickly, but household fillers set more slowly.

The most interesting and versatile moulding material children are likely to use is paper, torn into pieces and pasted or glued on to the outside of forms such as balloons or plastic boxes, and left to dry. Papier-mâché can be modelled on to box forms made in this way to decorate them, and a paper shell made over a round balloon can be cut in two lengthways and used as the basis of two masks. When moulding and modelling in this way, make sure the dried base-form is coated with glue or paste before applying the paper-mâché, or it may not adhere.

10.4 Form in context

We live in a world of forms, seeing, touching and interacting with hundreds of them during every normal day. In spite of this, helping children to an understanding of how form has been used in art is likely to present teachers with difficulties. This is because, if they are to be understood, sculptures and other forms must not merely be seen: they must be experienced. Images of forms, even the best of photographs, are of very limited use in this process. We have to confront and interact with the objects themselves if we are to understand them.

In order to experience sculpture at first hand children will have a great advantage if teachers find out what sculptural resources there are in galleries, sculpture parks and

other public places within reach of their schools, and become acquainted with these before arranging a visit. It is helpful to bear in mind here that, while many kinds of sculpture can be valuable and significant educational resources, by no means all sculpture is significant as artwork, and by no means all forms from which a lot can be learned are sculptures in the generally accepted sense of the term. For example, commemorative statues are often visually unexciting and placed so high up that they cannot be investigated visually, though the form of the horse in equestrian statues, usually seen from below, is interesting even when the human figure is not. But buildings, furniture, decorative work in stone, wood and brick, as well as objects from cultures distant from our own in space or time may have much to offer. If galleries and sculpture parks are out of reach, local museums, churches, mosques, temples and other buildings may provide valuable and accessible resources in the community for the study and enjoyment of forms.

When children have the opportunity to experience and interact with sculptures and other artefacts, they may need help to investigate them visually (pp. 107–9). The key is to move round the work while at the same time (as far as safety allows) observing how its appearance and its interaction with space change as the viewpoint shifts. Children's interest and active participation are likely to be engaged more readily if they can find out who made the objects being observed, when, where and for what purpose. They may also more easily gain ideas which they can use in their own work if information is available on the materials, tools and methods used.

Sculpture before the twentieth century

Most Egyptian, Greek, Roman and European sculpture, from ancient times to the end of the nineteenth century, was either ornamental or represented human and animal forms. Works were either carved from wood or stone, or modelled in a soft material and cast in a durable one, usually bronze. Apart from decoration, the purpose of most of them was religious, political, or civic: to proclaim an idea or message, or to perpetuate the remembrance of a person or event. This tradition persists down to our own day. To represent the mortal body or the insubstantial idea in a solid and durable form was, and still is, seen as a substitute for immortality.

At its best, representational sculpture is very powerful, but its effectiveness as a means of communication can make it difficult to use work of this kind to learn about the visual properties of form. We want to look at the means and learn about the medium, but the message is so strong that it gets in the way. One solution, in looking at sculpture before the twentieth century, is to concentrate on simpler artefacts which are easier to understand as forms because their emotional impact on us is less immediate (though it may have been very strong on those who made them). Cultures in many parts of the world and at different historical periods have produced simplified, stylized forms for a wide variety of purposes, many connected with religion and ceremony. Examples which are likely to give children ideas for their own work include the following.

Cycladic art Stones, ceramics and metals. From the Cyclades islands in the Aegean Sea, made during the Bronze Age (c. 2000–1400 BC). Particularly notable are the very simplified and stylized marble statues, and the ceramics decorated with figures and patterns painted in earth pigments. There is an extensive collection in London, at the British Museum.

Church architecture and decorative work Mostly carved stone and wood. In Britain, made during the Norman and mediaeval periods (11th–15th centuries AD). The stonework of supporting columns and arches, windows, doorways and fonts and the woodwork of pews and choir-stalls are all likely to be rewarding. Much of the ornamental work is in relief and uses motifs (including comic and grotesque faces) which children could draw and use in their own modelling. The best source of information for England is the series of handbooks by Nikolaus Pevsner.

Inuit sculpture Carved soapstone, bone and ivory from walrus and narwhal. Mostly North-eastern Canada, made by the Inuit ('Eskimos') of the Arctic. Beautifully simplified figures of animals and people, notable for the way they convey the spirit of the subject, and for the sensitive use of some given forms, for example whale vertebrae and curved walrus tusks. There is still a vigorous and developing tradition of Inuit art. Examples are in many museum and gallery collections.

African sculpture In a wide range of materials, though carved wood is the commonest. African sculpture is enormously diverse, and a wide range of objects have found their way into museums and galleries in the United Kingdom, mostly as a result of nineteenth- and twentieth-century colonial exploitation. These include figures, masks and small furniture in a wide range of styles and materials. The cast bronzes and carved ivories of the Benin culture from modern Benin City in southern Nigeria, are justly famous, but some sculpture being made at the present time, for example in Zaire and Mozambique, deserves to be much better known. African sculptures seen in Parisian museums were highly influential on many European artists early in the twentieth century, including Picasso, Braque and Derain. Examples are in many museum and gallery collections.

Twentieth-century sculpture

During the twentieth century, sculpture ceased to be solely or mainly concerned with decoration or commemoration. Of the many goals which sculptors pursued, the most relevant to children's work and learning is their investigation of the properties of form and our responses to it. Some of the sculptures produced as part of this exploration are abstract; that is, they are simply objects in their own right and do not seek to represent things which exist elsewhere in the world. But many sculptors used and still do use real objects, including the human body, as their starting-point, but then demonstrate their artistic expression by manipulating the form. This has often resulted in drastic simplifications and distortions which puzzle and even offend viewers who misunderstand the artist's purpose and expect a sculpture to faithfully represent its title.

The exploration of form was stimulated and influenced by the kind of simplified, stylized forms which have been discussed briefly above, but other influences were also significant. One of these, which is particularly relevant to children's work, was the influence of machine culture, industrialization and mass production on the development of constructive sculpture, a medium which takes machine products and transforms them into works of art while allowing them to keep their own identity.

The way in which children are introduced to modern sculpture will depend largely on the resources available, but it may be helpful to identify a few recurrent themes and to mention names of sculptors whose work will reward investigation. In the brief review

which follows, attention is directed towards sculptors whose work is well-represented in British collections, especially in London's Tate Modern and Tate Britain galleries.

Simplification and stylization

Constantin Brancusi (1876–1937) was a Romanian who worked mostly in Paris and mainly in carved wood and stone. He eliminated all decorative elements from his work and simplified forms to an extreme degree, in works which range from the bulky and powerful to the graceful and elegant, for example *Fish, Maiastra, Sleeping Muse* and *Bird in space* (see Appendix 5). Quite apart from the works themselves, Brancusi's achievement was to make other sculptors once more conscious of pure form as an end in itself, and this marks him out as one of the most influential artists of the twentieth century. The British sculptors Henry Moore (1898–1986) and Barbara Hepworth (1903–1975) were both strongly influenced by Brancusi and both worked with simplified forms. Most of Moore's work was based on the human figure, for example *Recumbent figure, Seated woman* and *Family group*, but he also developed much more abstract forms, such as *Four piece composition: reclining figure* and *Three points*. Hepworth's work became increasingly abstract as she moved into the exploration of pure form. Compare, for example, *Figure of a woman* and *Seated figure* with the later *Three forms, Two forms* and *Ball, plane and hole* (see Appendix 5). Both worked in a wide range of sizes and media, carved wood and stone, modelled plaster and cast bronze, and both had a particular sensitivity to surface texture.

Construction

Picasso made some of the first constructed sculptures about 1912 from card, thin sheet metal and everyday materials from his home and studio. The idea was quickly taken up and exploited in Russia by a group who called themselves the Constructivists. The most influential was Naum Gabo (1890–1977) who, trained as an engineer, developed many purely abstract constructions using different materials, starting with models (maquettes) which formed the basis for large versions. Compare, for example, *Model for 'Constructed torso', Model for 'Column'* and *Model for 'Rotating fountain'* with *Head No. 2 (enlarged version)* which is a large steel sculpture based on a small card maquette (see Appendix 5). It was Gabo who first experimented with kinetic sculpture, which is designed to move through space, for example *Kinetic construction (standing wave)* (see Appendix 5). Children often find his work highly stimulating and a fertile source of ideas. Another influential sculptor who worked largely through the medium of construction was an American, Alexander Calder (1898–1976). In the mid-1920s he began to make sculptures from bent wire and in the 1930s invented mobiles. These are balanced hanging structures, often very large, whose components move through space impelled by air currents and whose appearance changes constantly with movement and light conditions. Children may be familiar with both wire sculptures and mobiles, but seeing an original Calder will be a revelation (see Appendix 5).

Human and other figures

Although much twentieth-century sculpture is abstract, the bodies of animals and humans have remained powerful themes in the exploration of form. Whereas sculptors like Moore simplified the human figure, others have elaborated on it and distorted it. Influential sculptors who worked in this way include Picasso, who produced much modelled and constructed work, and Alberto Giacometti (1901–66), a Swiss sculptor

and painter, much of whose later work is based on very thin, elongated, roughly textured figures which are highly emotionally expressive and usually tragic, for example *Man pointing* (see Appendix 5). In complete contrast is the work of the British sculptor Elisabeth Frink (1930–93). Although some of her earlier work is highly simplified, most of it is very obviously figurative, but with an extraordinary power of suggesting tension, menace, movement and sometimes all three together, which has the capacity to bring the viewer's attention back to the form and its visual properties, for example *Bird, Harbinger bird IV* and *Goggle head* (see Appendix 5).

11 Texture

11.1 The concept of texture

Although texture is often considered to be one of the visual elements of art, it is not a simple property. Texture has to do with the quality of surfaces, not only as these are sensed by touch (tactile texture), but also as we see them (visual texture). Concepts of texture are not precise, and expressing them in words is difficult. Even more than when learning about other visual elements, each person's idea of texture has to be built up from experience.

Two kinds of texture

The original and basic meaning of 'texture' has to do with tactile qualities: what a surface feels like when it is touched. These qualities are, however, connected in a very obvious and direct way to visual properties, since we often see a surface before we touch it and can successfully predict what it will feel like. This has resulted in the term 'texture' being applied, particularly in art and craft work, to visual as well as tactile qualities.

Both visual and tactile texture are defined by their unevenness. If a surface feels perfectly smooth and looks perfectly uniform, as for example smooth polished metal and some moulded plastics do, it has no tactile or visual texture. But in fact most natural surfaces and many man-made ones are neither smooth nor of uniform appearance. They have irregularities such as furrows, dents and ridges, and projections which may be rounded or angular, as well as variations of tone and colour. It is combinations of these variations, their size in relation to ourselves and the way we perceive them, which give rise to texture, both tactile and visual.

Relating texture to the other visual elements

The quality of surfaces, as we perceive them by touch and sight, can be made up or at least affected by any of the other visual elements (Figure 1.2). Texture is rather like space as a visual element, in that it plays a very positive role in art and craft, but it sometimes seems easier to say what it is not than what it is. Texture is not shape, form or pattern, but it is related to all of them.

What makes texture distinctive is the scale at which shapes, forms or patterns occur on a surface. If each individual element is small enough, we will not be able to distinguish them at all and finger-tips or eyes will perceive only an apparently uniform surface. For example, the shell of a hen's egg seems to be smooth, but if it is viewed through a microscope we will find that it has a beautiful texture, though at such a tiny scale that we cannot detect it unaided. But if the individual elements are large enough, they will be felt or seen as forms, shapes or patterns rather than as texture. If you sit on a flat sandy beach you are likely to be very aware of the sand's texture, especially if it gets in your clothes, whereas if the beach is made up of large, rounded cobbles and boulders you are not likely to be aware of texture, but of individual forms being pressed into your skin. If either beach is viewed from a cliff-top, however, the scale is altered:

the sandy beach is likely to appear as areas of colour with no texture, whereas the pebble beach will have a distinct visual texture though the individual stones will not necessarily be clearly distinguishable.

The idea that texture occupies an intermediate position in our sensory world between the large and the small is a useful one, because it helps us not only to understand what texture is, but also to begin investigating it.

11.2 Tactile texture

Developing the idea of tactile texture

Like form (Chapter 10), tactile texture cannot be adequately illustrated and we can learn about it only through first-hand investigation, but children will almost certainly have a great deal of experience and tacit knowledge about it already. The best way to develop their awareness and the idea of tactile texture is to involve them in a first-hand investigation which will link up with what they already know.

Investigating tactile texture

An effective way to investigate tactile texture is to glue dry seeds firmly on to 5×5cm pieces of stiff card, and feel them with the finger-tips. A wide range of seed sizes is needed.

1 Very large: broad bean, runner bean
2 Large: pumpkin, sunflower, melon
3 Medium: mustard, wheat, rice
4 Small: poppy
5 Very small, grain size: use fine washed silver-sand, and include a piece of plain card to use for comparison.

Cover each of the five cards with seeds or sand glued on firmly. With their eyes shut, children can then feel the surfaces with their finger-tips and attempt to place the cards in order of grain size. Children who look at the cards before feeling them are likely to find this easier, showing how much we use our vision to predict what surfaces will feel like before we touch them.

The children then need to discuss what they saw and felt, with the aim of arriving at the idea of tactile texture as a quality or property associated with things in between the fairly small and the very small. To most people, it is only the medium, small and very small grains which have what they experience as tactile textures. The other seeds are too big and are perceived as individual forms, and the plain card is too smooth. This first investigation of tactile texture can be used as the starting-point for more extended and varied explorations.

Tactile texture and other properties

Exploring tactile texture

Children can explore textured surfaces effectively by handling a set of selected objects, and by making and using textured objects for themselves. There is significant overlap here between work in art and early scientific investigations into the properties of materials. A wide variety of materials and objects may be collected for children to look at and feel. Ideally these should include both natural and man-made objects with properties such as hard, soft, squashy, rough, smooth, hairy and

bristly. A permanent collection could consist of beach pebbles and other weathered rocks; pieces of broken rock; weathered, sawn and planed wood; tree bark; feathers; fabrics, with furry pieces; carpet; and bones. To such a collection can be added perishable items, with fruits such as orange, kiwi fruit, apple and pineapple.

> SAFETY NOTE: Bones must be completely clean of all soft tissue. Before children handle them they must be sterilized by immersing them in dilute bleach for 24 hours and dried.

Feeling without seeing

Once children have some experience of seeing and touching textured objects, they can be used both to link the visual with the tactile and to develop oral language. Feeling textured objects hidden in a bag of soft cloth will help children to learn more about their sense of touch and to link texture with size and weight as tactile properties. At the same time, through talking about what has been perceived, they can extend their descriptive vocabulary and become more confident in its use.

Making tactile objects

Form and texture

As well as looking at, feeling and talking about objects with tactile textures, children can make their own. There are many to choose from, but one of the most productive is to make a tactile sculpture, a three-dimensional form, which needs to be large and robust enough to be handled, with a variety of tactile textures on its surfaces. Some basic ideas for making forms are discussed on pp. 109–15. Tactile sculptures can be made in at least three different ways: first, by modelling in pottery clay which can then be fired, using pinching up, pressing in and added clay pieces to create texture; secondly, by modelling in papier-mâché on a pasted paper shell made round a balloon or box; thirdly, by glueing materials such as sand, seeds, small stones, sawdust, wood-chips and thin dried plant stems on to the surfaces of a box-card construction.

Work like this also offers the opportunity to discuss art for people with disabilities. By handling and touching each others' tactile sculptures with their eyes shut, children can start to gain some idea of the properties which sculptures or toys for blind and partially sighted people might need if they are to be successful. If they can discuss their work with visually impaired people, this will add reality and purpose to a project which is interesting in itself.

11.3 Visual texture

To most people the term 'texture' refers in the first instance to tactile properties and they may be surprised or puzzled to hear the term applied to visual qualities of images on smooth surfaces. At their most direct, however, visual textures are produced simply by making surface irregularities more easily visible. For example, if a piece of paper is held up in sunlight and then tilted so that the light falls across it at a very shallow angle, its texture will become visible as tiny shadows. A similar effect can be obtained by rubbing the surface of the paper with a very soft graphite pencil (Figure 11.1). The high spots on the paper become coated with graphite and the depressions are left white, so the textures of different kinds of paper can easily be compared.

Figure 11.1 The texture of paper

a: copier paper b: drawing cartridge paper c: rough hand-made paper

Visual textures from tactile surfaces: rubbings

A slightly less direct way of making tactile textures visible, with which children are likely to be familiar, is to take rubbings of them. If a piece of thin 'smooth' paper is placed over a textured surface and held still while a soft pencil or black crayon is rubbed over it, the (tactile) texture of the surface will appear as a (visual) texture on the paper. Results are often better if the pencil or crayon is held at a shallow angle, and some examples are shown in Figure 11.2.

Figure 11.2 Visual textures made by rubbing

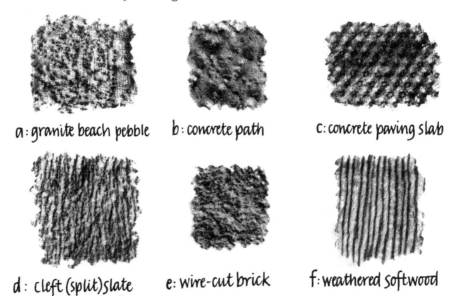

a: granite beach pebble b: concrete path c: concrete paving slab

d: cleft (split) slate e: wire-cut brick f: weathered softwood

Together, the examples in Figures 11.1 and 11.2 show that visual texture, like tactile texture, is perceived at intermediate size-scales. The paper used in Figure 11.1a is so nearly smooth that its very fine texture can be detected only by looking at it closely. In contrast, the bumps and ridges in Figure 11.2c and 11.2f, when seen close to, are not only distinct and easily countable, but form patterns (Chapter 12). From a normal reading distance these two examples are really too coarse to be called textures, though they are perceived as textures when the viewer is further away. The other examples in both figures are intermediate in scale and show something of the variety of visual textures which can be produced by taking rubbings of commonly available surfaces.

Printed textures

Essentially, printing consists of applying ink or paint to parts of a surface and transferring it to another material such as paper or fabric. Relief printing is a particular

kind of printing in which the inked parts of the printing surface are above the remainder. Examples include potato printing, using rubber stamps or taking fingerprints. At least in theory, any surface with tactile texture, coated with ink or paint, can act as a relief printing-block. If a large, textured surface such as a piece of weathered wood is coated with ink using a roller, paper can be laid over it and rubbed down to produce a very direct visual record of its texture and pattern. It is, however, possible to create new visual textures by printing with small pieces of textured material.

Printing textures

The easiest and most familiar example of texture printing is to take a sponge dipped in paint and dab it repeatedly on to paper or fabric (Figure 11.3a), but there are many other materials and objects with which this can be done, including bubble-wrap plastic and the cut edge of corrugated box-card (Figure 11.3b and 11.3c), and pieces of carpet and coarse fabric twisted and tied to make a small pad. In all three examples shown, the printing surfaces were rotated to give a more random effect, but the same technique, with systematic placing, can easily produce patterns (see pp. 140–2).

Figure 11.3 Textures produced by printing

a: natural sponge b: bubble-wrap plastic c: edge of box-card

Painted texture

Moving one step further away from tactile texture, one may use the combined properties of brushes and paint to produce visual texture while painting. If oil or acrylic paint is applied thickly to a surface, when dry it may have a tactile as well as a visual texture, a technique known as impasto. If more liquid paint such as ready-mixed poster paint is used, the resulting surface will be almost or completely flat, but may nevertheless have rich and varied textures which can make an important contribution to the finished work (see pp. 127–30).

Brush textures

There are many ways of producing visual texture with brushes and poster paint, but two are likely to be of special use to children. The first uses a bristle brush, which has a distinct tactile texture of its own. Take fairly thick (undiluted) paint and squeeze the brush out on the side of the palette so that it is partially dry; its bristles will make highly textured marks which can be manipulated in various ways, some of which are intermediate between texture and pattern (Figure 11.4). These include long strokes in one direction (a), long strokes at right angles (b), short dabbing strokes with the ends of the bristles (c), repeated short strokes with the brush almost dry (d), fast diagonal strokes with the bristle-ends (e) and strokes with uneven amounts of paint (f). Tonal gradations using a similar technique are shown in Figure 4.3c and 4.3d.

Mixed colour textures

The streaky effect in Figure 11.4f gives a clue to the second method of producing painted textures, which depends much less on the tactile texture of the brush and

much more on the properties of the paint as a thick, sticky liquid. One method is to use two colours and a wide, chisel-edged brush. Dip one corner of the brush in each colour and do not squeeze the brush out at all. Stroking or dabbing will produce a range of textures with variable amounts of colour mixing in streaks or patches (Figure 4.3e, 4.3h, 4.3i). Another way of producing colour textures by mixing is to apply paints as blobs directly to the paper and then brush these out. Often a single, bold stroke with a large brush is most successful as it shows the gesture of the hand and arm very clearly. Children will, however, find that the key to success is to temper boldness with knowing when to stop, or they will end up with something resembling mud, rather than with mixed colour textures.

Figure 11.4 Textures painted with a bristle brush

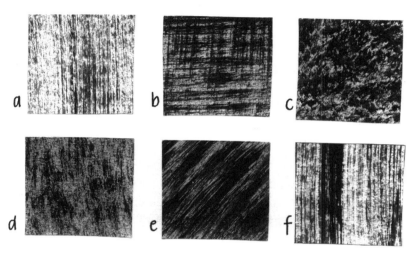

Drawn textures

Visual textures, or something rather like them, can be built up from pen and pencil marks. These textures are of course completely flat and have no connection at all with tactile texture. It could be argued that drawn textures of this kind are really a sort of pattern-making, but as we perceive them as textures rather than as patterns, some simple examples are included here (Figure 11.5; see also Figures 2.2, 2.3, 4.1b–d, 4.3k–l and 8.3i–m).

Figure 11.5 Textures drawn with a fibre-tipped pen

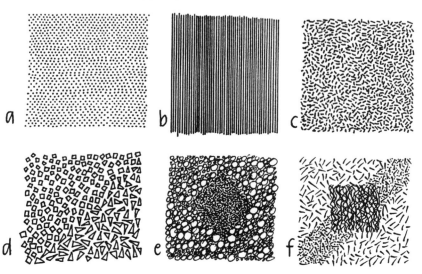

**Observing
drawn textures**

What makes the examples in Figure 11.5 pattern-like is the repetition of points, lines and shapes (see pp. 131–4). What makes them behave as visual textures is their scale. Because all the individual elements are fairly small, they can be seen clearly only when viewed close to. As the viewer moves away the panels will, at varying distances, appear first as visual textures and ultimately as grey areas. An almost exactly similar effect is seen when using some colour combinations in art programs on computers, where what are actually small-scale patterns are perceived as textures from a normal viewing distance, and as single colours from a little further away.

All these effects emphasize the way in which textures occupy the broad middle ground in our visual world, between forms and shapes which are large enough to be distinctly perceived, on the one hand, and the point at which everything blends into visual uniformity, on the other. It is by giving quality, variety and character to surfaces that textures assume much of their importance both in art and in the everyday environment.

11.4 Texture in context

Tactile texture

Although experiencing texture often involves both vision and touch, tactile texture can be experienced only when we are in physical contact with an object, so it is always an intimate property. Nevertheless, it makes an important contribution both to the quality of our environment and to work in art and craft.

In the world around us, tactile texture is experienced most obviously when touching and handling natural objects and man-made ones which have been subjected to use, wear and weathering. A few examples of textured objects have already been given on pp. 121–2, but textures are all around us, particularly on animals and plants, whose surface characteristics are usually important for their survival. Non-living, dead or man-made materials such as rocks, wood and metals are often much more highly textured and interesting when their surfaces have become worn or broken down by abrasion, weathering and corrosion.

Traditional and contemporary craftwork is widely exhibited for sale in galleries and specialist shops, and much of it incorporates various tactile and visual textures. At one extreme are materials such as polished perspex and metals which may seem to have no texture at all, and at the other are artefacts such as baskets, some ceramics, and woven and knitted textiles which have textures on all their surfaces. Carved wood, furniture and metalwork, including jewellery, may have tactile textures produced by tools as an integral part of their manufacture or added for decoration. If children visit craft workshops or a gallery they will be able to see and perhaps also handle some of these textured objects.

Tactile-visual texture

Many kinds of texture, both in craftwork and the wider environment, are both tactile and visual, but this combination of textures has been most exploited by sculptors and makers of textiles.

Many twentieth-century sculptors used texture as an integral significant part of their work. Rough surfaces modelled in plaster have been cast in bronze, smooth bronze surfaces have been treated with chemicals to give them colour and a subtle tactile surface texture (patina), and carved wood and stone have been left with tool-marks

visible. Sculptors who have used texture extensively in their work include Moore, Hepworth, Frink and Giacometti (see pp. 117–19).

Many hand-woven textiles, both traditional and produced by designer-weavers from the 1920s onwards, make creative use of the textures and patterns (p. 12) produced when fixed warp threads of one colour are woven with weft threads of another. Weavers such as Ethel Mairet (1872–1952) in England and Gunta Stölzl and Benita Otte in Germany produced hand-woven hangings, blankets and carpets, as well as highly successful designs for industry, in a great variety of threads and colours to produce both textures and patterns, some of which exploit the potential of optical colour mixing (pp. 47–9; see Anscombe 1984; 135–40, 148–55; many examples of Stölzl and Otte's work are illustrated in Scheidig, 1967).

Most traditional textiles from all parts of the world are dominated by pattern, but many of them also have characteristic visual-tactile textures. Outstanding examples, which children always find stimulating, include carpets, both knotted (hali) and flat-woven (kilim), as well as embroidered hangings (sumak) from Turkey and the Islamic countries further east, embroidered textiles from India, especially Gujarat, and knotted palm-fibre fabrics from the Congo (Kasai velvet). Examples of these and other textiles are held in many museum and educational collections (see also pp. 147–8).

Visual texture and visual diversity

Visual texture is an important depth cue which we use when judging distances, which can help to create illusions of space on the picture-plane of photographs and other images (p. 96 and Figure 9.5). It also makes a very significant contribution to our visual environment in general and to art and craftwork in particular, by giving complex surfaces the quality of visual diversity, which means that their appearance, and especially what we can see of their textures, changes as we move towards and away from them. For example, if we look at an old brick wall from a distance of about 3m we can see not only the individual bricks and the pattern in which they have been laid, but also their surface texture and any colour variations there may be. From 1km away, none of the pattern and variation can be distinguished; the same wall is seen simply as an area of colour. In between, as we move closer and closer to the wall, we see a whole range of colour variations and visual textures at different distances and scales, until we can see the pattern and textures of the individual bricks again.

It is this range of variations, patterns and textures at different scales which make up visual diversity and we can, if we expect it and look for it, see it all around us, in buildings and pavements (particularly old, weathered ones), trees, gardens, beaches, hedges, hills and mountains. Learning to perceive this visual diversity is an exercise in critical seeing (pp. 6–7), which could begin with almost any of the objects and artefacts discussed above in the context of tactile and visual-tactile textures.

Visual texture in painting: looking at contrasts

In this section, attention will be concentrated on visual texture and its role in painting. A good way to introduce children to texture in painting is to begin with strong contrasts, comparing painters who have, as far as possible, eliminated texture from their work with those whose work is highly textured. Many twentieth-century artists moved towards the use of flat, textureless colour, and a very influential one, Mondrian, is discussed on p. 101 and p. 130. However, few have been so witty and effective as Caulfield. He depicts everyday objects such as jars, bottles and pots, carefully arranged,

in flat, textureless, often vivid hues, outlined in uniform black lines with no tonal modelling or shading to give an illusion of depth or form, as in *Pottery* (see Appendix 5). Caulfield's paintings create a strong and pointed visual contrast between their own careful, static, colourful flatness and the world around them which is usually less colourful but much more diverse in texture than they are.

In complete contrast to Caulfield's uniform lines and sharp-edged, featureless shapes are the rich textures and soft edges created from very small points of colour by Seurat in the style known as divisionism or pointillism. Seurat's intention was not primarily to create textures, but to achieve luminous colours through optical mixing (see pp. 50–1). Many of his paintings, however, particularly the landscapes, show that he was acutely sensitive to the textures which resulted from his technique of painting in tiny points or short strokes of pure colours. In *Le Bec du Hoc, Grandcamp* (see Appendix 5), for example, he uses quite different textures for the sea surface and the vegetation of the cliff.

Textures built up of lines were used extensively by van Gogh, both in his ink drawings and paintings. The textures always tend towards pattern and play a significant part in how he expressed his emotions through painting and colour. Almost all of his later paintings show variations of this textural technique, but outstanding examples include *Starry night*, *Self-portrait 1889* and *Cottages at Auvers* (see Appendix 5). Perhaps most interesting of all are the works in which preliminary drawings and the paintings based on them can be compared directly, for example *Wheat fields with cypresses* (see Appendix 5). Line texture gives an extraordinary sense of movement and restlessness to van Gogh's work, perhaps reflecting the psychological disturbances which led eventually to his suicide.

The explorations of Seurat into colour-blending and of van Gogh into the direct expression of emotions were part of a revolution in art, but they did not start it. It had begun some 10–15 years earlier with an exhibition by a group of painters we now call the Impressionists, almost all of whom made an important use of texture in their paintings.

Painterly texture, Monet and Impressionism

Throughout the second half of the nineteenth century an artistic revolution was taking place which fundamentally changed the nature of European and American painting, leading to the development of modern art. The main stimulus for this revolution was the invention of photography, which made painting redundant as a means of recording what things and people looked like. Simply by taking a photograph, a (hopefully) permanent and very accurate record could be made of a person, object or scene. Some young painters began to concentrate, at first to a chorus of ridicule and only much later to critical acclaim, on doing what the camera could not do: exploring the fleeting effects of light, movement and change which they observed in the world around them. The result was a liberation of art, not only in the subject matter of painting, but also in its execution. Everyday and less noble subjects such as street scenes or the play of light on trees and haystacks were added to the old repertoire of formal portraits and narrative or historical pictures. To those accustomed to the work of previous generations these seemed quite unsuitable as the objects of a serious painter's attention.

Conventional techniques of the time, as taught in art academies, sought to eliminate texture and brush-marks from finished paintings. This lack of visual diversity was in contrast to sketches and preliminary studies, which often show a wide range of texture

and (to our eyes) convey a much greater sense of life than finished work by the same artists. In defiance of convention, painters of the new style often painted outdoors, using brush-marks and incompletely mixed colours in their finished work, to convey a sense of the immediacy and constant change which they perceived in the world around them. Styles of painting from any age which use texture in this way are often referred to as painterly, in contrast to highly finished academic work.

In 1874 a group of painters whose work had been refused by the French Academy because their painterly textures were seen as crude and their subject matter unsuitable, organized their own independent exhibition. Monet, a leading member of the group, called one of his paintings *Impression: sunrise* (see Appendix 5), and this led a journalist to call all the painters, as an insult, 'Impressionists'. This name was later accepted by the painters themselves and has been used to describe their work ever since.

Monet continued to create complex, subtle and beautiful painterly textures throughout his long career, often working on series of paintings of the same subject to explore and record the changing effects of light and colour (see p. 59). Especially in his late paintings of water-lilies and willows in his garden (for examples see Appendix 5), Monet builds up textures in layers, giving extraordinarily vivid impressions of depth and the reflection of light, using different kinds of brush-strokes for water, water-lily leaves and flowers and the hanging foliage of willow. Children can gain great insight into texture and the interaction of colours, as well as a lot of enjoyment, from studying Monet's work and attempting to make multi-layered textures of their own in media such as paint and oil-pastel.

Texture, communication and the real world

Although different kinds of texture were prominent in the work of the Impressionists and those who followed them, including Seurat and van Gogh, painterly texture was not a new device. A number of great painters since the Renaissance had developed their use of texture and freely painted brush-strokes, mostly late in life when they could paint in a more personal style than the highly finished academic manner demanded by their aristocratic patrons. An early example was Titian (Tiziano Vecellio, c. 1485–1576). Throughout his career his brush-work was freer than that of most other painters of his day, but his works in the National Gallery, London, show a wide variation in style and texture. This can be seen by comparing his *Bacchus and Ariadne* (see Appendix 5) with his *Death of Actaeon* painted 30 or more years later, with its loose brush textures and sensitive colour-blending.

Two centuries later the Scottish portrait-painter Henry Raeburn (1756–1823) used vigorous brush-strokes and texture to communicate vividly the personalities of his sitters, including *Mrs Downey, Miss Macartney* and *William Glendonwyn* (see Appendix 5). Contemporary with Raeburn was John Constable (1776–1837), the greatest of the English landscape painters who, half a century before the Impressionists in France, abandoned academic finish in an attempt to convey the shifting character of light and weather with much freer brush-work and more obvious textures. These qualities are well-illustrated by *The hay wain* and even more obviously by the full-size sketch for it (see Appendix 5), The English painter who developed this approach most fully in his later work was, however, Turner. Although his early and mature work often shows an apparently classical approach and formidable technical skill, for example

Rome from the Vatican, his late canvases such as *Snow storm* and *Rain, steam and speed* use brush-texture and colour-blending in an attempt to communicate movement and atmosphere (see Appendix 5; Bockemühl, 1993, 70–1).

As they grew older, Constable and Turner confronted the fleeting and changing nature of light and appearance more and more directly and, as Monet and the other Impressionists were later to do, both used increasingly complex textures to help them communicate this reality as they experienced it. This showed clearly how texture is an integral part of the complex, real world which we see all around us. In contrast, many artists during the twentieth century turned away from the real world, so that their work shows progression in exactly the opposite direction, towards simplicity and the abandonment of texture.

Perhaps the most well-known example is Mondrian, whose early work was representational and often made use of brush-texture, as in his *Mill by the water* of 1905 (see Appendix 5). Strongly influenced by Cubism, Mondrian's paintings became increasingly abstract, as shown by his series of paintings of apple trees (see Appendix 5). He later experimented with expressing philosophical ideas through his paintings, making less use of texture and greater use of controlled line with flat, almost textureless colour areas (see p. 101). Instead of confronting the real world and its complexity, as Constable, Turner and the Impressionists did, Mondrian turned away from it and created his own, ideal world; poised, motionless, elegant and without texture (Whitford, 1987: 12–20).

12 Pattern

Pattern in art and craft is often thought of as one of the visual elements, but like texture it is not a simple property. Most people's everyday environment has many patterns in it and we have an apparently inborn tendency to look for them, which may explain their very deep appeal to both children and adults. There are many different kinds of pattern, both natural and man-made. In mathematics, for example, children may look for and use patterns in number, but in art and craft we are concerned with visual patterns, perceived when objects, marks or shapes are arranged in space in particular ways. Patterns are generated by forms in three-dimensional space, as for example in the branching of trees, but these are rarely used in art, so attention is focused in this chapter on patterns of marks or shapes on surfaces. Even so, visual pattern is a very complex topic and we can do no more here than explore a few of its simpler aspects.

12.1 Concepts of visual pattern

Most if not all the patterns used in art and craft belong to one of two broad groups. In the first group, pattern is generated by arranging marks or shapes in space. In the second group, the space itself is divided up into a pattern of shapes with no free space between them. Space-dividing patterns are discussed on pp. 142–6.

What is a pattern?

To develop an idea of what makes patterns distinctive, a good strategy is to work with shapes or marks in space rather than with space-dividing patterns, and to begin by comparing non-patterned and patterned arrangements. In Figure 12.1, compare example (a) with example (d). To make example (a), eight small squares were dropped on to paper and glued down where they fell. No pattern can be perceived in their arrangement, a situation usually called random or chaotic. In example (d) the arrangement of the squares is highly ordered and we perceive a pattern.

Figure 12.1 Randomness into pattern

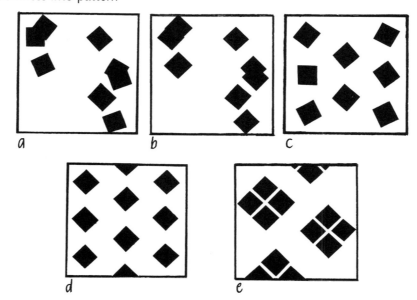

The essential difference between the arrangements in Figures 12.1a and 12.1d is their predictability, which here, as in most patterns, shows itself through some kind of repetition. If one of the squares in example (a) was removed and you were asked to replace it in its original position, you would be very unlikely to succeed: the remaining squares would give no clue as to where the square should be placed or the direction in which it should point. In example (d), on the other hand, the pattern would enable you to predict the correct position exactly.

This may be an appropriate point at which to introduce the idea of motif in pattern. Motifs are the basic building-blocks of patterns in space: the marks, shapes or groups which are repeated in predictable ways to make the pattern. In Figure 12d, for example, the motif is a simple square, whereas in example (e) it is a group of four squares.

Relating pattern to the other visual elements

Any of the other visual elements can contribute to patterns, whether they are based on motifs or on the division of space, so in a general sense pattern is related to all of them (Figure 1.2). When discussing patterns with children it is often a good starting-point to identify the visual elements which contribute most to each one. Doing this can help children to compare patterns and see more clearly how they were built up and why they have different effects.

Basic observations on pattern

What makes a pattern?

Look again at Figure 12.1 which shows something of how a pattern can be built up and enables us to make three important observations. Children could do this exercise interactively, by moving small squares of paper on a larger sheet and sticking them down with Blu-tack. The small squares relate to each other and to the space around them in two ways: where they are (position); and the direction in which they point (orientation). In example (b) the orientation of the squares has been organized so that they all point the same way, but their positions are still random, as in example (a), and the overall effect is only a little less chaotic. In example (c) the orientation of the squares is random, but they have been moved so that they are all about the same distance from each other, which makes their positions quite predictable. Most people perceive example (c) as being much more like a pattern than example (b). This is significant because it shows that in pattern-making, position is likely to have much more effect than orientation. However, neither (b) nor (c) is as obviously patterned as (d), in which both position and orientation are highly predictable. This makes a second important point about pattern: the more ways in which an arrangement is organized and predictable, the more obviously patterned it will appear.

Comparing Figure 12.1d and 12.1e illustrates a third important point. If the nature of pattern is investigated by starting with random shapes or marks and making patterns with them, it quickly becomes apparent there are basically only two ways of doing this. Shapes, marks or motifs can either be moved apart so that the distances between them become more and more similar and predictable (dispersal), or they can be grouped together (aggregation).

Dispersal and aggregation

Making patterns by dispersal and aggregation can investigated in a very direct way by drawing patterns with points and lines. These are in effect very small or thin shapes, which can be drawn quickly using felt- and fibre-tipped pens. Although this kind of mark-making is very useful for investigating the nature of pattern, children may find it better to begin their own experiments by drawing rotating and linear patterns (pp. 135–8; Figures 12.3–12.6), or by using cut paper shapes which they can move around (pp. 138–40; Figure 12.7).

Dispersed pattern

There are basically only two ways of generating pattern from randomness, illustrated by Figure 12.2. In example (a) the points are distributed at random. In example (b) the points have been distributed so that the distances between them are about equal. In itself this pattern is not interesting, but it could be developed by joining points in order to outline shapes and colouring these in. This is one way to begin making tessellations and other space-dividing patterns (pp. 142–6).

Figure 12.2 Patterns in point and line

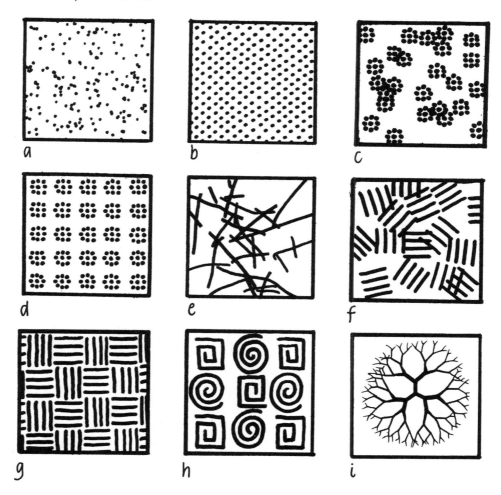

Aggregated pattern

In Figure 12.2c the points have been aggregated into groups to make simple motifs, and although some degree of pattern has been generated, this may not be immediately obvious because the motifs are arranged at random. Aggregated patterns can usually be developed in straightforward ways by moving such motifs around. One way to do this is to disperse them and make a more complex pattern,

as shown in example (d). The small motifs could also be grouped into bigger ones and then arranged in a yet more complex pattern. Comparing these two examples also makes the point that a higher degree of patterning and predictability is not always more interesting visually: many people would find the random scatter of motifs in example (c) more attractive than the regularity of example (d).

Patterns of lines

Similar experiments can be carried out using lines. In Figure 12.2e the lines were drawn at random, but partly because they suggest shapes within the frame, the result is much more visually interesting than the random points in example (a). In example (f), lines of similar length have been grouped in fours to make motifs which are arranged at random. In example (g) these are arranged in a very ancient pattern sometimes called basket-weave. Both (f) and (g) can be developed in many different ways with colour and texture.

Moving-line patterns

Simple spirals and branches

Making pattern from randomness is a good way of learning what pattern is, but not all patterns can be made in this way. Some very frequently seen and useful kinds of pattern are formed by one or more lines moving in an ordered and predictable path (Figures 3.5, 3.6, 3.7a–e). Use lines moving in this way to make shapes and other motifs (Figure 8.3h–l). Two of the most interesting of these moving-line patterns are spirals and branching, both of which expand outwards from a centre. Figure 12.2h shows a pattern based on two kinds of simple spiral. Notice that the distance between the lines is kept more or less constant and that both spirals can be right- or left-handed. Branching patterns, as shown in example (i), have many possibilities, because they rapidly become very complicated as they radiate outwards and the shapes defined by the branching lines are as interesting as the lines themselves.

Figure 12.3 Rotating patterns

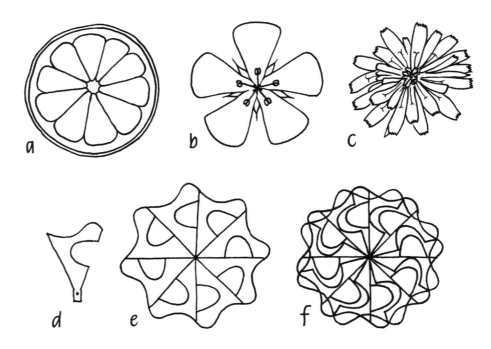

12.2 Rotating and linear patterns

In planning children's investigations into motifs and their arrangement into patterns, it can be useful to make a distinction between patterns which can be developed in two dimensions to cover whole areas, often called surface patterns, and those which are developed either along a line (linear pattern), or around a point (rotating pattern). Because linear and rotating patterns are limited in the ways they can be extended and developed, they are particularly useful for early experiments in pattern-making.

Rotating pattern

Rotating patterns from nature

Many patterns seen in plants and animals are based on all or part of a circle. These patterns radiate outwards from a point, but unlike branching patterns (Figure 12.2i), they do not grow indefinitely. They are formed when a motif is rotated and repeated so that one point stays still while a point opposite it moves round in a circle or an arc. Children should observe and look for examples such as an orange cut in two (Figure 12.3a) and flowers, some of which are highly regular (b), while others have a pleasing irregularity caused by variation in the length of their petals (c).

Rotating a template

Rotating patterns are always limited in their extent, but apart from their own interest they are useful for making motifs which can then be repeated along a line to make a linear pattern (see below) or over an area to make a surface pattern (pp. 139–42). A good way to make a rotating pattern is to draw round a template such as the one shown in Figure 12.3d, made of thin, stiff card. The basic shape of this template is a 45° wedge with a piece cut out of it and a small tab at its point. A pin pushed through this tab into the paper becomes the centre of the circle and makes it much easier to rotate and draw round the template. One rotation of this template produces a simple pattern (e), but if a second is added, the pattern becomes quite complex (f).

Linear pattern

In a linear pattern, one or more motifs are repeated along a line, so that the pattern forms a border rather than covering a whole area. The line can be used as a guide when placing motifs, so that patterns of this kind are an effective way to experiment with different orientations and placements. There are some kinds of pattern which are particularly effective when used on edges and borders rather than to cover surfaces, but most linear patterns can be converted into surface patterns by reproducing them sideways, as for example in Figure 12.9c.

Finding linear patterns

Linear patterns have been used in art and craft for thousands of years. Some children show a tendency to produce linear patterns spontaneously in their drawings (e.g. Figure 3.9), but others may find it easier to start working with them by looking for examples in their environment. The pattern of marks on the edges of a ruler, railway tracks and lane-markings on roads all form useful, if not very interesting, linear patterns. Children should look for and draw more complex and visually interesting examples. These can be found in man-made objects as diverse as chains, zip-fasteners, saw-teeth and rope (Figure 12.4a–d), but the most useful of all may be natural ones. Many can be found by looking at animals and plants (or pictures of them), especially at the edges of surfaces such as leaves and wings. Pictures of

butterfly wings (preferably magnified), often provide beautiful examples which can be drawn, and the edges of many kinds of leaf when looked at through a magnifying glass show patterns of shape in their lobes and teeth (Figure 12.4e–j). By making templates of cut card to draw round, linear patterns based on repeated shapes such as these can be extended in straight lines or bent into circles, squares or rectangles, and developed with colour and collage.

Figure 12.4 Linear patterns from the environment

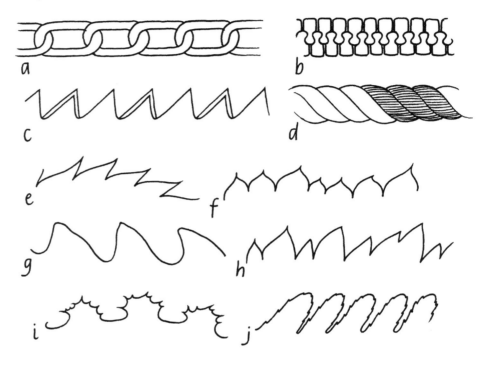

Moving a motif to make linear patterns

Linear patterns can be made by arranging motifs in lines rather than over areas (pp. 138–42). They not only are interesting in themselves, but also provide opportunities for children to investigate different ways of moving (or placing) and combining shapes, starting with very simple arrangements and progressing, if this is appropriate, to quite complex ones. Manipulating shapes in this way has very close relationships with work in mathematics on shape and space.

Motifs for linear patterns

Linear patterns with one motif

A simple and informative way to learn about linear patterns is to use as the motif a shape which has no lines of symmetry, for example the letter 'R'. In order to make a number of patterns for comparison the motif has to be reproduced and placed accurately. The easiest way to do this is to draw small shapes using a simple stencil and a felt-tip pen (Figure 12.5). Selected examples can then be developed further by enlargement and the use of other media.

Some of the ways in which a linear pattern can be developed from a single motif are shown in Figure 12.5. The simplest pattern is made by moving (translating) the motif along a straight line (a). The effect is likely to be more interesting if the line is not straight (b), or if the motifs are stacked in more than one way (c). The motif can be both turned and moved (translated and rotated) as in example (d) or used both upright and inverted, as in (e). By turning the stencil over the motif can be reversed

(f), and this reversal can be combined with rotation or inversion. It is also possible to turn the motif in a different direction and then move it along a line. In (g) the motif is horizontal rather than vertical and this is combined with reversal, but it could be tilted at any angle. This pattern is developed further in (h) by pairing the motifs, but the pattern has been made more complex by rotating rather than inverting the motif in every third pair. This interrupts the simple sequence and gives a little more variety.

Figure 12.5 Linear patterns based on a simple motif

Linear patterns from lines

In basic investigations of pattern (p. 134) it was pointed out that patterns can be made from spiral and branching lines (Figure 12.2h, 12.2i). Children can use these as the basis for making linear patterns which have been used as borders since ancient times. In Figure 12.6, examples (a) and (b) are each based on a single line moving in a reversed spiral, drawn freehand. In both, the line moves into the spiral clockwise, reverses and moves out anticlockwise in a parallel path.

More complex linear patterns

Figure 12.6c is based on a simple zig-zag branched line, shown by the mid-lines of the leaf shapes and the dotted lines. The leaf and bud shapes were drawn in freehand, using the branched line as a guide, and other kinds of branching could be used (see Figure 3.5). Finally, example (d) is an ornamental edging much used by carvers in both wood and stone. It is based on two arched lines which alternate with each other, drawn freehand with the other elements added later. All these patterns, and variations on them, can be developed with colour and texture in a variety of media.

Figure 12.6 Patterned friezes based on lines

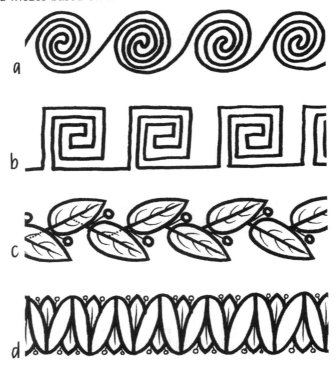

12.3 Investigations of surface pattern

When making a rotating or linear pattern (pp. 135–8), the growth of the pattern is limited to a circle or line. In contrast to this, some patterns such as those seen on many wrapping-papers and textiles can be extended indefinitely in any direction. These are known as surface patterns. Examples of surface patterns are used in Figures 12.1 and 12.2 to illustrate the nature of pattern. In surface pattern, interaction between motifs and with the space around them has a very prominent part to play in the overall effect and the visual interest aroused in the viewer.

Using shapes to create surface pattern

Shapes for pattern-making

Although small-scale patterns can be made quickly by drawing points and lines as shown in Figure 12.2, it may be more productive for children to begin their investigations of surface pattern by experimenting with simple cut paper shapes on larger squares or rectangles of paper. Preparing the cut shapes is laborious, but they can be moved around easily into different arrangements and glued down when a pleasing pattern has been arrived at. Children can usefully experiment with any of the following combinations.

1 Single shape: circle, square, triangle, rectangle, parallelogram
2 Shape combinations: two or more shapes used together
3 Colour: colours contrasting with the background
4 Orientation: constant or varying (can be varied systematically)
5 Grouping: motifs of single shapes, or shapes aggregated into groups
6 Position: any positions as long as they are systematic and predictable

Figure 12.7 shows four simple examples of patterns made from cut paper shapes, which use variations in shape, tone (instead of colour), orientation, grouping and position in

different combinations. From the point of view of art and design, as opposed to mathematics, trying to analyse even simple patterns like this is not often useful. What is likely to help children to understand more is to look at the ways in which the patterns create visual interest.

Figure 12.7 Surface patterns from cut paper shapes

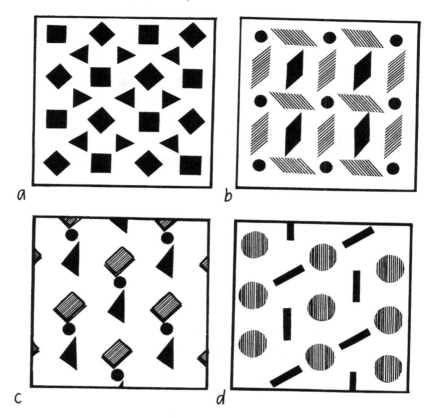

What makes patterns interesting?

In example (a) the motifs are simple shapes, but arranged so that there are four different lines or sequences, two running both horizontally and vertically, and two diagonally. Much of the interest of the pattern comes from the way the shapes interact with each other and the space around them to make it visually active (pp. 77–9).

In example (b) the shapes are grouped into what are in effect square motifs, and this gives rise to four (or five) sequences: one horizontal/vertical, one horizontal and two (or three) diagonal. Most of the interest comes from the way in which the shapes seem to recombine into different arrangements as one looks at them.

In example (c) the three-shape motifs are more complex than in the other examples, but their arrangement is much simpler. Space is critical in this kind of pattern. The motifs are interesting because the shapes which make them up seem to be poised on one another, so that the space around them becomes visually active. The spaces between the motifs need to be small enough for the pattern of vertical and diagonal lines to be obvious, but big enough to avoid the motifs interfering visually with one another.

In example (d) there are no horizontal sequences, but two vertical and at least three diagonal ones. As in example (b) the shapes seem to group and regroup themselves, but here it is into parallelograms, both right- and left-handed, giving a rather unstable and dynamic feel to the pattern.

Printed patterns

Working with cut paper shapes can produce beautiful patterns, but is a slow and rather limited way of working. Printing is much quicker and a greater range of motifs can be made, but more skill is needed to make the printing- block, place it accurately and print it well. Detailed instructions for printing patterns are given in many specialist books, and although special materials may solve some of the technical problems, they are not necessary for the preliminary experiments discussed here. The simple block-prints shown in Figures 12.8 and 12.9 were made using everyday materials, paint applied with a brush and printed on paper resting on a pad of newspaper.

Basic printing blocks

Block printing can be successful using blocks of any shape, but irregular ones usually require some guide-marks or a full grid in order to place the motifs consistently (see p. 143). The easiest way to start is with a rectangular or square printing surface, and a good material is flat, cleanly sawn end-grain of softwood. When paint is brushed on to this and it is printed, the grain should show up as a pattern (Figure 12.8a). Wood-blocks of course are long-lasting. A short-term alternative is to use large pieces of potato, again cut with a flat, rectangular or square face for printing. It is easy to make a pattern from a square or rectangular block because it can be placed accurately without the need for a drawn grid, for example to make a chequered pattern (Figure 12.8a).

Figure 12.8 Simple block prints

Figure 12.8
cont.

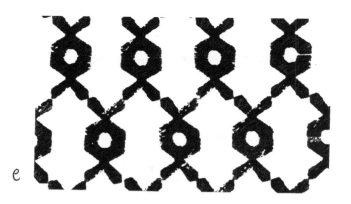

e

**Blocks for
patterns**

Using round, square or triangular files (or a knife for potato), the edges of the printing surface can be cut into to make a more interesting shape, as in Figure 12.8b. Placement will remain easy if at least three corners are left intact. This shape can then be printed over an area in different arrangements such as examples (c) and (d) to see how the shapes and, equally importantly, the spaces between them, interact and combine visually. Finally, a motif can be chosen and arranged in space to produce a more open pattern, as in example (e). This is a little more difficult to do accurately, but is less of a problem if the motifs remain touching. As with many prints of this kind, all three examples show strong figure-ground reversal (pp. 91–2; Figures 9.2, 9.3), whereas the more widely spaced motifs of Figures 12.7 and 12.10 do not.

String printing

Another method which is rewarding in pattern-making is string printing, shown in Figure 12.9. To make a block, cotton string is glued on to a cork or a wooden block, coated with paint and printed (a). The string is a line or a series of lines which means that impressions of it can be superimposed, making a more complex motif (b). This arrangement, in which the motifs are not touching, introduces the problem of placing them accurately in space, which can be solved by drawing the basic arrangement of shapes in pencil outlines before printing. This in turn acts as an introduction to the use of grids (see p. 143).

Figure 12.9 Simple string prints

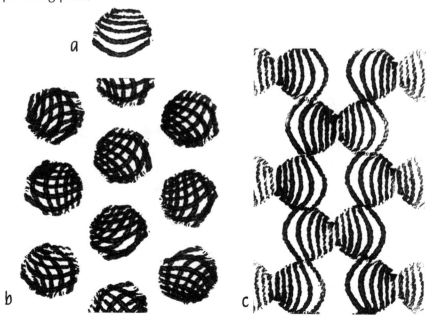

a

b c

As with block-prints, string-prints may be combined to make larger motifs. In Figure 12.9c, two-block motifs have been printed in zig-zag lines, so that some of the curved lines form a wave pattern, giving a sense of movement. This is also an example of a basically linear pattern being turned into a surface pattern by reproducing it sideways.

Painted patterns

Patterns of brush strokes

It is possible to draw a pattern of shapes and fill them in with paint, with pleasing results, but the best painted patterns are made by using the brush-strokes themselves to form the motifs. This requires more skill and confidence than either assembling shapes or printing, but produces livelier and more vigorous results. The first step is to experiment with the available brushes and base the motif on marks which they make easily and naturally. Always develop the motif directly with the brushes, in colour, rather than attempting to design it by drawing. Simple motifs using only one or two kinds of brush-stroke are usually more effective than more complicated ones.

The next step is to work out how the motifs are to be arranged. Experiments can be painted freehand, but once an arrangement has been decided on it will be necessary to draw guidelines on the paper or fabric to show where each motif will be placed. This is an example of a basic space-dividing pattern usually called a grid (see p. 143). A painted pattern using two kinds of brush-stroke and with part of its grid drawn in is shown in Figure 12.10.

Figure 12.10 Brush-painted pattern

12.4 space-dividing patterns

All the patterns discussed so far in this chapter have been made by arranging points, lines or shapes in space. Patterns can also be made by dividing space up in systematic ways. Very complex space-dividing patterns have been developed in some cultures (see p. 148), but attention will be confined here to a few simple examples for children to work with successfully.

Grids

The basis of any space-dividing pattern is a grid, a network of outline shapes over an area. Grids may be drawn as a guide for the accurate placing of motifs in space (p. 140; Figure 12.10), but they also act as patterns in their own right. Any of the space-dividing patterns discussed here can be developed in many ways with colour, texture and even other patterns, but they provide particularly good opportunities for using groups of colours to observe how these interact and people respond to them (see pp. 64–8). For example, if a pattern of contrasting warm and cool colours is compared with the same layout in graded tints and shades of the same hue, the two are likely to have very different effects (Colour figures 4, 8).

Tessellations

Squares and rectangles

The simplest grids are those made up of only one kind and size of shape, into which an area can be divided with no spaces left. This kind is known to mathematicians as a tessellation. Some of the simplest and most commonly used of these, each based on one four-sided shape, are shown in Figure 12.11a–e. It is noticeable that even these simple variations have distinctive visual properties. Most people perceive examples (b) and (c) as being more static and stable than (d); and (e) is seen as giving much more sense of movement than (a). This effect can also been seen in Figure 12.10, where the orientation of the grid reinforces the sense of movement conveyed by the brush-strokes.

Other four-sided shapes

Figure 12.11f is also quite dynamic but a little more complex, based on parallelograms reversed and rotated to make zig-zag lines, but with each of them divided in two, producing the arrow design. The remaining three examples in Figure 12.11 show how some other four-sided shapes can be used in tessellations. Examples (g) and (h) involve only rotation, but example (i) also uses reversal. Of the grids in Figure 12.11, those based on right angles (a–e) can easily be drawn with a ruler, but it is easier to cut and use templates of thin, stiff card for the others.

| **Figure 12.11** | Grids based on quadrangles |

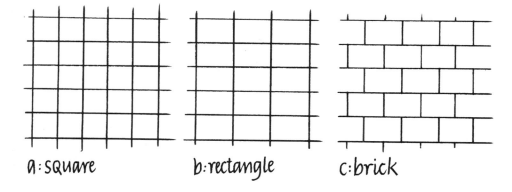

a: square b: rectangle c: brick

Figure 12.11 cont

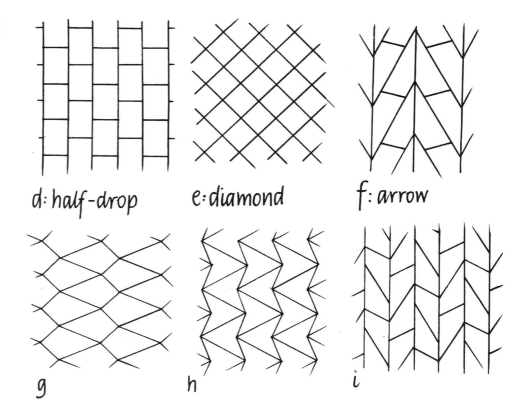

d: half-drop e: diamond f: arrow

g h i

Tessellations based on triangles

Any triangle can be used as the basis for a tessellation, but equal-sided triangles and the shapes made from them offer the greatest range and variety. The basic 60° grid can be drawn in two ways (Figure 12.12a, 12.12b), both of which can be developed by joining triangles to make shapes which will themselves form tessellations. There are so many of these that only a few of the most used ones, based on grid (a), are illustrated. All of the shapes can be drawn with card templates.

Figure 12.12 Grids based on equal-sided triangles

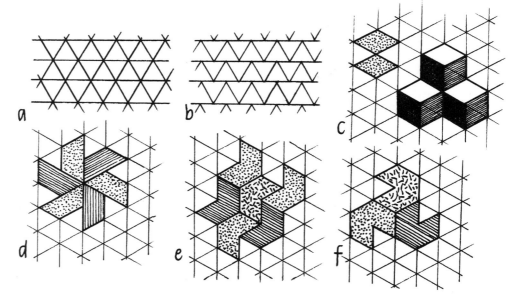

**Grouping
triangles**

Two triangles form a diamond, which can be combined into threes to form hexagonal outlines and the stacking-block pattern (Figure 12.12c). Groups of three triangles each can be joined up in many different ways. One of the most interesting combines six groups of three into a star-wheel (d), which itself tessellates. Groups of four triangles form chevrons (e), which with skilful use of colour give a strong sense of movement up and down. Groups of five triangles tessellate, but an interesting decorative grid can be made by combining three groups of five as shown in example (f). This combined shape of 15 triangles does not tessellate, but when it is used to draw a grid, six-pointed stars are left in between. Groups of six equal-sided triangles may be used to form regular hexagons, which tessellate to form the familiar honeycomb pattern and also appear in the cube pattern shown in example (c).

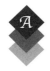

**Curved-line
tessellations**

There are many other kinds of tessellation, but children usually find ones with curved and wavy lines most interesting. The simplest curved-line example is based on semicircles and is usually called fish-scale (Figure 12.13a). Modified versions of this tessellation are often used on the tile-hung walls of houses (Field, 1996b: 52–8). Children can experiment with wavy-line tessellations by modifying grids based on squares or equal-sided triangles. To do this, a template is needed the same length as one side in the grid. This is divided into halves and a curved piece cut from one half is rotated and joined to the other half with adhesive tape (Figure 12.13b). The template can be modified to transform a square diamond grid into a wavy-line tessellation called an ogee (c). Both the ogee and fish-scale grids have a stable feel to them in spite of their curved and wavy lines, but if the curved template is used to modify a triangular grid into bendy triangles (d), a strong sense of movement is created. The bendy triangles can be grouped as in Figure 12.12c to make bendy cubes, which with some colour combinations give quite startling illusions of form, depth and movement.

Figure 12.13 Curved-line tessellations

Other space-dividing shapes

Tessellations use only one kind of shape to divide up an area, but space-dividing patterns can be made from combinations of two or more shapes in many different

ways. Two which children are likely to enjoy making are based on octagons and squares, and on circles placed in different ways.

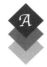

Octagons and squares

Unlike hexagons, octagons cannot form a tessellation, and if they are arranged on a regular square grid, square spaces are left between them (Figure 12.14a), a pattern frequently seen in tiles and other floor coverings. Though simple, this pattern is very useful, particularly for younger and less confident children, because it is easily drawn and can be developed in a variety of ways by joining the corners of the squares and subdividing the octagons, as shown by the dotted lines.

Circle patterns

Circles will not form tessellations and there are two obvious ways of arranging them into two-shape patterns, each of which leaves beautifully shaped spaces (Figure 12.14b, 12.14c). If the centres of the circles are joined, it will be seen that these two grids are based on equal-sided triangles (b) and squares (c), as shown by the dotted lines. Both patterns can be developed and new shapes created by drawing these lines in as a second grid. It is also possible to superimpose a second grid of circles over example (c) to make an ancient and very common two-shape pattern (d), which is also the basis of Colour figure 9b. An easy way to draw this pattern is to use the template for the fish-scale tessellation shown in Figure 12.13a. Examples of ways in which patterns based in circles can be developed are given by Field (1996a: pp. 14–17).

Figure 12.14 Grids based on two shapes

12.5 Pattern in context

Pattern is all around us in living things, the natural environment and man-made artefacts. Our strong tendency to look for predictability (or pattern) is shared with many animals and is revealed in art and craftwork from all periods and parts of the world, and by no means all interesting and stimulating patterns are in works of high art or treasured craftsmanship.

Children both enjoy and learn from natural patterns, patterns in buildings and from the work of anonymous craftspeople and designers in media such as basketwork, textiles and ceramics, furnishing and dress fabrics, wallpaper and gift wrapping-paper. A good preliminary step when working with pattern is to build up a collection of resources for the children. At the same time it is worth looking for patterns in and around school buildings, as well as finding out what patterned artefacts are displayed or available for loan in local museums, galleries and educational collections. This section attempts to provide a brief review of patterns and their sources which have proved particularly useful in teaching.

Linear patterns

Linear patterns were used extensively as decorations in ancient Egyptian painting and wall-sculpture, and on ancient Greek ceramics. In general, the Egyptian and early Greek linear patterns are simpler and easier for children to use as source material. Many of the later Greek patterns were highly evolved, for instance the elaborate versions of the double spirals shown in Figure 12.6a and 12.6b. Greek patterns were adopted by the Romans, particularly for their mosaic floors (Field, 1988b).

Many decorated pages in Anglo-Saxon manuscripts have borders with linear patterns. Most of these are developed from stylized leaf-shapes and some are very elaborate. Anglo-Saxon carving also shows examples of interlaced line patterns. Some of these are very complicated, but the simpler linear examples, which resemble a plait of cords, are useful to children. Although often associated with the Celts who, like the Romans, used them extensively (Bain, 1994), some of these interlaced patterns are very ancient, and very similar ones are carved in West Africa. Africa as a whole is a very rich source of linear pattern, and many varied examples are illustrated by Williams (1971: 32–54).

Linear patterns are frequently found in urban environments in Britain. For example, buildings of the nineteenth and early twentieth centuries, even small terraced houses, were often ornamented with a course of special exterior moulded bricks, making a linear pattern at first-floor level. In some towns and cities these provide a rich source of designs to be photographed and used by children for their projects (Field, 1996b: 29, 33).

Surface patterns in textiles

The richest medium for surface patterns is textiles. This is partly because of the variety of methods of generating them. Pattern in textiles is woven, knotted, knitted, embroidered, printed, and made by piecing fabrics together and applying one to another. Surface patterning in textiles can be built up by arranging motifs in space, or by dividing space up, and some methods such as knotting and knitting do both. Two invaluable resource books for surface patterns and tessellations are Proctor (1990) and Williams (1971).

Weaving threads generates both texture (see pp. 126–7) and pattern. By raising and lowering the fixed (warp) threads systematically in varying combinations, a range of patterns can be generated in the weave itself. Pattern can also be created by using a range of colours both in the warp threads and in the weft threads woven through them, a technique which also exploits optical colour mixing (see pp. 47–9). This is especially evident in some Scottish clan tartans, which are a well-known group of space-dividing patterns made up entirely of stripes woven at right angles.

Knotted and knitted textiles build up patterns from points of tone or colour (see p. 12). In both, the points themselves are arranged in a regular way; children can build up and study the patterns by plotting them on graph-paper. Knotted textiles made from the palm fibre raffia in central Africa, sometimes called Kasai velvet, provide many ingenious patterns in black and pale brown, mostly based on quadrangles and angular lines (Proctor, 1990: 40; Williams, 1971: 63–6). More varied, colourful and sophisticated are the patterns of tribal carpets from Turkmenistan, Uzbekistan and Afghanistan, sometimes wrongly called Afghan rugs. These show a big range of traditional patterns, including both spaced motifs and divided space, and there is often a contrast between the surface pattern of the main area and linear patterns in the border.

Knitting also produces point-patterns. The possible range is almost limitless, but a familiar group which children can look at are the traditional Fair Isle motifs. These consist of shapes built up from horizontal, vertical and oblique lines, using only two colours in each row of stitches.

One of the most helpful textile media for getting children to learn about pattern is the patchwork quilt, because here space is divided up in a very obvious way. Some simpler designs are based on true tessellations, but both traditional and modern quilt-makers also deploy a much greater variety of shapes. Quilts borrowed and displayed in the classroom will provide a great stimulus for children's work in other media.

Tessellations

Tessellations are the basis for much pattern-making, but often do not appear in the final work. This is because they are used mostly as basic grids (see above, p. 143), either to arrange motifs accurately in space or modified into more complex space-dividing patterns. Examples of tessellations may be easier to find in the environment. Simple quadrangular tessellations are uncommon in nature but common in buildings, for example in the bonding of bricks, tiles and slates on roofs, panes in rectangular windows, some floor tiles and chain-link fencing (see Field, 1996b). Hexagonal tessellations are less common in buildings, though they are formed in some kinds of fencing wire, but occur naturally in honeycomb, the eyes of many insects and geological formations such as the basalt of the Giant's Causeway in Antrim.

Space-dividing patterns

Geometric space-dividing patterns dominate much Islamic decorative art. Like patchwork quilts (see above), only the simplest decorations are true tessellations: most are space-dividing patterns made up of two or more shapes, based on a tessellated grid. Children are likely to be able to draw only the simpler examples for themselves, but Field (1988a) gives numerous examples which show something of their range and variety, together with the basic grids from which they are developed. These precise and angular designs are often contrasted with the flowing shapes of Arabic calligraphy and patterns made of sinuous plant motifs, so that it would help to show the children illustrations of the patterns in their architectural contexts (see, for example, Scerrato, 1976).

Space-dividing patterns are very widespread both geographically and in time. There is huge variety in African craftwork, including both geometric designs and others which are more flowing and organic (Williams, 1971: 55–66). Roman mosaics and European churches both show a comparable variety of space-dividing patterns, though of a different character (Field, 1988b, 1996a).

Pattern in twentieth-century art

In Europe and America, strictly executed pattern is more characteristic of craft than of art, but some twentieth-century artists use elements of pattern in their work.

Some painters who explored the interaction of colour used pattern as a means of giving their ideas a shape on the picture-plane. Prominent among them were Sonia and Robert Delaunay (see p. 50), for example Robert's *Windows open simultaneously* (see Appendix 5). Other artists used pattern as a symbol of the machine age in their attempts to communicate the idea of modernity and of modern life itself, for example Fernand Léger (1881–1955), *Still life with a beer-mug*, and Wyndham Lewis (1882–1957), *Workshop* (see Appendix 5).

Klee made patterns throughout his work in various media, in ways which children can use in their own work (Hall, 1992). Klee's pattern-making is sometimes decorative, but it is never only or simply decorative: it was part of his lifelong attempt to discover the potential and properties of shape, colour and, especially, line.

Much of the work of Escher is based on tessellations, which he looked at in the Moorish architecture of Spain as a student. He had an unrivalled understanding of interacting shape and illusory space and his work, which always fascinates children, is a rich source of ideas on ways to transform shapes and patterns (p. 36; Escher, 1992).

The work of the contemporary British painter Bridget Riley (1931–) is also based on patterns. Of all her works, those which children are likely to enjoy most are the paintings completed between 1987 and 1998, such as *Nataraja* (see Appendix 5), in which she uses parallelograms and other geometric shapes in patterns which are interrupted in intriguing ways, with high-chroma colours interacting with each other and with the pattern. The result is a great tension between predictability and apparent randomness which is always beautifully balanced.

The combination of the predictable and unpredictable is also a powerful factor in many of the late cut-outs of Matisse (see pp. 58–9). These provide some good examples of pattern as well as colour interaction, based on freer, more organic shapes than those used by Escher and Riley (Néret, 1994: especially 54–7, 74–5, 84–5). In all these patterns, Matisse places his shapes and colours in space with complete confidence and mastery.

Appendices

Appendix 1 Materials used in Colour figures 1–8

Colour figures 1–8 were made by painting sheets of paper, then cutting and assembling them. The paints used were Ocaldo ready-mixed poster paints, made and supplied by:

Calder Colours
Nottingham Road
Ashby-de-la-Zouch
Leicestershire LE65 1DR
Telephone: 01530 412885

The six colours used as primary hues were:

lemon yellow Y[g]: 020 lemon
orange yellow Y[r]: 021 brilliant yellow
scarlet R[o]: 026 brilliant red
magenta R[v]: 012 cerise
ultramarine B[v]: 031 brilliant blue
cyan B[g]: 067 sky blue

042 black and 046 white were used as well, together with occasionally 027 crimson as a very high-chroma red (e.g. in Colour figure 6b).

Appendix 2 Shape alphabet

This alphabet, suggested for use when investigating letters as shapes (pp. 83–4), is based on a design by the German designer Hans Schmidt, which he originally printed from a set of simple wooden blocks in the 1960s.

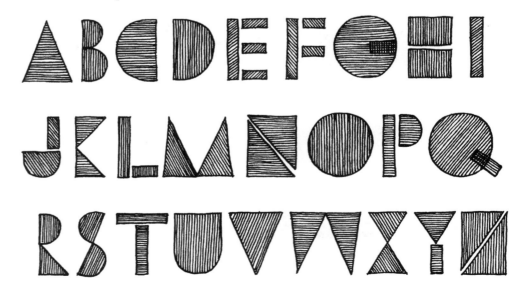

Appendix 3 Notes on children's work

Figure 3.9 *Tŷ Coeden (Tree-house)* by Hefin, age 8
Pencil on paper; original size A4

Hefin drew from his imagination the tree-house he would like to have in his garden, and the trees in the forest behind. He built up the picture in stages, drawing the tree-house first, then the steps up to it along the fallen tree, then the garden underneath and finally the trees behind. This is really a narrative drawing, in which he tells us about an imaginary place by way of a picture rather than in words. (The drawing is reproduced from a photocopy, as the original has unfortunately been lost.)

Hefin has developed his lines in a variety of ways, making shapes and textures which grow into linear and rotating patterns. It is also noticeable that, in order to show exactly what he wants, he has drawn parts of the scene as if they were tilted forward. In this way he is able to show us the walkway up the fallen tree and the garden underneath, which would be invisible with conventional perspective. This tilting, which cancels out any illusion of depth and flattens the whole scene on to the picture-plane, was a device used by Cézanne in many of his late still-lifes, and contributed to the development of Cubism by Picasso and Braque (p. 38). Hefin's drawing, however, has more in common with the fantasy landscapes of Henri Rousseau (p. 103).

Colour figure 9a *Mixing cool colours* by Max, age 6
Poster-paint on paper; original size A4
Colour figure 9b *Hot colour pattern* by Isabella, age 6
Poster-paint on paper; original size A3

Both these paintings resulted from a series of colour mixing activities in a Year 1 class. Max, experimenting with controlled mixing, found that 'because it was cool colours it was like water, so I did the curly shapes like the ripples'. He also put the most vivid green and blue he had available next to each other to obtain the greatest possible colour contrast. Isabella, at a later stage in the same programmme, used what she had learned about colour mixing to develop a pattern she had found at home, drawn in her sketch-book and then redrawn much larger. She said: 'It was nice going round and not going over the edges. I liked the diamond shapes.'

These paintings show several interactions between visual elements such as shape, colour and texture, and, in Isabella's case, line as well. Of particular interest is the coupling of cool colours with energetic shapes by Max, and static shapes with hot colours by Isabella (compare Colour figures 11a and 11b). Isabella's painting also shows that the clearer the lines separating areas of colour are, the stronger the contrast between the colours will appear (p. 59).

Colour figure 10a *Seaside collage* by Mollie, age 7
Colour figure 10b *At the seaside I saw ...* by Hannah, age 7
Both poster-paint on paper, cut and assembled; original sizes 320×230mm

Both these assembled pieces were part of a longer programme of work in a Year 2 class. After a visit to the seaside, the children chose three colours which they felt went well together, from hundreds of samples in paint shade-cards (pp. 56–7), mixed poster-paint to match them and painted sheets of paper. Having discussed some of Matisse's late cut-outs, especially *Les bêtes de la mer* (see Appendix 5) they made the own collages from the painted papers, using shapes which reminded them of what they had seen at the seaside.

Of the many comparisons to be made between these two works, perhaps the most significant are the way in which layout, shape and tonal contrast reflect the different approaches. Hannah's layout in three panels appears well thought out and structured, whereas Mollie's appears freer, though it is not haphazard. Mollie's shapes are more organic and most of them interact only with the colour-panel they are on, whereas Hannah's are more angular and are overlaid so that they interact with each other. This, combined with the layout and strong tonal contrast, gives Hannah's work a more static, considered feel, whereas Mollie's is more spontaneous and dynamic.

Colour figure 11a *Peaceful* by James, age 9
Aquarelle pencil and poster-paint on paper; original size A4
Colour figure 11b *Angry* by Zoë, age 9
Poster-paint on paper; original size A4
Colour figure 12b *Sleepy* by Robin, age 9
Poster-paint on paper; original size A4

These three paintings resulted from an exercise carried out by a Year 4 class, in which they were asked to express and communicate a mood through colour, but not by painting a picture. By presenting the idea in this way it was hoped that the work would be non-representational. All three are very successful examples of the potential of colour to communicate emotional states. Two of them are easy to decipher, and the third is a little more mysterious. As James put it, it was 'challenging to express, with colours and shapes, the picture I had in my mind'.

The paintings of Zoë and James show in a clear way how colour can interact with shapes and textures to communicate very divergent emotional states, from the aggressive energy of anger to the sensation of floating in a cool, free environment. Robin's painting was the only one from the whole class in which the mood being communicated could not immediately be guessed at, but when he was asked about his painting, he replied that he dreams in colour. His use of dilute paint, especially light-over-dark tonal contrast and complementary colour pairs, gives the whole painting a dynamic, shifting, kaleidoscopic feel, which expresses very well the unreality of a dream.

Colour figure 12a *Ffrwythau (Fruits)* by Bethan, age 8
Pencil, pencil crayon and wash on paper, original size A4

Bethan does a lot of drawings from memory and imagination, so I suggested that she tried to draw or paint something she was looking at, as a simple kind of still-life. This was one of the results. Although Bethan's painting and Robin's (Colour figure 12b) are equally successful, the contrast between them could hardly be stronger. On the one

hand, we have simplicity, delicacy and space with very few shapes and colours, and on the other complexity, energetically filling its frame completely and using almost every part of the colour-wheel.

Bethan, like Hefin (Figure 3.9) uses a lot of line in her work. A second, undulating line covers some of her first, confident outlines, then she develops her simple line drawing with colour. Here there is a contrast between the strong, fairly precise pencil-crayon colour and the delicate wash applied later, each of which has its own distinctive texture. Colour intensity is also varied skilfully, to emphasize that the banana is an angular object, not a round one. This painting is also a good example of space as a positive visual element. The three shapes float weightlessly in space, the shapes of the fruits interacting with each other and with the ellipse of the plate, which in turn interacts with the edge of the paper so that all of the space is active.

Appendix 4 Image resources

Learning from the artwork of others is an essential part of an exploration of art, and doing so through investigations of the visual elements has the advantage that, while resources of images are just as vital as for any other approach to art, particular examples are not often essential. In the final sections of Chapters 2–12, artists' works are quoted together with comments. These are listed, together with their locations, in Appendix 5 and many of them can be viewed on-line on interactive gallery websites (see p. 154). Apart from visits to local art galleries and visits from local artists, image resources available to schools will be in the form of posters, books, CD-Roms and the Internet.

Posters

Posters are very good resources for display at the start of a programme of work and for whole-class teaching, but are less useful for supporting individual work. The main limitations are first, the availability of images to exemplify what is being investigated or discussed, and secondly their cost. Twentieth-century art is under-represented in most low-cost art poster catalogues, partly because of high fees required by copyright holders, and posters from specialist suppliers are often in the art-print end of the market and correspondingly expensive. On a cost-per-image basis posters are usually much more expensive than books, and it is worth enquiring into the possibility of borrowing them from other schools or library services.

Books

Although less usual than posters for whole-class teaching, books are often better for individual or small groups, and good art books contain many images to compare and contrast, as well as an informative commentary. To support and extend investigations into the visual elements, books on individual artists will be more rewarding than those on themes or historical periods. More specialized and expensive art books are available from library services, but it is worth trying to build up a basic art library in the school, for day-to-day use by both children and teachers. The range of mass-market art books has expanded significantly in recent years and this, together with greatly reduced prices, means that many of them may now be considered for in-school image resources.

The most affordable best-value art books at present (2002) are the Basic Art series

published by Taschen. Somewhat more expensive, but of excellent quality and still very good value, is the Colour Library series by Phaidon. Books in the Thames and Hudson's World of Art series are very informative and the series is wide-ranging, but their smaller format reduces their usefulness in the classroom. All these publishers have websites which list the titles available in each series. Many Dover Books are also good value, but it can be difficult to get hold of the whole of their range.

CD-Roms

CD-Roms are an excellent source of images, if a high-resolution colour monitor is available. Most major galleries market CD-Roms, but these vary in quality, and unless a high proportion of the images will be used, they can be a very expensive resource, judged on a cost-per-image basis. When assessing quality, it is worth investigating the images before purchase to find out whether, when the magnifying option is selected, the enlarged image is actually more detailed than the overall one, or is simply expanded with no added information. The latter is, of course, much less useful.

The Internet

The availability of images on the Internet is changing so rapidly that any information here is almost certain to be out-of-date before it is read. However, a few general remarks may be useful. On-line images rarely have enough detail to make serious study possible, but are good for a general overview. In addition, even with good equipment, textures become invisible in most images and colour values are often seriously distorted.

Few art galleries, even major ones, have fully interactive websites in which their collections are available for viewing on-line. At present the best appear to be: National Gallery, London (www.nationalgallery.org.uk); Tate Gallery, UK (www.tate.org.uk); Guggenheim Collection, New York (www.guggenheimcollection.org), all of whose collections are accessible from their home pages for on-line viewing. In addition, the Tate website gives the location of every item in the collection which is currently being exhibited. The Musée Nationale de l'Art Moderne in Paris has an excellent collection, but the links are a little more complex. The sequence is: www.centrepompidou.fr > musée > les Modernes > recherches (in bottom bar) > artist's name.

Some major museums also have excellent websites. Two of the best are the British Museum, London (www.britishmuseum.org.uk) and the Metropolitan Museum in New York (www.metmuseum.org/collections). The website of the Victoria and Albert Museum in London has fairly high-quality images but only a small proportion of the collection is featured.

Viewing art on-line is not without its complications. The availability of images is constantly changing. At the time of writing (March 2002), some galleries are experiencing problems with copyright. Many images of works by artists alive after 1930, which are often the most worthwhile for studying the visual elements, are not available, and images which were on-line a year ago have been withdrawn. All you can do is log on and try.

Appendix 5 List of artists and artworks

The works and the galleries in which they are usually displayed are listed under artists' names, arranged alphabetically. Nearly all the listed works are paintings, and a note is put beside those such as drawings, scuptures and posters which are not. Where a work is illustrated in a book listed in the References section, a page reference is given.

Anonymous

Wilton Diptych: London, National Gallery

Bellini, Giovanni (died 1536)

The Doge Leonardo Loredan: London, National Gallery

Brancusi, Constantin 1876–1957

Bird in space (bronze and marble sculpture): Paris, Musée Nationale de l'Art Moderne

Fish (bronze sculpture): London, Tate Gallery

Maiastra (bronze and stone sculpture): London, Tate Gallery

Sleeping muse (marble sculpture): Paris, Musée Nationale de l'Art Moderne

Braque, Georges 1882–1963

Violin and jug: Basle, Kunstmuseum

Violin and palette: New York, Guggenheim Collection

Calder, Alexander 1898–1976

Mobile (metal, wood, wire and string sculpture): London, Tate Gallery

T and swallow (wood and steel sculpture): London, Tate Gallery

Cassandre, A.M. (pseudonym of Adolphe Mouron) 1901–68

Normandie (printed poster): copies in various museums including London, Victoria and Albert Museum; Hillier, 1976: 78

Caulfield, Patrick 1936–

Pottery: London, Tate Gallery

Cézanne, Paul 1839–1906

Forked pine-tree in the park of Château-Noir: London, National Gallery

Kitchen still-life: Paris, Musée d'Orsay

Le Château de Médan: Glasgow, Burrell Collection

Still-life with fruit and vase: London, Courtauld Institute

Still-life with ginger-jar and melons: London, National Gallery

Still-life with water-jug: London, Tate Gallery

Constable, John 1776–1837

The hay wain: London, National Gallery

The hay wain (full-size preparatory sketch): London, Victoria and Albert Museum

Delaunay, Robert 1885–1941

Circular forms, sun no. 2: Paris, Musée Nationale de l'Art Moderne; Düchting, 1994: 47

Rhythm: joy of life: Paris, Musée Nationale de l'Art Moderne; Düchting, 1994: 66

Window on the city no.4: New York, Guggenheim Collection; Düchting, 1994: 29

Windows open simultaneously: London, Tate Gallery

Delaunay, Sonia 1885–1979

Electric prisms: Paris, Musée Nationale de l'Art Moderne; Düchting, 1994: 44

Flamenco singer: Lisbon, Gulbenkian Foundation; Düchting, 1994: 50

Le Bal Bullier: Paris, Musée Nationale de l'Art Moderne; Düchting, 1994: 42–3

Rhythm colour: Lille, Musée des Beaux-Arts; Düchting, 1994: 78

Derain, André 1880–1954

Mountains, Collioure: Washington, DC, National Museum of Art

Escher, Maurits (M.C.) 1898–1972

Dream (woodcut): Escher, 1994: plate 7

Development 1 (woodcut): Escher, 1994: plate 16

Three worlds (lithograph): Escher, 1994: plate 49

Eyck, Jan van (died 1441)

Man in a turban: London, National Gallery

Frink, Elisabeth 1930–93

Bird (bronze sculpture): London, Tate Gallery

Goggle head (bronze sculpture): London, Tate Gallery

Harbinger bird IV (bronze sculpture): London, Tate Gallery

Gabo, Naum 1890–1977

Head no. 2 (enlarged version) (steel sculpture): London, Tate Gallery

Kinetic construction (standing wave) (metal and wood with electric motor): London, Tate Gallery

Model for 'Column' (construction): London, Tate Gallery

Model for 'Constructed torso' (construction): London, Tate Gallery

Model for 'Rotating fountain' (metal and plastic construction): London, Tate Gallery

Giacometti, Alberto 1901–66

Man pointing (bronze sculpture): London, Tate Gallery

Gogh, Vincent van 1853–1890

Cottages at Auvers: Paris, Musée d'Orsay; Walther, 1990: 77

The postman Joseph Roulin (drawing): Malibu, CA, J. Paul Getty Museum; Walther, 1990: 42

Self-portrait 1889: Paris, Musée d'Orsay; Walther, 1990: 73

Starry night: New York, Museum of Modern Art; Walther, 1990: 71

Still-life with onions: Otterlo, Rijksmuseum Kröller-Müller; Zelanski and Fisher, 1989: 50

Wheat fields with cypresses (drawing): Amsterdam, Rijkmuseum Vincent van Gogh; Walther, 1990: 68

Wheat fields with cypresses: London, National Gallery; Walther, 1990: 69

Hepworth, Barbara 1903–75

Ball, plane and hole (wood sculpture): London, Tate Gallery

Figure of a woman (stone sculpture): London, Tate Gallery

Seated figure (wood sculpture): London, Tate Gallery

Three forms (marble sculpture): London, Tate Gallery

Two forms (alabaster and limestone sculpture): London, Tate Gallery

Hobbema, Meyndert 1638–1709

The Avenue, Middelharnis: London, National Gallery

Hokusai, Katsushika 1760–1849

Great Wave of Kanagawa (woodblock print): copies in many museums, including London, Victoria and Albert Museum

Johns, Jasper 1930–

Flags: collection of the artist; Zelanski and Fisher, 1989: 96

Kandinsky, Wassily 1866–1944

Blue mountain: New York, Guggenheim Collection; Becks-Malorny, 1999: 35

In grey: Paris, Musée Nationale de l'Art Moderne; Becks-Malorny, 1999: 118

Murnau: landscape with a tower: Musée Nationale de l'Art Moderne; Becks-Malorny, 1999; 31

Red oval: New York, Guggenheim Collection; Becks-Malorny, 1999: 33

With a white border: New York, Guggenheim Collection; Becks-Malorny, 1999: 93

Klee, Paul 1879–1940

Ad Parnassum: Berne, Kunstmuseum; Hall, 1992: 99

A young lady's adventure: London, Tate Gallery; Hall, 1992: 55

Conqueror: Berne, Kunstmuseum; Hall, 1992: 91

Crystal gradation: Basle, Kunstmuseum; Hall, 1992: 59

Fruits on red: Munich, Stadtische Galerie; Hall, 1992: 89

Fugue in red: private collection; Hall, 1992: 61

Hanging fruit: New York, Metropolitan Museum of Art

Little jester in a trance: Cologne, Museum Ludwig; Hall, 1992: 81

Polyphony: Basle, Kunstmuseum; Hall, 1992: 97

They're biting!: London, Tate Gallery

Three subjects, polyphony: private collection; Hall, 1992: 93

Uplift and direction (glider flight): private collection; Hall, 1992: 95

Léger, Fernand 1881–1955

Still-life with a beer-mug: London, Tate Gallery

Lewis, Wyndham 1882–1957

Workshop: London, Tate Gallery

Malevich, Kasimir 1878–1935

Dynamic suprematism: London, Tate Gallery

Suprematist composition: airplane flying: New York, Museum of Modern Art; Whitford, 1987: 107

Matisse, Henri 1869–1954

Blue nude III (paper cut-out): Paris, Musée Nationale de l'Art Moderne; Néret,1994: 67

Flowering ivy (paper cut-out): Dallas, Museum of Fine Arts; Néret, 1994: 83

Les bêtes de la mer (paper cut-out): Washington, DC, National Museum of Art; Néret, 1994: 79

Open window, Collioure: New York, John Hay Whitney Collection

Polynesia, the sky (paper cut-out): Paris, Musée Nationale de l'Art Moderne; Néret, 1994: 48

The snail (paper cut-out): London, Tate Gallery; Néret, 1994: 82, Whitford, 1987: 31

View of Collioure: St Petersburg, Hermitage Museum

Woman with amphora (paper cut-out): Paris, Musée Nationale de l'Art Moderne; Néret, 1994: 75

Zulma (paper cut-out): Copenhagen, Statens Museum for Kunst; Néret, 1994: 64

Moholy-Nagy, László 1895–1946

K VII: London, Tate Gallery; Whitford, 1987: 111

Mondrian, Piet 1872–1944

Blue tree: The Hague, Gemeentenmuseum; Whitford, 1987: 18

Composition in colour B: Otterlo, Rijksmuseum Kröller-Müller; Blotkamp, 1994: 92

Flowering apple-tree: The Hague, Gemeentenmuseum; Whitford, 1987: 19

Grey tree: The Hague, Gemeentenmuseum; Whitford, 1987: 18

Mill by the water: New York, Museum of Modern Art; Blotkamp, 1994: 33

Red tree: The Hague, Gemeentenmuseum; Whitford, 1987: 18

Rousseau, Henri 1844–1910

 Snake charmer: Paris, Musée d'Orsay

 Tropical storm with tiger (surprise!): London, National Gallery

Rubens, Peter Paul 1577–1640

 Susanna Lunden: London, National Gallery

Seurat, Georges 1859–91

 A Sunday afternoon on the island of La Grande Jatte: Chicago, Art Institute

 Bathers at Asnières: London, National Gallery

 Le Bec du Hoc, Grandcamp: London, National Gallery

 Young woman powdering herself: London, Courtauld Institute

Spencer, Stanley 1891–1959

 Daphne: London, Tate Gallery; Robinson, 1990: 83

 Shipbuilding on the Clyde: welders: London, Imperial War Museum; Robinson, 1990: 90–5

Stieglitz, Alfred 1864–1946

 Avenue of trees (photograph): Weber, 1994: 53

 From my window: New York (photograph): Weber, 1994: 15

 Later Lake George: weathervane on wooden cottage (photograph): Weber, 1994: 72–3

 Looking north . . . NY (photograph): Weber, 1994: 48

Titian *see* Vecellio, Tiziano

Turner, Joseph 1775–1851

 The fighting Téméraire *tugged to her last berth*: London, National Gallery; Bockemühl, 1993: 82, 85

 Rain, steam and speed: London, Tate Gallery; Bockemühl, 1933: frontispiece

 Rome from the Vatican: London, Tate Gallery; Bockemühl, 1993: 31

 Snow storm: steam-boat off a harbour's mouth: London, Tate Gallery; Bockemühl, 1993: 70–1

van Eyck *see* Eyck, Jan van

van Gogh *see* Gogh, Vincent van

Vecellio, Tiziano (Titian) c. 1485–1576

 Death of Actaeon: London, National Gallery

 Bacchus and Ariadne: London, National Gallery

References

Anscombe, Isabelle (1984) *A Woman's Touch*. London: Virago.

Backhouse, Janet, Turner, D.H. and Webster, Leslie, eds (1984) *The Golden Age of Anglo-Saxon Art*. London: British Museum.

Bain, George (1994) *Celtic Art: the methods of construction*. London: Constable.

Becks-Malorny, Ulrike (1999) *Wassily Kandinsky*. Cologne: Taschen.

Benke, Britte (2000) *Georgia O'Keeffe*. Cologne: Taschen.

Billcliffe, Roger (1978) *Mackintosh Watercolours*. London: John Murray.

Blotkamp, Carel (1994) *Mondrian: the Art of Destruction*. London: Reaktion Books.

Bockemühl, Michael (1993) *J.M.W. Turner: the World of Light and Colour*. Cologne: Taschen

Caruana, Wally (1993) *Aboriginal Art*. London: Thames and Hudson.

Düchting, Hajo (1994) *Delaunay*. Cologne: Taschen.

Escher, M.C. (1992) *The Graphic Work*. Cologne: Taschen.

Field, Robert (1988a) *Geometric Patterns from Islamic Art and Architecture*. Diss, Norfolk: Tarquin Publications.

Field, Robert (1988b) *Geometric patterns from Roman Mosaics*. Diss, Norfolk: Tarquin Publications.

Field, Robert (1996a) *Geometric Patterns from Churches and Cathedrals*. Diss, Norfolk: Tarquin Publications.

Field, Robert (1996b) *Geometric Patterns from Tiles and Brickwork*. Diss, Norfolk: Tarquin Publications.

Gombrich, E.H. (1977) *Art and Illusion*, 5th edn. Oxford: Phaidon.

Gregory, Richard, Harris, John, Heard, Priscilla and Rose, David, eds (1995) *The Artful Eye*. Oxford: Oxford University Press.

Hall, Douglas (1992) *Klee*, 2nd edn. London: Phaidon.

Hillier, Bevis (1976) *Travel Posters*. Oxford: Phaidon.

Kudielka, Robert and Riley, Bridget (2002) *Paul Klee: the Nature of Creation*. London: Hayward Gallery and Lund Humphries.

Laing, Lloyd and Laing, Jennifer (1992) *Art of the Celts*. London: Thames and Hudson.

Lewison, Jeremy (1991) *Ben Nicholson*. London: Phaidon.

Lynton, Norbert (1998) *Ben Nicholson*, abridged edn. London: Phaidon.

Néret, Gilles (1994) *Matisse Cut-Outs*. Cologne: Taschen.

Payne, Laura (2000) *Essential Picasso*. Bath: Parragon.

Pevsner, Nikolaus (various dates) *The Buildings of England* series. London: Penguin Books. (This series has a volume for each county.)

Proctor, Richard M. (1990) *Principles of Pattern Design*. New York: Dover Books.

Riley, Bridget (2002) 'Making Visible', in R. Kudielka and B. Riley (2002) (see above).

Robinson, Duncan (1990) *Stanley Spencer*. London: Phaidon.

Schools Curriculum and Assessment Authority (SCAA) (1997): *Expectations in Art at Key Stages 1 and 2*. London: Schools Curriculum and Assessment Authority.

Scerrato, Umberto (1976) *Monuments of Civilization: Islam*. London: Cassell.

Scheideg, Walter (1967) *Crafts of the Weimar Bauhaus*. London: Studio Vista.

Walther, Ingo F. (1990) *Vincent van Gogh: Vision and Reality*, Cologne: Taschen.

Weber, Eva (1994) *Alfred Stieglitz*. London: Bison Books.

Whitford, Frank (1987) *Understanding Abstract Art*. London: Barrie and Jenkins.

Willats, John (1997) *Art and Representation*. Princeton, NJ: Princeton University Press.

Williams, Geoffrey (1971) *African Designs from Traditional Sources*. New York: Dover Books.

Zelanski, Paul and Fisher, Mary Pat (1989) *Colour for Designers and Artists.* London: Herbert Press.

Index